CAMERA PORTRAITS

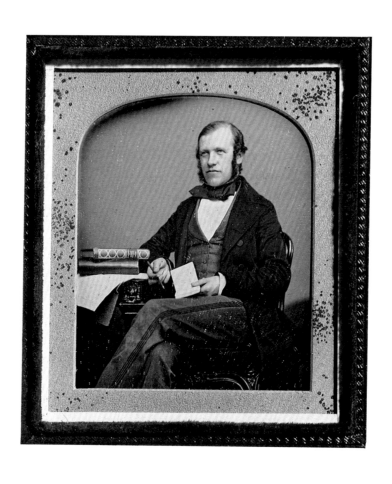

William Edward Kilburn, *Sir George Scharf, the first Secretary and Director of the National Portrait Gallery*, 1847, daguerreotype.

CAMERA PORTRAITS

PHOTOGRAPHS FROM THE
NATIONAL PORTRAIT GALLERY, LONDON 1839–1989

MALCOLM ROGERS

OXFORD UNIVERSITY PRESS
NEW YORK
1990

WITH THE SUPPORT OF

First published by National Portrait Gallery Publications,
National Portrait Gallery, St Martin's Place, London WC2H 0HE,
England, 1989

Copyright © National Portrait Gallery, London, 1989

Published in North America by
Oxford University Press, Inc.
200 Madison Avenue
New York
NY 10016

Oxford is a registered trademark of Oxford University Press

Library of Congress Cataloguing-in-Publication Data

National Portrait Gallery (Great Britain)
 Camera portraits: photographs from the National Portrait
Gallery, 1839–1989/Malcolm Rogers.
 p. cm.
 Originally published: London, England: National Portrait
Gallery Publications, National Portrait Gallery, 1989.
 Includes index.
 ISBN 0-19-520858-7.—ISBN 0-19-520859-5 (pbk.)
 1. Photography—Portraits—Exhibitions. 2. National Portrait
Gallery (Great Britain)—Exhibitions. I. Rogers, Malcolm.
II. Title.
TR680.N34 1990
779'.2'07442132—dc20 90-36406
 CIP

ISBN 0-19-520858-7 (cloth)
ISBN 0-19-520859-5 (paperback)

Catalogue edited by Gillian Forrester
Designed by Tim Harvey
Colour origination by P.J. Graphics, London
Typeset and printed by BAS Printers, Over Wallop, Hampshire
Bound by Hunter & Foulis Limited

Front cover: Virginia Woolf by George Charles Beresford (no.65)
Back cover: Christopher Isherwood and Wystan Hugh Auden by
Louise Dahl-Wolfe (no.107)

PHOTOGRAPHIC ACKNOWLEDGEMENTS

The Gallery would like to thank the following for kindly giving
permission to reproduce copyright photographs in the catalogue
in the following entries: © Gilbert Adams FRPS (110); © 1959 by
Richard Avedon. All rights reserved (131); Cecil Beaton
photograph (115) courtesy of Sotheby's London; © Bruce
Bernard (141); © Michael Birt (140); by kind permission of Noya
Brandt copyright 1989 (114, 117); © David Buckland (148);
© Cornell Capa/Life (121); © Jonty Daniels (109); © Daniel Farson
(124); © Mark Gerson (129); © Fay Godwin (137); © Brian
Griffin (147); © Hulton-Deutsch Collection (120); © Geoffrey
Ireland (128); © Paul Joyce (139); © 1949 Yousuf Karsh (119);
© John R. Kennedy (127); © Monika Kinley (125); © Trevor
Leighton (150); © Jorge Lewinski (134); © Simon Lewis (146);
© Cornel Lucas (122); © Mayotte Magnus (138); © Felix H. Man
Estate (113); © Angus McBean (116); © Lee Miller Archive, 1985.
All rights reserved (112); © Lewis Morley (132); © Arnold
Newman (126); © Helmut Newton (136); © Terry O'Neill (143);
© Norman Parkinson (133); © Dudley Reed (144); © reserved
(123); © Snowdon/Camera Press (130); © Wolf Suschitzky (118);
© John Swannell (145); © John Walmsley (135); © Denis Waugh
(142). Fig. 10 is reproduced by kind permission of Godfrey
Argent ©.
All other photographs are copyright of the National Portrait
Gallery.

All original photographs were photographed in colour by Frank
Thurston except for nos. 76, 90, 96, 98, 101, 108, 119, 133 and
fig. 12 which were photographed by Barnes & Webster.

AUTHOR'S NOTE

The photographs are arranged in approximately chronological
sequence.

Sizes of photographs are given (height before width) in
centimetres with the size in inches shown in parentheses.
Photographs are reproduced at the same size as the originals
where the originals measure 20 centimetres or less on their
longest dimension.

Inscriptions are noted where they give significant information.
The date given for each photograph indicates when it was taken,
and not the date of the print. The National Portrait Gallery
accession number is given at the end of each entry heading:
numbers prefixed by 'P' are in the Gallery's Primary Collection,
and those prefixed by 'X' or 'AX' are in the Reference Collection.

The names of sitters are given in their fullest form, except in the
case of living sitters where their professional or preferred names
are used. Photographers are generally given their professional
names.

Camera Portraits

For primitive peoples, the camera was often seen as an evil force which would steal a person's soul and capture it on paper. In some ways, they may not have been totally wrong, for photographs often do capture the heart and soul of life.

To mark the 150th anniversary of the invention of photography and celebrate its unique contributions, Mobil is proud to sponsor the exhibition, *Camera Portraits*, a series of historic photographs from the National Portrait Gallery in London and recreated in this inspiring book.

The National Portrait Gallery's collection spanning one hundred and fifty years of portrait photography encompasses some of the most important personalities in Britain's past – as well as some of the most intriguing. *Camera Portraits*, chosen from the riches of this collection, offers the reader a unique opportunity to transcend time and lock eyes with history – not in some Keatsian 'cold pastoral', but in the warm, sometimes even startling, immediacy of a private encounter face to face.

While history is important to each of these photographs, the exhibition itself represents another historical first. *Camera Portraits* is the first joint venture of the National Portrait Gallery in London and the National Portrait Gallery in Washington, D.C. Mobil was proud to co-sponsor the exhibition in London and is proud today to make this splendid collection available to American audiences. We are equally pleased to be able to promote the fine exchange between these distinguished and significant institutions.

Mobil has long enjoyed a very fine relationship with the British people, their arts and their culture. Our two Nations as well have long shared common interests and common goals. This exhibition is one more testament of that enduring relationship.

ALLEN E. MURRAY
Chairman, Mobil Corporation

Contents

Foreword

Twenty-five years ago photographs were still assigned a secondary role in the Gallery's collecting policy. Julia Margaret Cameron may have been accepted as an 'old master', but there was nothing by Cecil Beaton in the Gallery. Eminent sitters were asked to sit to the Gallery's chosen photographer, but this was purely for record purposes. There was no question of contemporary photography being considered an art form that would contribute to any deeper understanding of the personalities of the makers of British history.

All this has now changed. Today the Gallery's collection of photographs is one of the most important in the world; and, in point of distinction as well as comprehensiveness, unique as a collection of portrait photographs. However, since many of these photographs remain in our research collections, they are not as well known as they might be. The intention of this book and the accompanying exhibition is to highlight some of the masterpieces of the art which we now possess.

JOHN HAYES
Director, National Portrait Gallery, London

With the publication of *Camera Portraits* a selection of masterpieces from the remarkable collections of the National Portrait Gallery in London is brought before the American public for the first time. The appearance of this book in the United States coincides with the showing of these photographs in the National Portrait Gallery in Washington, and this is an occasion of special significance. The photographs in *Camera Portraits* are of surpassing interest, both as objects of aesthetic quality and as historical documents.

The staff of the American Portrait Gallery had long admired the richness of the collections and the energetic program of special exhibitions that has given the Portrait Gallery in London its special quality, and had long hoped to be able to express this admiration by sharing a portion of the British collection with American audiences. At last it has become possible to do so, with this striking selection of photographic masterpieces. Since the two National Portrait Galleries have a special relationship, this is a particularly happy occurrence for us, and a welcome opportunity to pay tribute to a museum with which we have a special affinity.

It has been a pleasure to work with the staff of the National Portrait Gallery in London on this project; special thanks are due to the Director John Hayes, Malcolm Rogers, John Adamson, Carole Patey, and the many others who originated this exhibition and this book. And all of us are deeply grateful to the Mobil Corporation for its imaginative support of the exhibition both in Great Britain and in the United States.

ALAN FERN
Director, National Portrait Gallery, Washington, D.C.

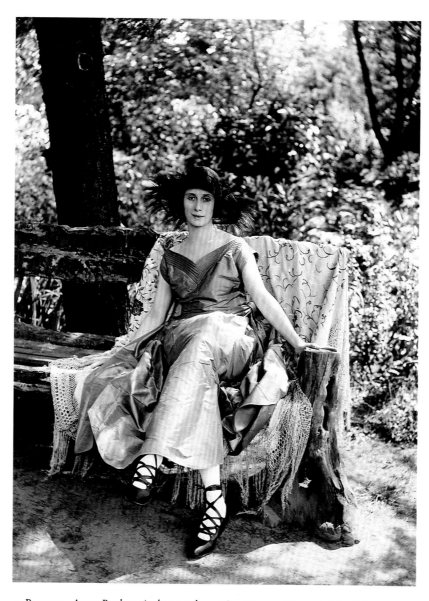

1 Bassano, *Anna Pavlova in her garden at Ivy House, Hampstead*, 28 June 1920, from the original glass negative.

Introduction

The idea of a National Portrait Gallery was first put forward in the House of Commons in 1845, and the Gallery itself founded in 1856, seventeen years after the invention of photography. This 'Gallery of the Portraits of the most eminent Persons in British History' was created in a spirit of high idealism. Lord Palmerston (no. 18) in the debate on its foundation put this into words:

> There cannot, I feel convinced, be a greater incentive to mental exertion, to noble actions, to good conduct on the part of the living, than for them to see before them the features of those who have done things which are worthy of our admiration, and whose example we are more induced to imitate when they are brought before us in the visible and tangible shape of portraits.

Among the first Trustees of the Gallery were Disraeli (no. 39) and the historian Lord Macaulay; the first vacancy was filled by Carlyle (no. 31), and the second by Gladstone (no. 38). All the Trustees were men distinguished in public life, and with a powerful sense of the history of a great nation.

They chose as the first Secretary (later Director) of the Gallery (Sir) George Scharf (1820–95; frontispiece), the son of a Bavarian draughtsman and lithographer of the same name who had come to London in 1816. Scharf studied with his father and at the Royal Academy Schools, and, like his father, worked largely as a draughtsman and book-illustrator. His natural bent was antiquarian. In 1840 he travelled with the archaeologist Sir Charles Fellows to Asia Minor, and three years later was official draughtsman on the government expedition to the same area; among the works illustrated with his efficient line drawings were Macaulay's *Lays of Ancient Rome* (1847), Layard's books on Nineveh, Dr Smith's celebrated classical dictionaries, volumes on Italian painting, Greek history and Indian ethnography, as well as the poems of Keats. In the 1850s he worked with Charles Kean (no. 9) on his revivals of Shakespeare's plays at the Princess' Theatre, advising him on the design of authentic classical costumes and scenery, and was an enthusiastic organizer of art exhibitions. But from 1857, the year of his appointment to the Gallery, Scharf devoted himself almost entirely to the study of portraiture.

When it opened to the public for the first time in 1859 at 29 Great George Street, Westminster, the Gallery owned fifty-seven portraits; when Scharf retired in 1895 (just a year before the opening of the present building) there were nearly a thousand – paintings, drawings and sculptures, but no photographs. This omission was to be expected, for the Gallery had been founded with one of its specific aims to inspire portrait artists 'to soar above the mere attempt at producing a likeness, and to give that higher tone which was essential to maintain the true dignity of portrait painting as an art'. Photography is not mentioned explicitly here, but there is an implied comparison in the dismissive 'mere attempt at producing a likeness', and perhaps also the recognition of

the threat it posed to 'portrait painting as an art'. The odds against photography were further increased by the Trustees' rule that no portrait of any living sitter (apart from the sovereign and his or her consort) was to be admitted to the collection.

Despite this, George Scharf was himself a keen collector of photographs, and as from 1857 until his death in 1895 his bachelor life was inextricably entwined with that of the Gallery, it is entirely reasonable to regard his personal collection as the beginning of the Gallery's own. Indeed, he bequeathed it to the Gallery, along with his notebooks, papers and library.

Scharf himself first sat to a photographer in 1847 – to William Kilburn of Regent Street, for a daguerreotype which is still in the Gallery's collection (frontispiece). This was taken ten years before he joined the Gallery. He is shown (in reverse, as is always the case with a daguerreotype) with a copy of Macaulay's *Lays of Ancient Rome*, and a map, presumably of Asia Minor, in allusion to his travels with Fellows, which, like the *Lays*, were published that year. In his hands he holds one of the sketchbooks which he used throughout his life as a kind of visual diary.

In the course of his career he sat to a dozen other photographers, among them Ernest Edwards (see nos. 30 and 34), Maull & Polyblank (see nos. 14, 16 and 29), Bassano, and, in Paris at the end of a visit to the Exposition Universelle of 1867, to the celebrated French photographer Nadar (see no. 26). Scharf records in his diary for Wednesday 21 August 1867: 'Had my portrait photographed by Nadar'. In his sketchbook on the previous day he had drawn the view from the window of Nadar's studio (fig. 2). Two poses survive from the sitting. The first (fig. 3) shows him holding his exhibition catalogue; the other (fig. 4) drawing in his sketchbook. Scharf commissioned photographs of himself to commemorate significant events in his life, but above all, as was the fashion, for presentation. The Nadar cartes-de-visite are inscribed 'Mother'; a cabinet photograph now in the collection was presented to his Masonic Lodge, and his diary records several distributions to friends, usually at the New Year. On 6 January 1876, for instance, he 'sent out Photographs of self (by [Cecil W.] Wood) to various friends', and on 13 January the following year paid Wood 12 shillings for a further twelve cabinet photographs 'of self'. As a collector of photographs Scharf was also typical of his day. He restricted himself almost entirely to cartes-de-visite and cabinet photographs, and his favourite subjects were royalty, distinguished figures in public life, singers and actors, and sportsmen. He also assembled a small album of views of places he had visited. Many of the figures in public life were his friends or acquaintances, and Mayall's carte of Charles Longley, Archbishop of Canterbury (fig. 5), for instance, was bought, as Scharf noted on the reverse, immediately after he had lunched with him, on 10 July 1863. It was his habit throughout his career at the Gallery to record his purchases of photographs in his diary, and he noted under the entry for that day that he spent 1s 9d on 'Carte de visite of the Archbp. & Punch'.

What he did not collect is more surprising. In his time at the Gallery he acquired none of the published pantheons of the famous, such as Herbert Watkins' *National Gallery of Photographic Portraits* (1857–8), Maull & Polyblank's *Living Celebrities* (1856–9; see nos. 14 and 29), Lovell Reeve's *Men of Eminence* (1863–7; see no. 30), Barraud's *Men and Women of the Day* (1888–91; see nos. 48 and 50), or Ralph W. Robinson's *Members and Associates of the Royal Academy of Arts in 1891* (see no. 55). Nor did he show any interest in the photographers who were trying to raise photography above the 'mere attempt at producing a likeness', as, for instance, David Wilkie Wynfield (no. 25) or Julia Margaret Cameron (nos. 28 and 33). Yet Scharf was aware of the value

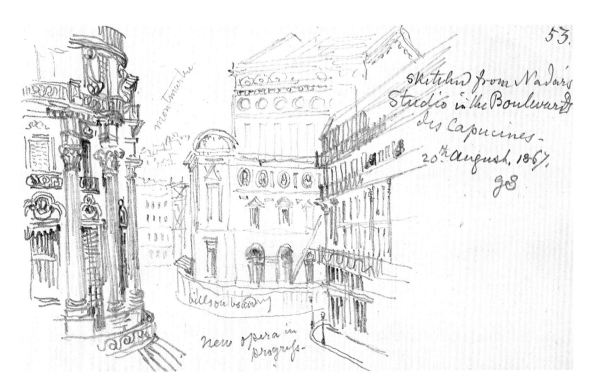

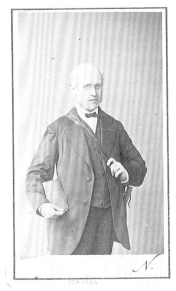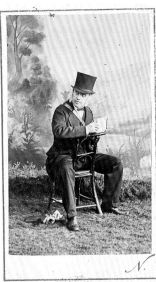

2 Sir George Scharf, *The view from the studio of the photographer Nadar, 35 Boulevard des Capucines, Paris,* 20 August 1861, silverpoint on paper.

3 & 4 Nadar, *Sir George Scharf,* 21 August 1867, albumen cartes-de-visite.

of photographs as historical evidence, and, on a visit to Florence Nightingale's home, Embley, Hampshire, in December 1857, he sketched there (fig. 6) her photograph by Goodman of Derby (no. 17).

In the years which followed Scharf's directorship and bequest – the early years of this century – the Gallery began to acquire photographs by purchase and gift for its 'Reference Portfolios'. The first to be noted individually in the Gallery's *Annual Report* was the imposing print of Queen Victoria at Frogmore (no. 60), purchased in 1901–2, in the directorship of (Sir) Lionel Cust. There followed a group of photographs of Edward VII and Queen Alexandra purchased shortly after their coronation, and in 1903–4 the Day Books of Camille Silvy (see no. 22), containing some 10,000 of his photographs 'of celebrities and well-known persons in society between 1860–1866'. This substantial acquisition did not set a precedent, and between 1904 and 1913 a mere half-dozen photographs were added to the collection. The *Report* for 1912–13 however does record one

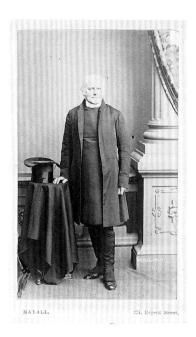
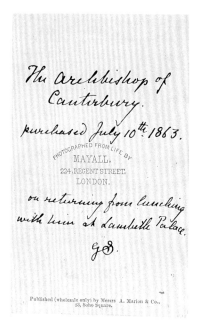

The Archbishop of Canterbury.

purchased July 10th 1863.

PHOTOGRAPHED FROM LIFE BY
MAYALL,
224, REGENT STREET,
LONDON.

on returning from luncheing
with him at Lambeth Palace.

gd.

MAYALL. 224, Regent Street,

Published (wholesale only) by Messrs A. Marion & Co.,
23, Soho Square,

5 J.J.E. Mayall, *Charles
Longley, Archbishop of
Canterbury*, c.1863, albumen
carte-de-visite (recto and verso).

innovation: the first photograph acquired for the Gallery's Primary or Display Collection as opposed to the Reference Collection. This was the ambrotype of Barbara Bodichon (1827–91), benefactress of Girton College, Cambridge (fig. 7), received as a gift, and given only a supplementary register number. It had to wait until 1920 for a companion – Kilburn's daguerreotype of the Reverend F.W. Robertson, author of *Two Lectures on the Influence of Poetry on the Working Classes* (1852), and then until 1932 for Mrs Beeton (no. 16).

In 1917, in the directorship of J.D. Milner, the Gallery's photographic policy advanced one stage further, with the foundation of the National Photographic Record. This had its origins in a project undertaken as an independent venture in 1916 by the photographers J. Russell & Sons of 51 Baker Street, London. In 1917 Russells donated the first batch of their photographs for the Record to the Reference Collection, and the Trustees of the Gallery then decided to adopt the project themselves and

> to commemorate by a uniform series of permanent photographs . . . the features of all distinguished living contemporaries of British nationality. In this series they hope to include all persons, naval, military or civilian, holding important or responsible positions, and others who have rendered service to their country by their valour or by their promotion of the welfare of the Empire.

Invitations to sit were sent out to a host of eminent figures (with varying degrees of success), and the official photographers were naturally Russell & Sons, a choice which aroused considerable criticism in the photographic press and anger in their fellow photographers.

Between its foundation in 1917 and demise in 1970 some 9,000 photographs were taken for the Record, mainly by Russells, and their chief photographer and chairman Walter Stoneman (see no. 111). After his death in 1958 the firm was taken over by an employee, Walter Bird, becoming Walter Bird Photography Ltd in 1961. Bird retired in 1967, when the firm was sold to Godfrey Argent, who continued the Record for a further three years.

The scheme was called a 'record' with some appropriateness, not just because it aimed at comprehensive coverage, but also because the format of the photographs (head

and shoulders or half-length), studio location, and the choice of photographer, ensured that the likenesses themselves rarely rose above the documentary. The whole project is a frustrating missed opportunity, as time and time again the eminent figures of the age are fossilized in likenesses of unimpeachable dullness (figs. 8 and 9). Moreover, Stoneman boasted his opinion that 'Women do not make beautiful photographs. Men have more character in their faces', and from 1932 onwards ceased to photograph women for the Record, with the exception of members of the Royal Family. Under the stewardship of Walter Bird the formats were varied a little to include the three-quarter-length, props such as spectacles introduced, and occasionally the photographer even ventured beyond the confines of the studio, but it was not until Godfrey Argent that the deadpan approach was finally banished. With the encouragement of the then Director of the Gallery (Sir) Roy Strong, he brought to the project a new flair and invention. He introduced new formats (including double portraits of distinguished husbands and wives), captured a wider range of emotions in his subjects, and liked to work on location. His portrait of Lord Ramsey, taken in 1969, shows the then Archbishop of Canterbury contemplating Howard Coster's photograph of one of his predecessors, William Temple (fig. 10).

In 1926, six years after the founding of the National Photographic Record, the art critic Roger Fry wrote in his introduction to a book of photographs by Julia Margaret Cameron:

> One day we may hope that the National Portrait Gallery will be deprived of so large a part of its grant that it will turn to fostering the art of photography and will rely on its results for its records instead of buying acres of canvas covered at great expense by fashionable practitioners in paint.

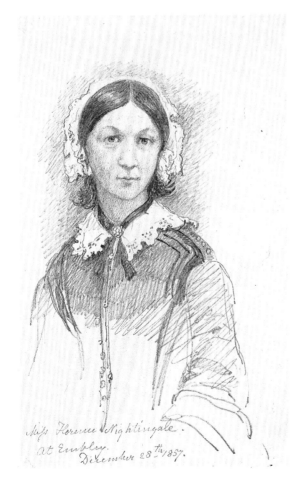

7 Silas A. Holmes of New York, *Barbara Bodichon*, 7 October 1863, ambrotype.

6 Sir George Scharf after Goodman of Derby, *Florence Nightingale*, 28 December 1857, silverpoint on paper.

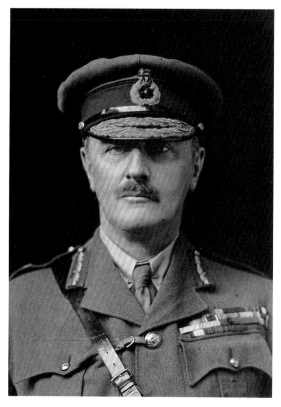
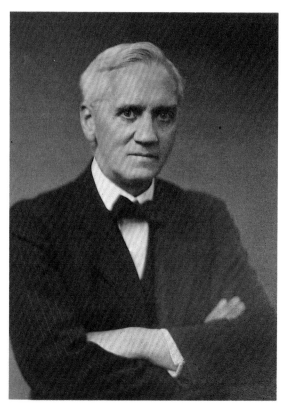

8 J. Russell & Sons, *Field Marshal Viscount Allenby of Megiddo*, 1919, bromide print.

9 J. Russell & Sons, *Professor Sir Alexander Fleming*, 1943, bromide print.

The Gallery had, in fact, acquired by gift a photograph of Thomas Carlyle by Mrs Cameron in 1922 (though in the *Annual Report* for that year the photographer is given as 'Beatrice Cameron'), and it purchased its first Cameron, again of Carlyle, in 1931. Nevertheless, Fry's views suggest that the Gallery was perceived as taking little interest in photography, either historic or contemporary. Attitudes, however, seem to have changed about this time, for in the second half of the 1920s and the 1930s the rate and significance of the acquisitions for the Reference Collection increases. Outstanding among the purchases of this period is the collection of the writer, critic and literary portraitist Sir Edmund Gosse, acquired from his estate in 1929 (nos. 25 and 56). In 1934 the then Director (Sir) Henry Hake, less than a month after Sir Edward Elgar's death, was in touch with the composer's friends about likenesses of him, and acquired two 'admirable photographs' (see no. 68). Photographers and their heirs increasingly came to see the Gallery as an appropriate home for representative collections of their work – G.C. Beresford (see no. 65) in 1933, Mrs Albert Broom (no. 81) in 1940, and Olive Edis (fig. 11; nos. 85 and 90) in 1948. The Gallery also took steps to acquire significant groups of original negatives. Negotiations were in hand to buy Beresford's negatives in 1943, and a group of them was finally acquired in 1954. Two years later the Gallery was given some 12,000 of (Sir) Emery Walker's negatives by Emery Walker Ltd (no. 49).

This process of growth continued throughout the 1950s and 1960s, but the Gallery's whole attitude to photographs and the collecting of them was transformed by four events which took place around 1970. First, the retrospective exhibition of the photographs of Sir Cecil Beaton, held at the Gallery in the winter of 1968–9, the first photographic exhibition to be mounted at the Gallery. Organized by Roy Strong and designed by Richard Buckle, this was seen by some 77,000 people, and did much to establish the taste for photography among museum visitors. Secondly, in 1969 the Trustees' rule which

barred any living sitter or person who had died during the last ten years from inclusion in the collection was abolished. Thirdly, in 1970, the National Photographic Record was discontinued in favour of a policy of buying photographs from a range of contemporary photographers: a decision which would have pleased Roger Fry. Finally, in 1972 the Gallery established a separate Department of Film and Photography with its own Keeper, Colin Ford, now Director of the National Museum of Photography, Film and Television, Bradford. From that time forward the display and acquisition of photographs for both Primary and Reference Collections have been recognized as major functions of the Gallery. There has been an outstanding series of photographic exhibitions, including one-man shows of the work of Paul Strand (1976), Arnold Newman (1979), Norman Parkinson (1981), Bill Brandt (1982), Robert Mapplethorpe (1988) and Helmut Newton (1988–9). Thematic exhibitions have included 'The Camera and Dr Barnardo' (1974), 'Happy and Glorious' (1977) in celebration of The Queen's Silver Jubilee, 'The Victorian Art World in Photographs' (1984), and 'Stars of the British Screen' (1985–6). Important acquisitions include the Hill and Adamson Albums (1973; nos. 2 and 3), and major groups of the work of Cecil Beaton (1970; no. 115), Madame Yevonde (1971; no. 106) and Dorothy Wilding (1976; no. 102), and in one extraordinary year, 1974, 2,000 prints and 8,000 negatives of distinguished figures, mainly writers, by Howard Coster (no. 108); 2,000 prints of his parliamentary colleagues by Sir Benjamin Stone MP (no. 73), and some 30,000 negatives of the firms of Bassano & Vandyk (fig. 1) and Elliott & Fry, dating from the 1890s to the 1950s. These last constitute, like the Silvy Day Books before them, an invaluable survey of English society of the period. In recent years a particular effort has been made by the Gallery's Twentieth Century Department to watch and encourage the careers of the best young portrait photographers, as exemplified by the exhibition

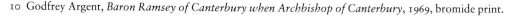

10 Godfrey Argent, *Baron Ramsey of Canterbury when Archbishop of Canterbury*, 1969, bromide print.

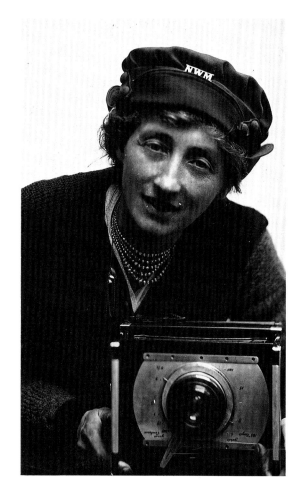

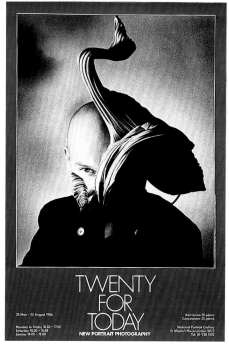

12 Poster for the exhibition 'Twenty for Today', with Nick Knight's portrait of Stephen Jones, 1985.

11 Olive Edis, *Self-Portrait 'ready to start to photograph the British Women's Services in France and Flanders'*, 1918, platinum print.

'Twenty for Today' (fig. 12). This included the work of Michael Birt (no. 140), David Buckland (no. 148), Brian Griffin (no. 147), Trevor Leighton (no. 150) and Dudley Reed (no. 144). The collection has been greatly enriched as a result.

In 1989 the Gallery's photographic collections comprise more than 100,000 images, dating from the early 1850s to the present day: an extraordinary accumulation, brought together partly by chance and partly by design. At its heart is a certain ambiguity, for, though it contains many masterpieces of portrait photography, the collection has always been envisaged as a historical one: a collection of eminent figures, who may or may not have been captured by great photographers. This book reflects that ambiguity. It contains many photographs which are objects of considerable aesthetic beauty, and some which are not; the humble snapshot (no. 93) has its place beside the most rarified concoction of the art studio (no. 94); all have been chosen for their historical and cultural significance. This is not historical academicism, for these images have a power to stimulate the imagination and stir the emotions. As portraits they bring before us men and women who are now, or one day will be, lost to us as physical presences, and they are thus a means of making contact with the great spirits of the past. Thomas Carlyle wrote of his own experience:

> In all my poor historical investigations it has been, and always is, one of the most primary wants to procure a bodily likeness of the personage inquired after – a good portrait if such exists; failing that, even an indifferent if sincere one.
>
> In short, any representation made by a faithful human creature of that face and figure which he saw with his eyes, and which I can never see with mine, is now valuable to me, and much better than none at all.

And again:

> Often have I found a portrait superior in real instruction to half a dozen written biographies. . . . or, rather let me say, I have found that the portrait was as a small lighted candle, by which the biographies could for the first time be read.

He was thinking primarily of painted portraits, but his remarks apply equally to photographs. Indeed, the initial impact of a photograph may well be greater than that of a painted portrait. Whatever insight it gives into character or qualities of mind – and this may be as great as in any portrait – it offers above all a magical illusion of that physical reality, of a specific moment in time and place, which has gone forever. We see, as the camera saw, Lord Raglan in the Crimea (no. 6), a courageous man in a situation where courage is of little help; Queen Victoria quietly working in her garden at Frogmore, her *munshi* standing silently by (no. 60); the poet Isaac Rosenberg, a Private on leave from the army in a commercial studio in Notting Hill Gate (no. 83); E.M. Forster in Aldeburgh struggling with an idea (no. 120). Some photographs, like the ambrotype of Derwent Coleridge and his wife (no. 10), may still be timed to the very minute, and, though they are only fragile objects, seem to represent a triumph over time. Marie Lloyd (no. 51), photographed in New York a hundred years ago, is caught at that moment and, it seems, forever in the thinnest layer of albumen. She beckons to us across the years and offers the promise which is also the promise and fascination of all photographs; that is: 'Yours Always'.

Acknowledgements

In the preparation of this book I am indebted for their help to Miss Frances Dimond of the Royal Archives, Windsor Castle; Professor Urmilla Khanna of the University of Delhi; Miss Louise West of the Ferens Art Gallery, Hull; Dr Pieter van der Merwe of the National Maritime Museum, Greenwich and Eddie Chandler, Dublin. Many of my colleagues at the Gallery have given me advice and encouragement, but I owe a particular debt to Terence Pepper of the Photographic Archive, without whose enthusiasm for the subject and great expertise this work would have been impossible. His colleague, Ian Thomas, has given invaluable support, as have Dr Tim Moreton, Julia King and Penny Dearsley. Gillian Forrester has been a meticulous and creative editor. Above all I am grateful to those contemporary photographers whose work is featured here who have supplied biographical information, donated or lent prints and transparencies, and waived copyright fees.

MALCOLM ROGERS

I

Charles John Canning, Earl Canning 1812–62

Richard Beard 1801–85

Daguerreotype, with the photographer's imprint on the gilt slip, early 1840s
5.1 × 3.2 (2 × 1¼)
Purchased, 1979 (P119)

A son of the great statesman George Canning, Charles Canning entered politics in his twenties, and rose rapidly. In 1841 Sir Robert Peel appointed him Under-Secretary for Foreign Affairs, and this daguerreotype was probably taken in London shortly after that date. A controversial Governor-General of India (1856), he steered the subcontinent through the crisis of the Indian Mutiny, and in 1858, following the transfer of the government of India from the East India Company to the Crown, became the first Viceroy. He was created an earl in the following year.

Richard Beard, a coal merchant from Blackfriars, London, set up in photography as a business speculation. He purchased a licence to use the daguerreotype process in March 1841, and opened Britain's first photographic portrait studio. There were huge profits from his studios in London and Liverpool and from the sale of licences to take daguerreotypes, but Beard was ruined by his many legal actions against rivals, above all Claudet (no.4), and went bankrupt in 1850.

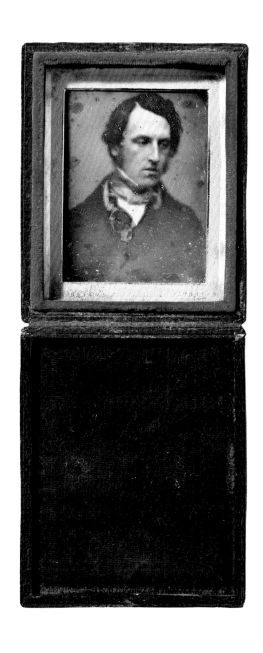

2

Sir David Brewster 1781–1868

David Octavius Hill 1802–70 and *Robert Adamson* 1821–48

Calotype, *c.*1845
19.4 × 14.4 (7⅝ × 5⅝)
Given by an anonymous donor, 1973 (P6/10)

The Scottish physicist Sir David Brewster was a founder member of the British Association for the Advancement of Science (1831), and a key figure in the early history of photography in Britain. Much of his own experimental work was devoted to optics – he invented the kaleidoscope (1816) and the lenticular stereoscope (see no. 4) – and he was a close correspondent of Fox Talbot, inventor of the calotype, who wrote explaining the process to him in May 1841.

It was Brewster who persuaded Robert Adamson to make a profession of calotype photography, and who introduced him to the painter D.O. Hill, with whom he worked in partnership from a studio in Edinburgh until 1847. In their photographs, 'executed by R. Adamson under the artistic direction of D.O. Hill', Adamson's scientific technique is transformed by Hill's aesthetic sensibility. The Gallery owns three albums of their finest work, presented by Hill to the Royal Academy in 1863, and given to the Gallery by an anonymous benefactor in 1973. They contain 238 prints, covering the whole range of Hill and Adamson's work: portraits, studies of fishermen and fishwives, topographical and genre scenes. See also no.3.

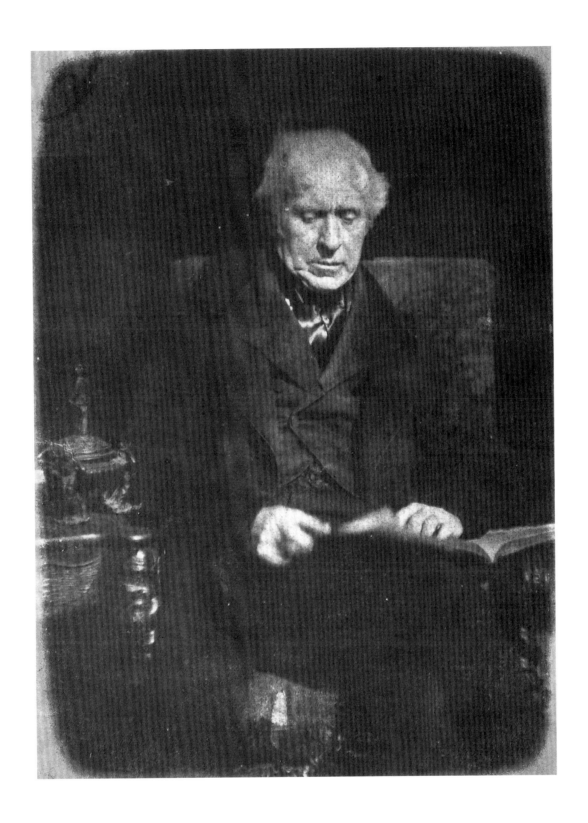

3

Anne Palgrave, Mrs Edward Rigby 1777–1872 and her daughter Elizabeth, Lady Eastlake 1809–93

David Octavius Hill 1802–70 and *Robert Adamson* 1821–48

Calotype, *c*.1845
20.1 × 14.8 (8 × 5⅞)
Given by an anonymous donor, 1973 (P6/134)

Mrs Rigby was the widow of the physician Edward Rigby of Norwich, by whom she had twelve children (including quadruplets). In October 1842 she moved with two daughters, Elizabeth and Matilda, to Edinburgh. There Elizabeth, who had already travelled in Germany and Russia and published *A Residence on the Shores of the Baltic*, worked for the publisher, John Murray, at whose house she met Hill. She, her mother and sister often visited Hill and Adamson's studio at Rock House on Calton Hill, and were photographed there on several occasions. This double portrait of mother and daughter, which has the atmosphere of a genre study, is one of the photographers' most poetic treatments of the fall of light on fine fabrics.

In 1849 Elizabeth married Charles (later Sir Charles) Eastlake, future President of the Royal Academy, Director of the National Gallery and first President of the Royal Photographic Society. In London this statuesque bluestocking (she was almost six feet tall) moved in the highest intellectual, literary and political circles, and pursued a long career as critic, art historian and biographer (among her subjects was the sculptor John Gibson [no. 26]).

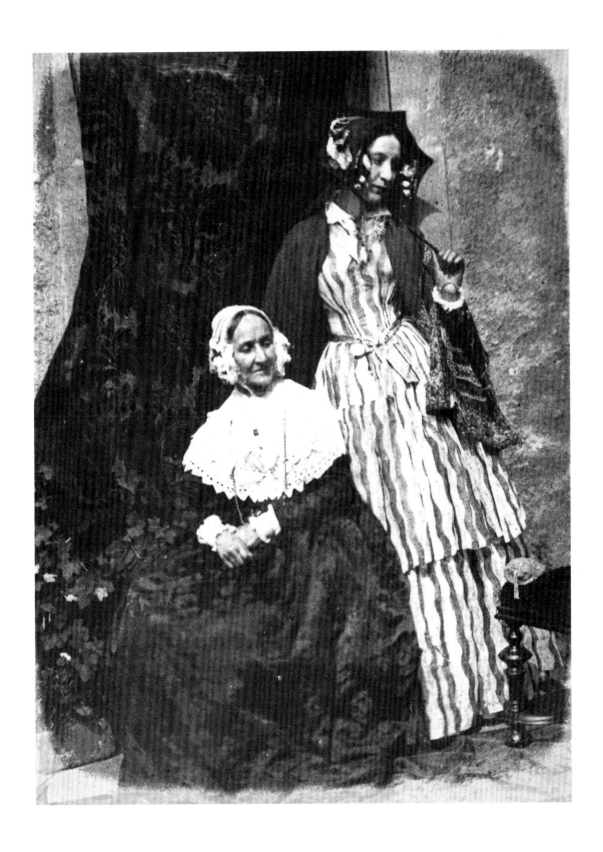

4

Sir Charles Wheatstone 1802–75 and his Family

Antoine François Jean Claudet 1797–1867

Stereoscopic daguerreotype, with the photographer's label on the backing, *c*.1851
Each 7.3 × 5.7 (2⅞ × 2¼), arched top
Given by the Governing Body of King's College, London, 1980 (P154)

The sitters are (left to right): Arthur William Frederick, son (born 1848); Wheatstone; Florence Caroline, daughter (born 1850); Charles Pablo, son (born 1857), and Emma West, Mrs Wheatstone (*c*.1813–65), who died before her husband's knighthood.

Charles Wheatstone began his career as a musical instrument maker, and from the start revealed his powers as an inventor when he patented the concertina (1829). He was the first to make possible the sending of messages by electric telegraph, a pioneer of submarine telegraphy, and instrumental in the creation of the modern dynamo. In the history of photography he has a special place, for in 1832 he invented the stereoscope, by which an impression of solidity in an image is obtained through the combination of two pictures in slightly dissimilar perspective. He announced his discovery in 1838, a year before the invention of photography, and, on the publication of Fox Talbot's and Daguerre's work, he quickly asked the leading photographers (among them Richard Beard [no. 1]) to take pictures for his instrument. It was not however until the invention of the lenticular stereoscope by Sir David Brewster (no. 2) in 1849 that it was possible to obtain a satisfactory result from stereo-daguerreotypes. These were displayed at the Great Exhibition in 1851, and thereafter achieved widespread popularity. This seems to have gone to the head of Brewster, who claimed pre-eminence over Wheatstone, and there followed a war of words in which the Scotsman showed especial spite.

Claudet, a native of Lyons, came to London in 1829 and opened a glass warehouse in High Holborn. He was the first to import daguerreotypes and cameras from France, and soon eclipsed his rival Beard. He applied himself keenly to the development of stereoscopic photography, and was largely responsible for its popularity. His pictures were taken by two cameras set up side by side – there was no binocular camera – and this gives them an effect of exaggerated rotundity. This historic photograph shows the inventor of the stereoscope surrounded by his family. A man of 'an almost morbid timidity', he turns away from the cameras to examine one of his own inventions, the wave model (*c*.1840) by which he demonstrated the wave properties of light.

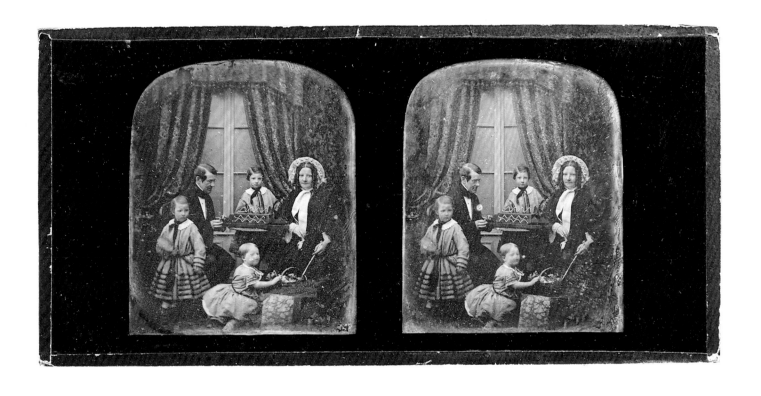

5

Robert Stephenson 1803–59

Unknown photographer

Daguerreotype, *c*.1851
11.4 × 8.9 (4½ × 3½)
Given by Miss M.K. Lucas, grand-daughter of the painter John Lucas, 1927 (P4)

The only son of the pioneer of railways, George Stephenson, Robert Stephenson's early career was spent in the locomotive business, and the famous *Rocket* (1829) was built under his supervision at his father's Newcastle works. But his enduring fame rests on his work as a civil engineer, and above all on his bridges: the high-level Tyne bridge at Newcastle, the Royal Border Bridge at Berwick, the Britannia Bridge across the Menai Straits (1850), in which tubular girders were used for the first time, and the Victoria Bridge across the St Lawrence at Montreal.

To commemorate the building of the Menai Bridge the artist John Lucas painted for the Institute of Civil Engineers his group portrait *Conference of Engineers at the Menai Straits prior to floating a Tube of the Britannia Bridge* (*c*.1851–3). In this the central figure of Stephenson is based closely on this daguerreotype, which was given to the Gallery by a descendant of the painter, and may have been taken specially to help Lucas in his project. If so, it is likely that the artist himself suggested Stephenson's thoughtful pose.

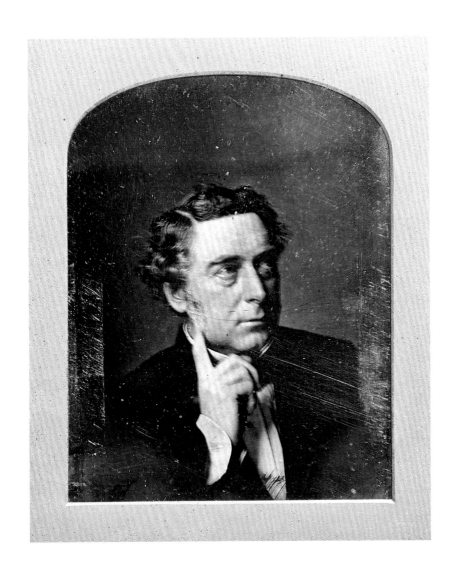

6

Lord Fitzroy James Henry Somerset, 1st Baron Raglan 1788–1855

Roger Fenton 1816–69

Salt print, on the publisher's printed mount; taken between March and June 1855
20 × 14.9 (7$\frac{7}{8}$ × 5$\frac{7}{8}$)
Purchased, 1983 (AX24901)

The youngest son of the Duke of Beaufort, Raglan entered the army at the age of sixteen, and was later aide-de-camp and military secretary to Wellington. He lost his right arm at Waterloo, and after the amputation called to the surgeon: 'Hallo! don't carry away that arm till I have taken off my ring'. In 1854, aged sixty-five, he was chosen to command the British troops against the Russians in the Crimea, but, though highly experienced in warfare and heroically brave, he had never led troops in the field. His victory at the Alma raised hopes for the prompt capture of Sebastopol, but the calamity of the Light Brigade at Balaclava (October 1854), a winter of starvation, and the disastrous attack on the Malakoff and the Redan before Sebastopol in the spring of 1855 were blows to morale both in England and at the front. He died of dysentry on 28 June, 'the victim of England's unreadiness for war'.

Roger Fenton first trained as a painter in Paris with Paul Delaroche, famous for his pronouncement, when confronted with a daguerreotype, 'From today painting is dead'. In 1852 Fenton circulated his 'Proposal for the formation of a Photographical Society', and, after its establishment, became the first secretary. He was the British Museum's official photographer, and in 1854 had a dark room built at Windsor Castle for the use of Queen Victoria and Prince Albert. In 1855 he was commissioned by the art dealers Thomas Agnew & Sons to photograph the Crimean War, and with the support of Prince Albert gained access denied to others. Nos. 6 and 7 are from the Gallery's copy of his *Historical Portraits, Photographed in the Crimea during the Spring and Summer of 1855*, and published by Agnew's in 1855–6. The photograph of Raglan, taken shortly before his death, is characteristic of Fenton's unforced documentary style, which gives his work its acute historical poignancy. Its perfection of technique belies the conditions in which he worked – in extreme heat, often under fire, and threatened by disease (he left the Crimea suffering from cholera).

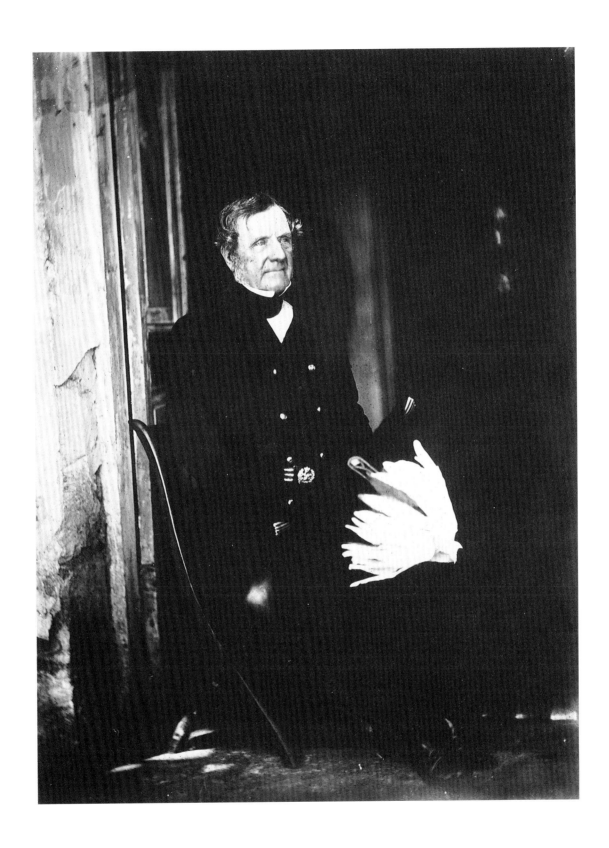

7

Sir John Campbell Bt. 1807–55 and his aide-de-camp Captain Hume

Roger Fenton 1816–69

Salt print, on the publisher's printed mount; taken between March and June 1855
19.8 × 17 (7¾ × 6⅝)
Purchased, 1983 (AX24906)

Campbell (seated), who joined the army aged fourteen, had served in India, Burma, the Mediterranean, the West Indies and Canada when he was posted to the Crimea as Brigadier-General. He was present at the Alma and Inkerman, and in December 1854 promoted to Major-General. On hearing of the intended attack on the Redan he volunteered to lead a storming party. On 18 June 1855, contrary to strict orders, and sending away Captain Hume, this was 'exactly what he did, and accordingly lost his life, and did not win. Poor fellow, he was as kind-hearted and gallant a man as you would meet anywhere but, alas for his wife and family, he thought of nothing but carrying the Redan with his own sword' (Colonel C.A. Windham). For Fenton, see no. 6.

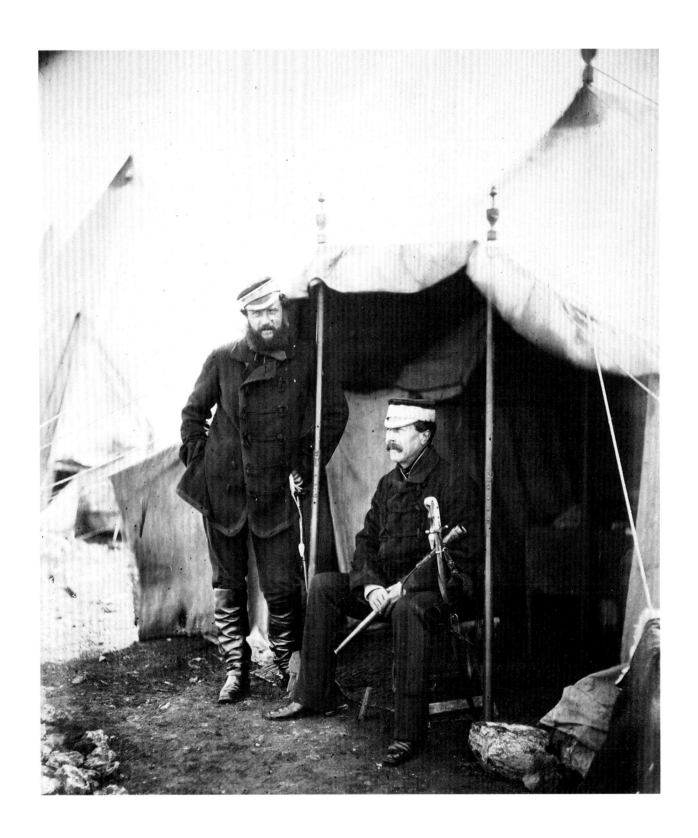

8

Jane Baillie Welsh, Mrs Thomas Carlyle 1801–66

Robert S. Tait active 1845–75

Albumen print, April 1855
14.6 × 11.6 (5¾ × 4⅝)
Given by Major-General C.G. Woolner, 1975 (x5665)

The self-willed and precocious daughter of a country doctor – on her tenth birthday she burnt her doll on a funeral pyre in imitation of Dido – Jane Welsh was known because of her wit and beauty as 'the flower of Haddington'. In 1826 she married, against her mother's wishes, the essayist and historian Thomas Carlyle (no. 31), her social inferior, determined to make a great man of him. Together, in Edinburgh and later in London, they forged one of the legendary marriages of literary history, formidable in public, turbulent in private: Carlyle was demanding and self-absorbed, Jane frugal yet deeply romantic, obsessed by her childlessness, intensely jealous, and, in her later years, a great invalid.

Tait, a relatively obscure portrait and genre painter and amateur photographer, became friendly with the Carlyles in the 1850s, and painted and photographed them and their house at 5 Cheyne Row, London. This photograph conveys much of Jane's passionate *Angst*, within the confines of a conventional format. It once belonged to the sculptor Thomas Woolner, who in 1855, the year it was taken, made a medallion portrait of Carlyle which is in the Gallery's collection.

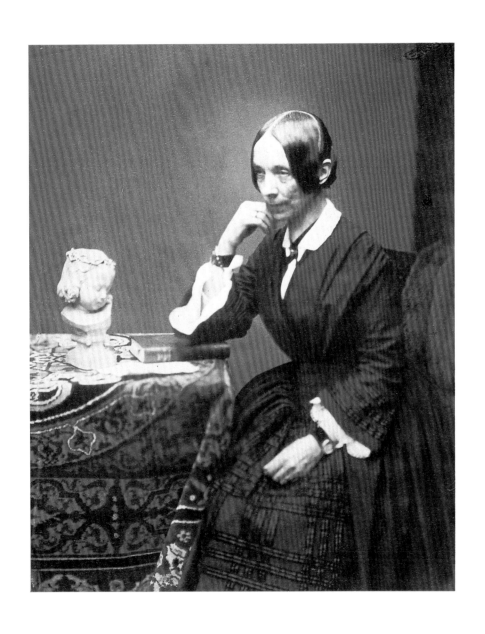

33

9

Charles John Kean ?1811–68 and Dame Alice Ellen Terry 1847–1928 as Leontes and Mamillius in Shakespeare's *The Winter's Tale*

Martin Laroche

Salt print, inscribed and dated on the reverse of the mount, 26 April 1856
22.3 × 17.6 (9⅛ × 6⅞)
Given by Miss Hipkins, 1930 (X7954)

Born into a theatrical family, Ellen Terry made her stage début on 28 April 1856 at the age of nine, as the boy Mamillius in *The Winter's Tale* with Charles Kean's company at the Princess's Theatre, Oxford Street. The performance was attended by Queen Victoria. This photograph, one of the earliest theatrical photographs in the Gallery's collection, was taken two days before, when the play was in rehearsal, and shows Terry and Kean in costume. Ellen Terry recalled: 'When Mr Kean as Leontes told me to 'go play', I obeyed his instructions with such vigour that I tripped over the handle [of the cart] and came down on my back! A titter ran through the house, and I felt that my career as an actress was ruined'.

Kean, the son of the celebrated tragedian Edmund Kean, and married to the actress Ellen Tree, was the first of the line of successful actor-managers who dominated London's theatre in the nineteenth century. Terry, following her disastrous marriage to the painter G.F. Watts (1864) and a liaison with the architect E.W. Godwin, went into theatrical partnership with Henry Irving at the Lyceum (1867). She played alongside him in a wide range of Shakespearian roles, and with her vitality, luminosity and intelligence, established herself as the leading actress of the period. She gave her last performance in 1925. Over many years, she enjoyed a spirited correspondence with George Bernard Shaw (no. 49), who wrote: 'Ellen Terry is the most beautiful name in the world; it rings like a chime through the last quarter of the nineteenth century'. Edward Gordon Craig (no. 77) was her son by Godwin.

Listed as a 'Daguerrotype artist' in the 1851 census, Martin Laroche (born William Henry Silvester) had a studio at 65 Oxford Street, seven doors away from the Princess's Theatre. Laroche collaborated extensively with Kean, and a large number of photographs survive, mainly of scenes from Shakespearian productions.

IO

The Reverend Derwent Coleridge 1800–83 and his wife Mary Pridham

Unknown photographer

Ambrotype, 19 August 1856
12.7 × 10.2 (5 × 4)
Purchased, 1986 (P322)

The second son of the Romantic poet Samuel Taylor Coleridge, Derwent was educated with his brother Hartley at a small school near Ambleside, where Southey and Wordsworth watched over them. His later career was dedicated to education and the church, and he was the first principal of St Mark's College, Chelsea (1841–64). He was a passionate believer in the teaching of Latin as a form of mental training, and considered the most accomplished linguist in England. Expert in all the major European languages, he knew Hungarian and Welsh poetry, and could read Arabic, Coptic, Zulu and Hawaiian.

This ambrotype shows him with his wife, whom he married in 1827, and is unusual in being precisely datable. Among the still-life of objects on the table is a ?calendar lettered: *FIELD FOOT AUG 19 1856*, and the watch on a stand gives the time as ten minutes past one. The Gallery also owns an ambrotype of Derwent alone, from the same sitting, taken, if the watch is to be believed, at seven minutes to eleven. The significance of 'Field Foot' is unknown, but may perhaps be the name of the otherwise unrecorded photographer.

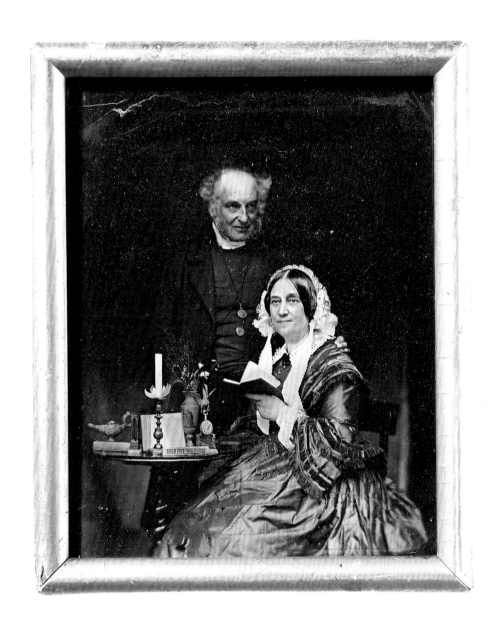

II

Charles Lutwidge Dodgson (Lewis Carroll) 1832–98

? Self-portrait

Albumen print, *c*.1856–60
9.1 × 5.7 (3⅝ × 2¼)
Bequeathed by G. Edward Pine, 1984 (P237)

The shy author of *Alice's Adventures in Wonderland* (1865) and *Through the Looking Glass and what Alice found there* (1871) was a mathematics don at Christ Church, Oxford. Fascinated by all forms of gadgetry, he was from about 1856 an enthusiastic amateur photographer. Although always interested in the techniques, he saw photography primarily as a means of expressing himself artistically, and often signed his prints 'from the Artist'. Of portrait photography he wrote in 1860:

> a well-arranged light is of paramount importance . . . as without it all softness of feature is hopeless . . . In single portraits the chief difficulty to be overcome is the natural placing of the hands; within the narrow limits allowed by the focussing power of the lens there are not many attitudes into which they naturally fall, while, if the artist attempts the arrangement himself he generally produces the effect of the proverbial bashful young man in society who finds for the first time that his hands are an encumbrance, and cannot remember what he is in the habit of doing with them in private life.

This photograph is perhaps a self-portrait, set up by Carroll, with a friend or assistant on hand to take off the lens cap. In it he has taken particular care with 'the natural placing of the hands'. In addition to a number of individual prints, the Gallery also owns an important album of twenty-eight photographs by Carroll of his friends and contemporaries at Oxford. See also no. 24.

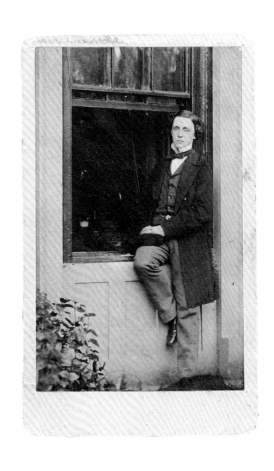

12

Clarkson Stanfield 1793–1867

William Lake Price 1810–96

Albumen print, on the photographer's printed mount, with a facsimile of the sitter's signature, c.May 1857
28.9 × 24.8 (11½ × 9¾), arched top
Given by an anonymous donor, 1976 (X1397)

The marine and landscape painter Stanfield, whom Ruskin (no. 47) regarded as 'the leader of the English realists', and 'incomparably the noblest master of the cloud-form of all our artists', spent his early career in the Merchant Navy, and this gave him an enduring love of the sea. He first came to London as a theatrical scene-painter, working above all at the Theatre Royal, Drury Lane. He also supervised the scenery for Dickens' (no. 19) private theatricals. He soon turned to painting, however, and his accomplished works, usually variations on well-tried formulæ, quickly won him academic and commercial success. A characteristic work stands on the easel in this photograph. It is a reduced version (location unknown) of his large canvas *A Dutch Blazer coming out of Monnickendam, Zuyder Zee* (1856), which Stanfield presented to the Garrick Club, London.

William Lake Price trained as an architectural and topographical artist with C.W. Pugin, but took up photography in the early 1850s. He is best known for his elaborate genre studies, studies of architecture and topography (some commissioned by the Queen), and for portraits, especially of artists. His writings on photography in the *British Journal of Photography* (founded in 1854) reveal his interest in the aesthetic possibilities of the medium, and he endows the heavy features of the worthy Stanfield with a notable romantic intensity. He wrote to Stanfield on 27 May 1857 from his house at 58 Queen's Terrace, London:

> I write to say that I am happy to find your Portrait the most admired of any which I have done and on the Printer sending me some more which I have ordered, I will do myself the pleasure of sending you up six copies for yourself. The one you have will not be permanent being full of Chemicals which I did not take time to remove. (National Maritime Museum, Stanfield MSS)

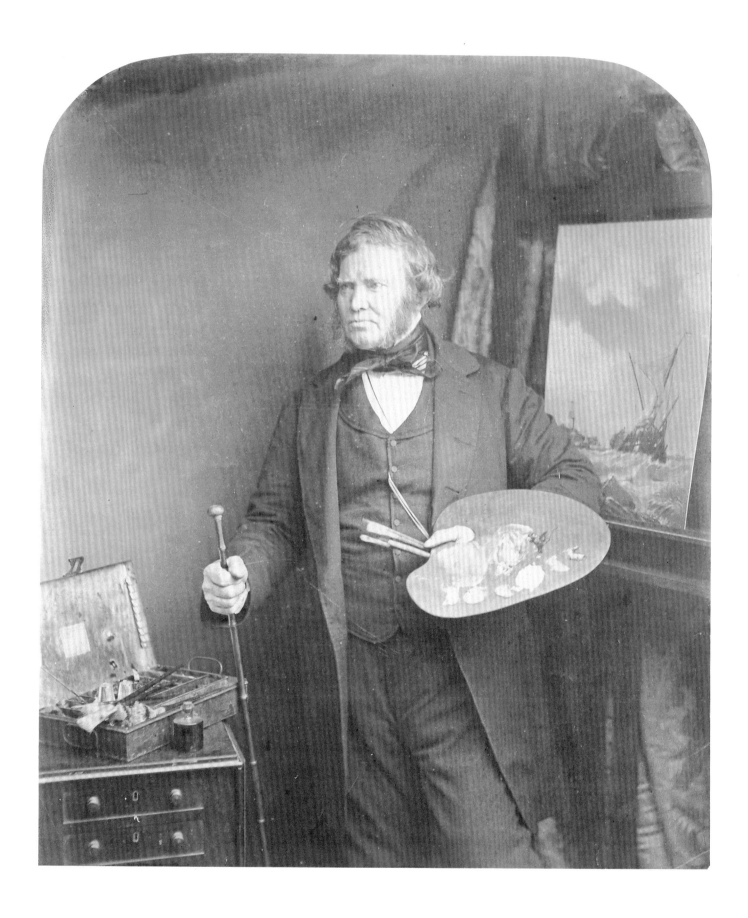

13

The Royal Family on the Terrace at Osborne House

Leonida Caldesi active 1850s–90s

Albumen print, 26 May 1857
15.9 × 21.3 (6¼ × 8⅜)
Purchased, 1977 (P26)

The sitters are (left to right) : Prince Alfred, Duke of Edinburgh 1844–1900; Prince Albert 1819–61; Princess Helena 1846–1923; Prince Arthur, Duke of Connaught 1850–1942; Princess Alice, later Grand Duchess of Hesse 1843–78; Queen Victoria 1819–1901, holding Princess Beatrice, later Princess Henry of Battenberg 1857–1944; Princess Victoria, Princess Royal and later Empress of Germany 1840–1901; Princess Louise, later Duchess of Argyll 1848–1939; Prince Leopold, Duke of Albany 1853–84, and Prince Edward, later Edward VII 1841–1910.

Queen Victoria and Prince Albert first began to collect photographs in the early 1840s, and did much to encourage the spectacular rise of photography in Britain. Photographs were included in two sections of the Great Exhibition (1851), and the Queen and her consort were the first patrons of the Photographic Society of London when it was founded in January 1853. Their collection was wide ranging, and included not just portraits, but also topographical, architectural and genre studies. But above all they valued photography for the opportunities it gave to commemorate the major events in their large and closely-knit family.

Princess Beatrice, their youngest child, was born on 14 April 1857, and the Queen went shortly afterwards with the infant princess and the rest of her family to Osborne on the Isle of Wight to recuperate. On 23 May the Florentine Signor Caldesi of Caldesi & Montecchi of 38 Porchester Terrace, London (see also no. 22), a firm much patronized by the Royal Family, was called to Osborne to photograph the new baby and the rest of the party.

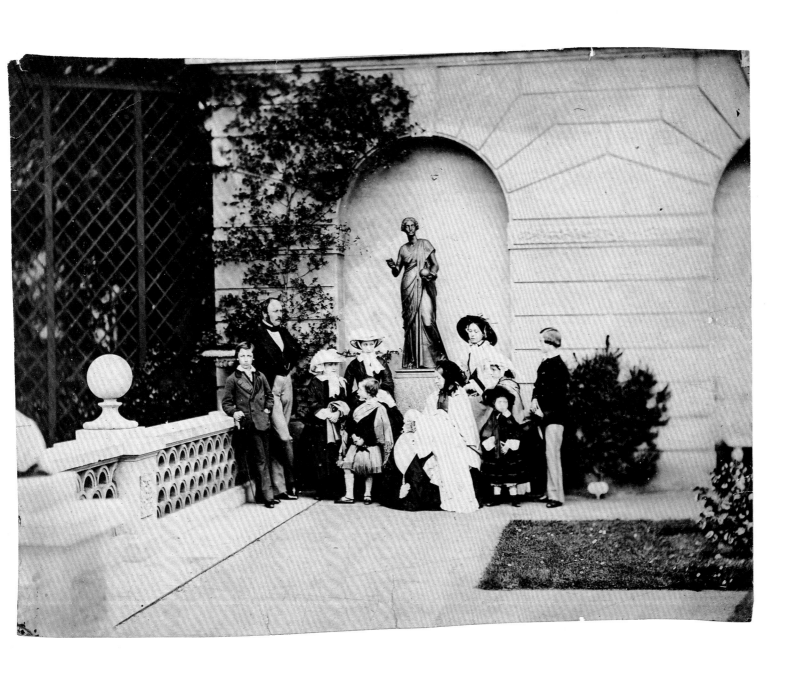

14

Michael Faraday 1791–1867

Maull & Polyblank active 1856–65

Albumen print, 1857
19.9 × 14.7 ($7\frac{3}{4}$ × $5\frac{3}{4}$), arched top
Purchased before April 1938 (AX7281)

The son of a blacksmith, Faraday began work as a bookbinder's errand boy, but went on to become one of the greatest of British scientists. From 1812 to 1823 he worked as assistant to Sir Humphry Davy in his research on the properties of gases, and witnessed the discovery of chlorine. Later his own researches at the Royal Institution, carried out in experiments of the greatest elegance, made possible the development of electricity as a source of energy by his discovery of electromagnetic induction (1831) and of diamagnetic repulsion (1845). He also originated the theory of the atom as the 'centre of force'.

The London commercial photographers Maull & Polyblank had studios at 55 Gracechurch Street and 187A Piccadilly, and produced from the late 1850s a series of 'Photographic Portraits of Living Celebrities' which were widely collected. The portrait of Faraday was issued in October 1857, and was presumably taken at the Piccadilly studio, which was close to the Royal Institution. He was by all accounts a brilliant lecturer (with typical thoroughness, he took lessons in elocution), and the photographers have shown him as if in the act of lecturing. He holds up a magnet, as he used to do; he would knock it with his knuckle, and exclaim: 'Not only is the force here, but it is also here, and here, and here', passing his hand through the air around the magnet at the same time. For Maull & Polyblank see nos. 16 and 29.

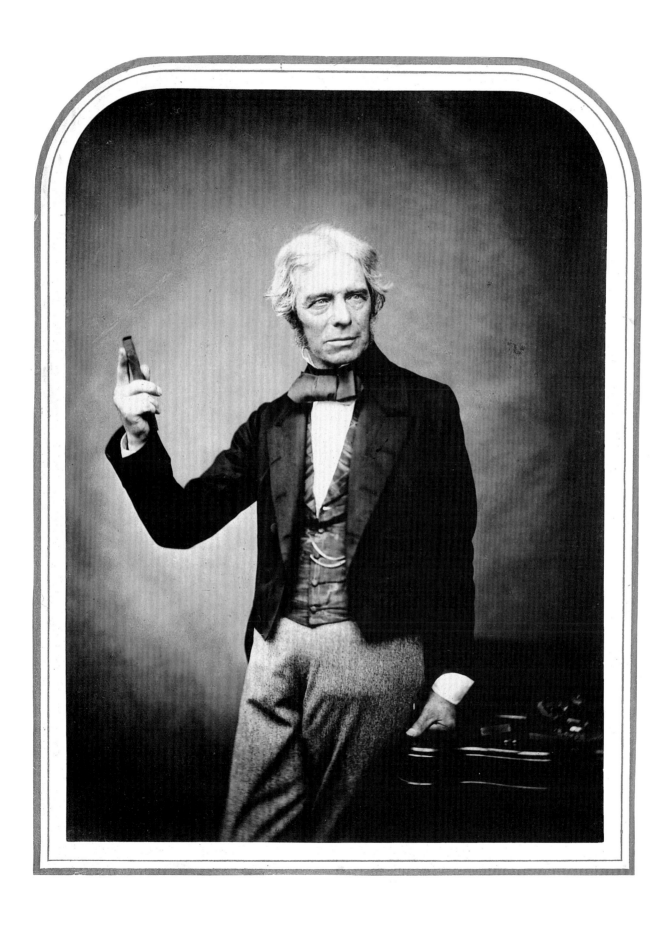

15

Isambard Kingdom Brunel 1806–59

Robert Howlett 1830–58

Albumen print, November 1857
38.6 × 22.5 (11¼ × 8⅞), arched top
Given by A.J.W. Vaughan, 1972 (P112)

The only son of the engineer Sir Marc Isambard Brunel, Brunel gained his earliest experience as an engineer working on his father's Thames Tunnel, where he showed his ability to work impossibly long hours, and in several emergencies, his sheer courage. He was the designer of the Clifton suspension bridge, and built railways in Italy, Australia and India, as well as at home, where the Great Western Railway is his most celebrated creation. But his greatest fame came as a designer of ocean-going steamships, of which the *Leviathan* or *Great Eastern*, as it came to be known, was the last and greatest. It was five times the size of any other ship, and in both design and construction revolutionary.

The photographer, Howlett, and his partner Joseph Cundall, were commissioned to take a series of photographs of this prodigious vessel by *The Illustrated Times*, a popular rival to *The Illustrated London News*, and a special number devoted to the *Leviathan* was published on 16 January 1858. Howlett portrays Brunel standing, casual and confident, in front of the massive breaking drum chains which let the ship down the slip when it was launched. Little is known of Howlett whom *The Illustrated Times* rightly called 'one of the most skilful photographers of the day'. He died less than a year after this photograph was taken, poisoned, it was suggested, by his own photographic chemicals.

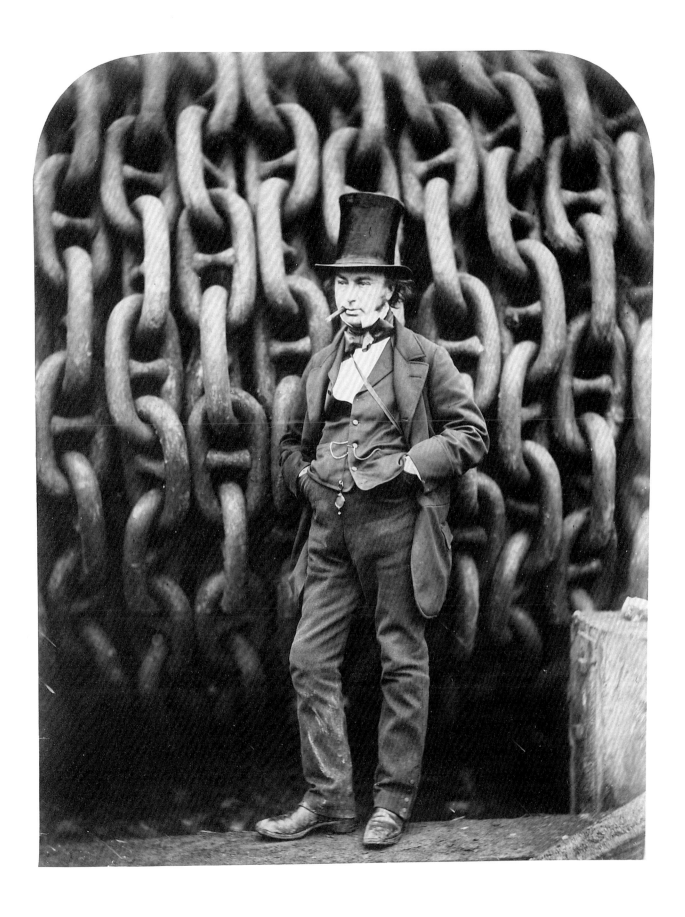

16

Isabella Mary Mayson, Mrs Samuel Beeton 1836–65

Maull & Polyblank active 1856–65

Albumen print, with ? later hand-colouring, on the printed mount of Maull & Co, 1857
18.4 × 14.4 (7¼ × 5⅞), arched top
Given by the sitter's son, Sir Mayson Beeton, 1932 (P3)

Isabella Mayson, from an old Cumberland family, married the editor and publisher Samuel Beeton in 1856. She worked with her husband as a journalist, writing fashion articles and notes on housekeeping for his periodicals, among them *The Queen* and *The Englishwoman's Domestic Magazine*, the first journal to issue paper dress-making patterns to its readers. At the same time she began 'the four years incessant labour' which led to the publication of her *Book of Household Management*, an encyclopaedia of information for the efficient running of the home, in which all the recipes had been personally tried. This was issued in twenty-four monthly parts from October 1859, and in book form in 1861. The second edition appeared after her death, in 1869, with a preface by Mr Beeton paying tribute to his wife. She died giving birth to their fourth child.

Sir Mayson Beeton, when he gave this photograph to the Gallery, stated that he believed it had been coloured by his sister after their mother's death. The original photograph was probably taken by Maull & Polyblank. Polyblank left the firm in 1866 and it continued under the names of Henry Maull & Co (1866–72), Maull & Co (1873–78) and Maull & Fox (1879–1908). This print was made by Maull & Co, which had premises in London at 67 Cheapside and 187A Piccadilly. For Maull & Polyblank see nos. 14 and 29.

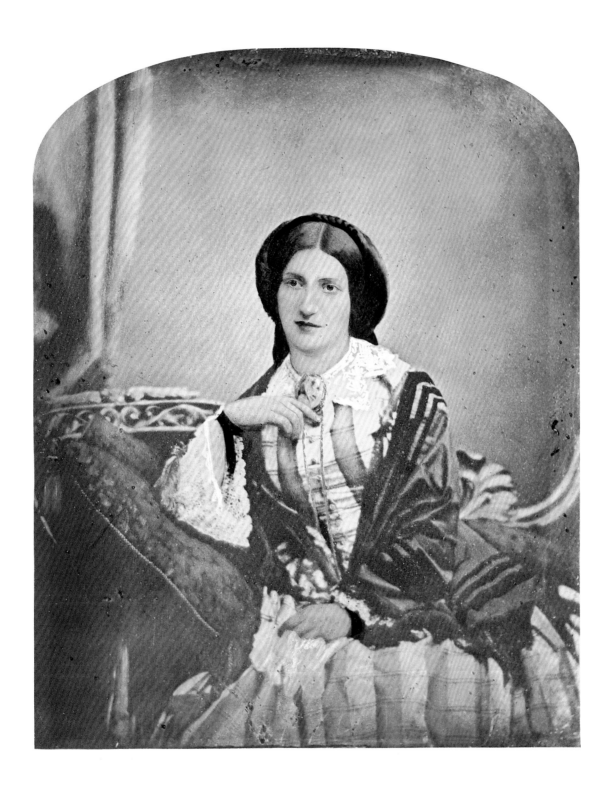

17

Florence Nightingale 1820–1910

Goodman of Derby active 1850s–60s

Albumen carte-de-visite, on the publisher's printed mount, *c*.1857
8.8 × 5.8 (3½ × 2¼)
Given by Hugh Tolson, 1936 (x16139)

Florence Nightingale arrived in the Crimea with a band of thirty-eight nurses on 4 November 1854. She went there in the face of official opposition, and found appalling conditions. But 'the Lady-in-Chief', as she became known, established herself at Scutari, and succeeded against all odds in transforming the military hospitals there. In the process she laid the foundations of the reforms which led to the modern nursing system. A national heroine, she nevertheless returned to England in 1856 with a minimum of fuss, and lived afterwards the retired life of an invalid, though never slow to give encouragement to those who continued her work. She was the first woman member of the Order of Merit.

At the time of Florence Nightingale's greatest fame there was an enormous demand for photographs, and this image, by the obscure Derby photographer Goodman, was widely published in carte-de-visite form. She is said to have referred to it, with characteristic incisiveness, as 'Medea after killing her Children'.

51

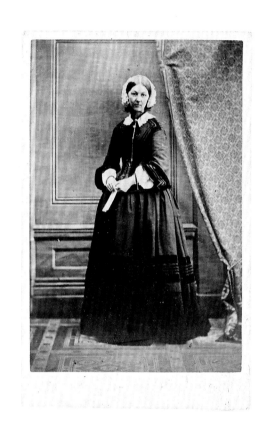

18

Henry John Temple, 3rd Viscount Palmerston 1784–1865

(William) Graham Vivian 1827–1912

Salt print, with the photographer's blind-stamp, inscribed and dated on the mount (now detached), 1858
17.9 × 12.4 (7 × 4⅞), oval
Purchased, 1980 (P152)

Palmerston was a dominating figure in British politics for more than fifty years. As Foreign Secretary (1831–41 and 1846–51) he raised British prestige to unparalleled heights by a mixture of craft, bluster and force. He was largely responsible for establishing the new state of Belgium, rescued Turkey from Russia, and went to war with China. As Prime Minister (1855) he brought the Crimean War to an advantageous peace, and his political position seemed thereafter virtually unassailable. In 1858, however, about the time of this photograph, 'Pam' was defeated on the Conspiracy to Murder Bill, and resigned. He became Prime Minister once more a year later, and died in office. Queen Victoria wrote shortly after his death: 'He had many valuable qualities, though many bad ones, and we had, God knows! terrible trouble with him about Foreign affairs. Still, as Prime Minister he managed affairs at home well, and behaved to me well. But I *never* liked him!'

Graham Vivian was the second son of J.H. Vivian, FRS, MP for Swansea and, like Palmerston, a Liberal. Rich and well-connected, he owned houses at 7 Belgrave Square, London and at Clyne Castle and Parc le Breos in Glamorgan (where he was High Sheriff for a period); his uncle was the 1st Baron Vivian; his elder brother, the 1st Baron Swansea. As a young man, between the 1850s and 1870s, Vivian was an enthusiastic amateur photographer, a member of the Photographic (or Calotype) Club, which had many aristocratic members, and which in 1853 became the Photographic Society. He specialized in portrait and topographical photography. This portrait of Palmerston, in a pose which recalls full-length paintings by Van Dyck and Gainsborough, was taken on the steps of his country house, Broadlands in Hampshire, where Vivian was no doubt a member of a house-party.

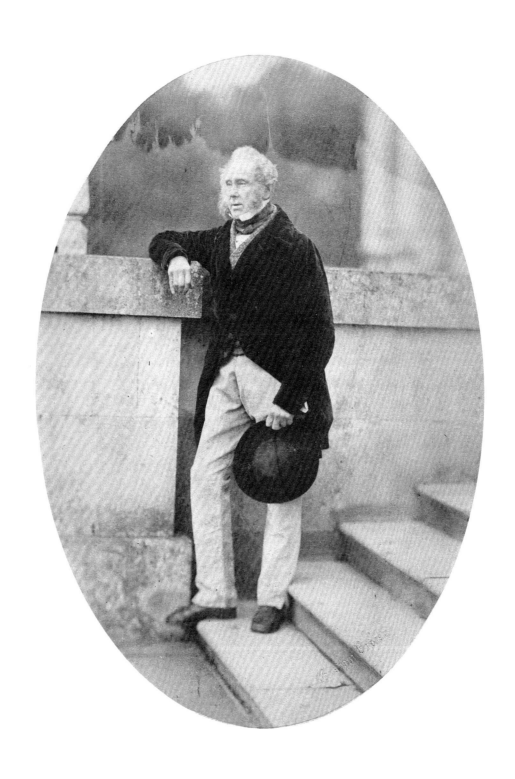

19

Charles John Huffam Dickens 1812–70

Herbert Watkins active 1850s–90s

Albumen print, 1858
20.3 × 15.1 (8 × 6), arched top
Purchased, 1985 (P301/20)

The year of this photograph, 1858, between the completion of *Little Dorrit* and the beginning of *A Tale of Two Cities*, was a momentous one for Dickens, for it was at this time he first became infatuated with a teenage actress, Ellen Ternan, and decided to separate from his wife. In the same period he began to give public readings from his works on a fully professional basis. Financial pressures made the readings a necessity, but the ageing Dickens soon found that he could not live without the excitement and public acclaim which they brought as well.

Herbert Watkins worked from the Institute of Photography, 179 Regent Street, London, from 1856 and produced a series of photographs of distinguished contemporaries, which he published with printed biographies under the title of *National Gallery of Photographic Portraits*. His portrait of Dickens shows him at his reading desk, about to begin a recital. Watkins claimed in his advertisements that his photographs were 'as remarkable for their agreeable fidelity to nature as for their brilliancy of production and their economy of cost', and 'untouched'. There is no doubting the vivacity of this likeness, but it has in fact been heavily retouched, most obviously in Dickens' hands, his book and in the still-life of objects on the desk. The Gallery owns two albums of Watkins' finest work. See also no. 20.

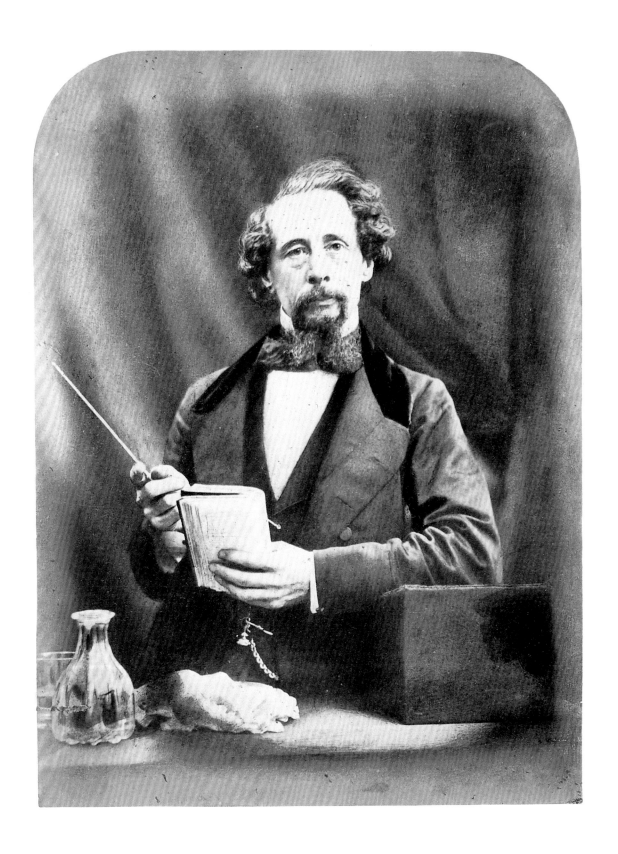

20

Sir Charles Barry 1795–1860

Herbert Watkins active 1850s–90s

Albumen print, 1859–60
20.8 × 15.8 (8 × 6¼)
Purchased before April 1938 (AX7339)

Barry was already one of the most prominent architects of his day – the builder of the Travellers' Club, the Reform Club and Bridgewater House – when in 1836 he won first prize in the competition to design the new Houses of Parliament. Work began in 1840, and was nearing completion at the time of his death (it was finished under the supervision of his son E.M. Barry). As a work of the Gothic imagination his Palace of Westminster is unrivalled in its scale and vision. The Tsar of Russia called it 'a dream in stone', and, on its site by the Thames, in all seasons and weathers, it has been an inspiration not only to Londoners and tourists, but to many artists, among them Monet.

This photograph was taken shortly before Barry's death from heart disease, and yet still shows a man 'of the toughest fibre, of almost super-human industry, . . . thirsting for fame' (George Aitchison). For Watkins see no. 19.

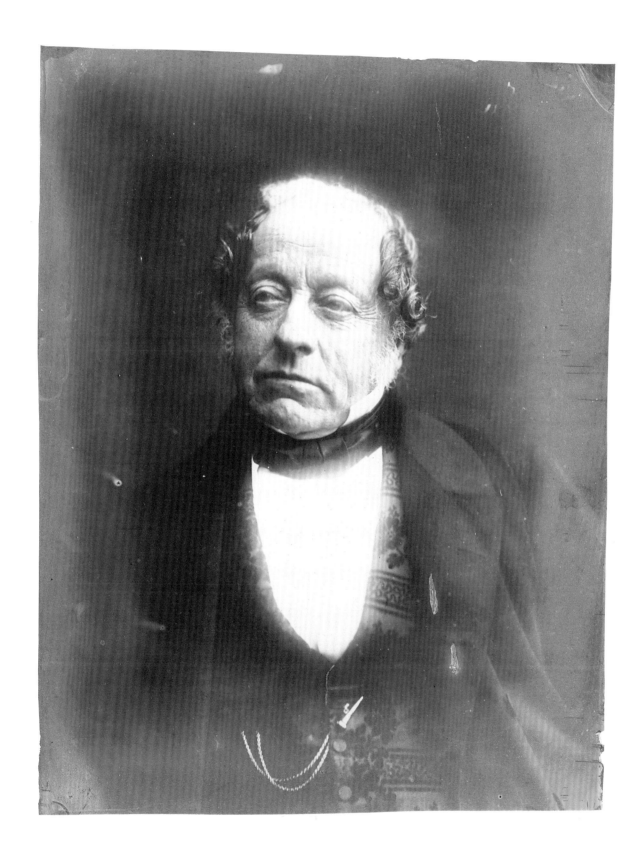

21

Alfred Tennyson, 1st Baron Tennyson 1809–92

Attributed to James Mudd active 1852–1901

Albumen print, early 1861
24.6 × 19.4 (9⅝ × 7½)
Given by the Pilgrim Trust as part of the Macdonnell Collection, 1966 (x8005)

With the publication of his Arthurian poems *Idylls of the King* in 1859, Tennyson, who had succeeded Wordsworth as Poet Laureate nine years earlier, finally won popular recognition and a celebrity which lasted until his death. As a result the demand for photographs of him greatly increased, and his strong, idiosyncratic features made an especially good subject. Carlyle (no. 31) described him as 'one of the finest looking men in the world. A great shock of rough, dusky, dark hair; bright laughing hazel eyes; massive aquiline face, most massive yet most delicate'.

This photograph, which has previously been attributed to Lewis Carroll, is probably by the Manchester photographer James Mudd, best known for his photographic inventory of locomotives built by the local firm of Beyer-Peacock. It was given wide currency by its publication on 15 April 1861 by Cundall & Co (founded by Joseph Cundall 1819–95), whose Photographic Institution was at 168 New Bond Street. Unlike the later photographs of Tennyson by Julia Margaret Cameron, which are distinguished by their heroic, poetical mood, Mudd's photograph conveys something of the truculence of this reclusive man, impelled to the studio by fame.

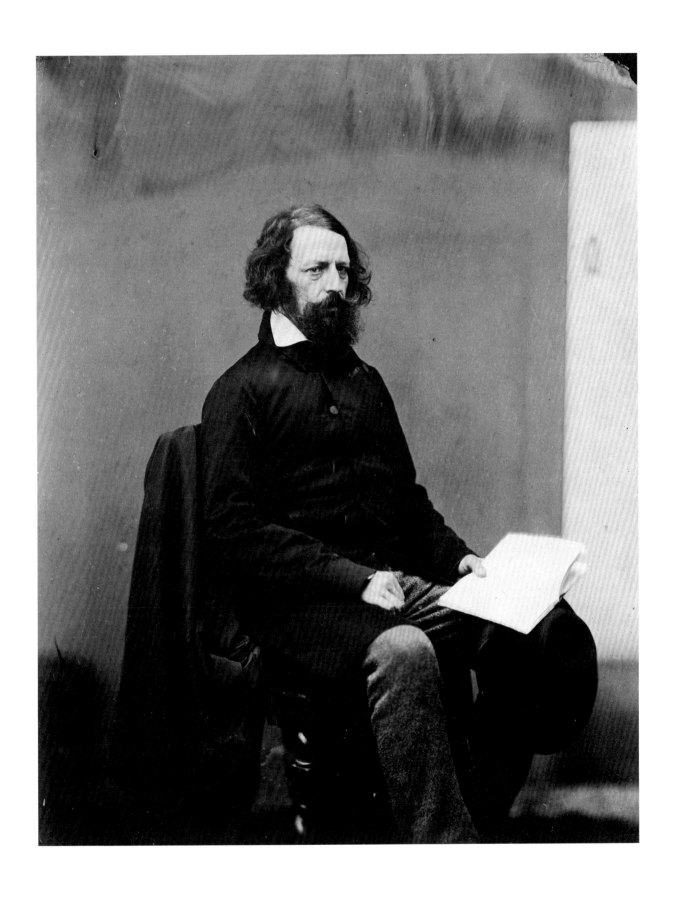

22

Adelina Juana Maria Patti, Baroness Cederstrom 1843–1919

Camille Silvy active 1850s–60s

Carte-de-visite albumen prints (5), all, with the exception of X12680, on the
photographer's printed mounts, July 1861
X12677: 8.4 × 5.5 ($3\frac{1}{4}$ × $2\frac{1}{4}$); X12679: 8.3 × 5.5 ($3\frac{1}{4}$ × $2\frac{1}{8}$); X12680: 8.1 × 5.2 ($3\frac{1}{4}$ × 2);
X21724: 8.6 × 5.6 ($3\frac{3}{8}$ × $2\frac{1}{4}$); X25072: 8.5 × 5.6 ($3\frac{3}{8}$ × $2\frac{1}{4}$)
X12677: given by an anonymous donor, 1947; X12679: given by an unknown donor, 1973; X12680: given
by M. Hutchinson, 1965; X21724: given by Clive Holland, 1959; X25072: given by Algernon Graves, 1916

The Italian opera singer Patti, the last of the line of great coloratura sopranos, made
her London début on 14 May 1861 at the Royal Italian Opera, Covent Garden as Amina
in Bellini's *La Sonnambula*, and from that time, as Lucia (X12677; below left), Violetta
(?X12679; above right), Zerlina, Martha (X12680; top left), Leonora (X21724; below
right) in *Il Trovatore*, and above all as Rosina (X25072; top centre) in *The Barber of
Seville*, she delighted audiences throughout Europe and in North and South America.
Her public career lasted nearly sixty years, and is virtually without parallel.

The French aristocrat Silvy came to London at about the same time as Patti, and
rapidly established himself as one of the most fashionable of portrait photographers,
with a studio at 38 Porchester Terrace, noted for its elegant furnishings and range of
elaborate painted back-drops. Several of these are seen in his photographs of Patti, taken,
no doubt with an eye to publicity, shortly after her sensational début, and illustrating
the range of her roles, and her considerable charm.

In addition to many individual prints by Silvy, the Gallery also owns the photo-
grapher's Day Books, which contain some 10,000 prints, and which constitute a unique
record of London society of the day.

23

James Glaisher 1809–1903 and Henry Tracey Coxwell 1819–1900 in their balloon

Negretti & Zambra active 1850s–60s

Albumen carte-de-visite, on the photographers' printed mount, probably late 1862
9 × 6.2 ($3\frac{1}{2}$ × $2\frac{3}{8}$)
Given by the Earl of Harrowby, 1957 (X22561)

On 5 September 1862 the intrepid balloonists and meteorologists Glaisher and Coxwell ascended from Wolverhampton in their hot-air balloon to a height of 37,000 feet, the greatest height ever reached by balloon. Glaisher lost consciousness and Coxwell, who had lost the use of his hands, managed just in time to pull the valve-cord with his teeth, and brought the balloon down at Ludlow, dropping 19,000 feet in fifteen minutes.

This tiny photograph almost certainly commemorates the record-breaking ascent, and is an example of the inventive skills of the photographers Henry Negretti (1818–79) and Joseph Warren Zambra (born 1822) of Hatton Garden, Cornhill and Regent Street, London, who superimposed an image of the aviators in their basket on an aerial back-drop, and painted in the superstructure of the balloon. A year later Negretti himself made with Coxwell the first aerial trip in Britain for purposes of photography.

In 1870, at the outbreak of the Franco-Prussian war, Coxwell went to manage the Prussian fleet of war-balloons, while in later life Glaisher devoted his time increasingly to astronomy.

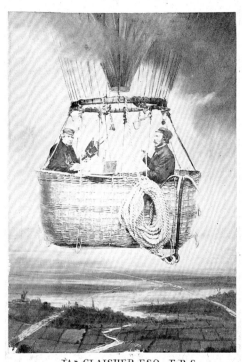

JA⁹ GLAISHER ESQ. F.R.S.
& M⁰ COXWELL.

Ent⁴ Stationers Hall.

24

Gabriel Charles Dante (Dante Gabriel) Rossetti 1828–82

Charles Lutwidge Dodgson (Lewis Carroll) 1832–98

Albumen print, numbered 85 in the print, with the sitter's clipped signature on the mount and his letter
heading: *16 Cheyne Walk*, CHELSEA with the motto *FRANGAS NON FLECTAS* and his monogram GDR;
probably 7 October 1863
14.6 × 12.1 (5¾ × 4¾)
Purchased, 1977 (P29)

Lewis Carroll (no. 11) spent four days in October 1863 photographing the Pre-Raphaelite
painter Rossetti, his family, friends, and some of his drawings. The sessions took place
at Rossetti's home, 16 Cheyne Walk, London, which he shared with his brother William
Michael, and the writers Swinburne and Meredith. He photographed Rossetti by the
steps which led down from the house to the garden. It was a time of great sadness and
uncertainty in the artist's life, for he had only recently moved to Chelsea from Blackfriars,
following the death of his wife and obsessional model Elizabeth Siddal in the previous
year. She had died of an overdose of laudanum, and Rossetti never ceased to reproach
himself. Indeed, this was thought to be one of the major factors which contributed to
his mental instability in his later years. Dependent on chloral, he became obsessed with
the idea that people were plotting against him. According to his brother, one of his
later fantasies was that Lewis Carroll's own *Hunting of the Snark* was a satirical attack
on him.

25

Sir John Everett Millais 1829–96

David Wilkie Wynfield 1837–87

Albumen print, with the sitter's clipped signature on the mount, *c*.1863
21 × 16.2 (8⅜ × 6⅜)
Purchased from the estate of Sir Edmund Gosse, 1929 (P79)

One of the original members of the Pre-Raphaelite Brotherhood (1848), Millais' artistic career is a classic example of the young revolutionary who turns with artistic recognition and material success into a pillar of the establishment. This photograph was taken about the year of his election to the Royal Academy, when the hostility aroused by his early works such as *Christ in the Carpenter's Shop* (1849–50, Tate Gallery, London) was long forgotten.

David Wilkie Wynfield, nephew of the painter Sir David Wilkie, was himself a painter, and one of the founders of the St John's Wood Clique, a group of young artists devoted to preserving the tradition of genre painting. He took up photography in the early 1860s, and photographed many of his artist friends, usually in fancy dress evocative of the Renaissance period, and appropriate to the character of the sitter. Millais is presented in a way which recalls the poet Dante, in profile, wearing a laurel wreath, and clutching a book to his breast. Wynfield gave at least one lesson in photography to Julia Margaret Cameron (nos. 28, 33), who wrote of his influence on her: 'To my feeling about his beautiful Photography I owed *all* my attempts and indeed consequently all my success'.

This print is one of more than thirty photographs by Wynfield owned by the Gallery. Like no. 56, it once belonged to the writer Sir Edmund Gosse.

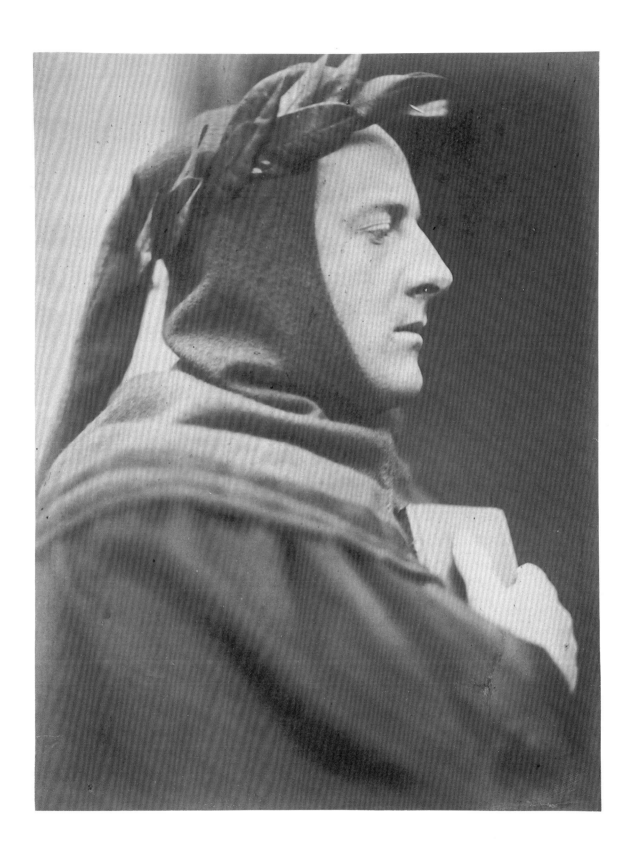

26

John Gibson 1790–1866

Nadar (Gaspard Félix Tournachon) 1820–1910

Salt print, with the photographer's blind stamp on the mount, *c*.1862
22.2 × 17.1 (8¾ × 6¾), oval
Purchased, 1983 (P227)

'The human figure concealed under a frock coat and trousers is not a fit subject for sculpture', said Gibson, the last great British neo-classical sculptor, who lived for most of his life in Rome, and who in all his work attempted to embody abstract ideals through the human form. In this he consciously followed the Greeks, imagining that Phidias would have said of Michelangelo: 'He is a most clever and wonderful sculptor, but a barbarian'. It was imitation of Greek practice which led him to produce his 'Tinted Venus'; this caused a sensation at the International Exhibition in London in 1862, when according to Lady Eastlake (no. 3):

> every young lady at dinner-table or in ballroom in that London season . . . felt herself called upon to tell her partner what she thought of Gibson's coloured Venus. . . . In truth the question lay totally beyond the English public, who at best have scarcely advanced . . . beyond the lowest step of the aesthetic ladder.

Nadar, arguably the greatest of French nineteenth-century photographers, and the friend of most of the leading writers and artists of his day, became one of the country's most celebrated caricaturists before drifting, with a characteristic blend of nonchalance and rashness, into photography in the mid-1850s. He opened spacious premises at 35 Boulevard des Capucines, Paris, in 1860, and it was there that Gibson sat to him, one of few British sitters to do so, perhaps on his way to London to the International Exhibition. In that same studio the first Impressionists' exhibition was held in 1874.

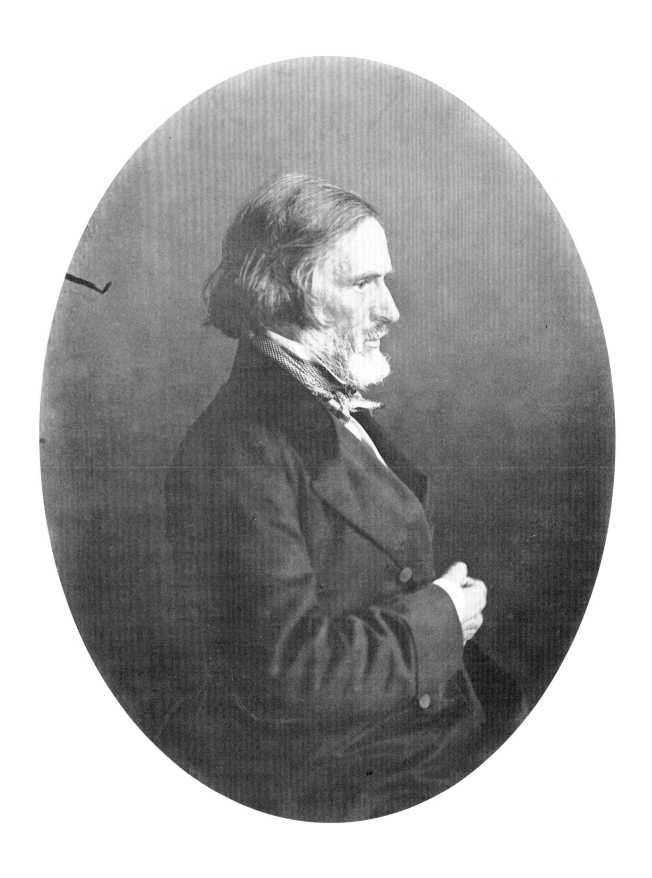

27

Charles Samuel Keene 1823–91

Horace Harral active 1844–91

Platinum print, signed by the photographer on the mount, 1860s
24 × 19.4 (9½ × 7½)
Given by John A. Hipkins, 1927 (X20150)

The humorous artist and illustrator Keene, whose name is forever associated with *Punch* and *The Illustrated London News*, and whose spirited draughtsmanship brought added vividness to the works of Meredith and Thackeray, was by all accounts a shy and uncommunicative man. This rare photograph was taken by a friend and associate, the woodengraver and etcher Harral, who like Keene worked for *The Illustrated London News*, and on a number of occasions produced etchings or engravings after Keene's drawings. It shows Keene holding 'the thick-stemmed, small-bowled "Fairy" pipe which was his special weakness'.

The Gallery owns a small group of Harral's photographs of his friends and associates, which are distinguished by their technical assurance and faintly theatrical air. This platinum print must have been made some years after the original sitting, for the process was first used in 1873. As a wood-engraver, Harral made the engraving of Robert Howlett's photograph of I.K. Brunel (no. 15) for the issue of *The Illustrated Times* devoted to the launch of the *Leviathan*, published on 16 January 1858.

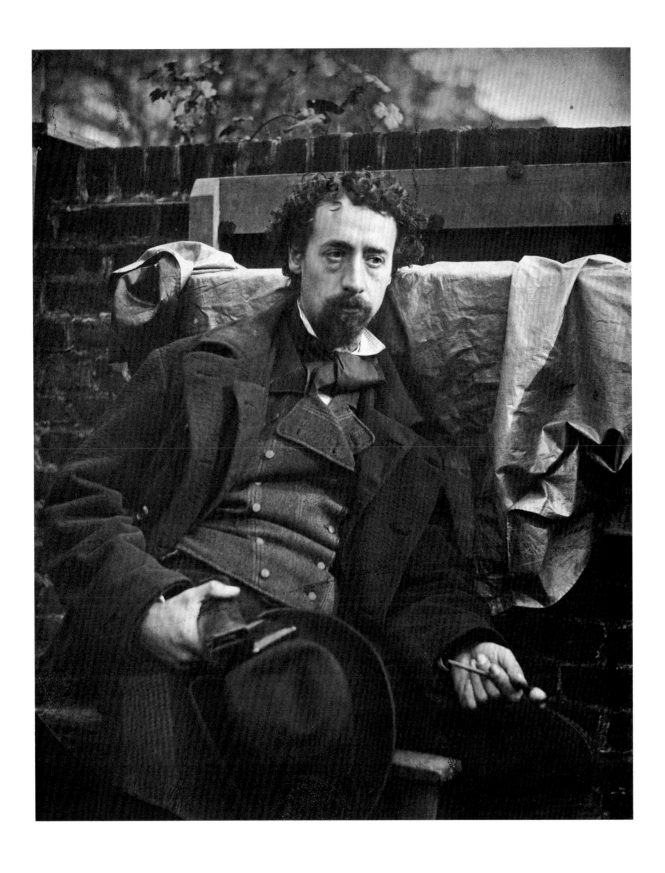

28

Anthony Trollope 1815–82

Julia Margaret Cameron 1815–79

Albumen print, signed by the photographer and sitter on the mount, October 1864
25.4 × 19.7 (10 × 7¾)
Purchased, 1982 (P214)

In 1863 Julia Margaret Cameron, the wife of a retired coffee-planter, was given a wet collodion photographic outfit by her daughter and son-in-law. As a young woman she had corresponded with Sir John Herschel (no. 33) about the new medium, and she now began to practise photography with great enthusiasm and idealism: 'My aspirations are to ennoble Photography and to secure for it the character and uses of High Art'. She took many portraits of her family and friends, servants and photogenic villagers on the Isle of Wight where she lived, but above all, like the commercial photographers of the day, she pursued celebrities.

This image of the novelist and postal-official (the inventor of the pillar-box) Trollope was taken when he was on holiday at Freshwater, Isle of Wight in 1864, at a time of crisis in his career with the post-office. In March that year his enemy Sir Rowland Hill, founder of the penny post, had retired, and Trollope hoped at last for preferment. He was, however, passed over, and, though it took him two years to make up his mind, he finally retired. It was the right decision for this passionate devotee of fox-hunting, who found daily attendance at the office to be 'slavery', but it stung him. Yet he was by this time firmly established as a best-selling novelist; his great human comedies, the Barchester novels were, with the exception of *The Last Chronicle of Barset* (1867), behind him; the ambitious late political novels such as *The Way We Live Now* (1875), to come.

29

David Livingstone 1813–73

Maull & Polyblank active 1856–65

Albumen print, *c.*1864–5
19.8 × 14.7 (7¾ × 5¾), arched top
Purchased before April 1938 (AX7279)

The legendary African missionary and explorer Livingstone arrived in England in July 1864, for the first time in seven years. He left a year later, having visited his mother in Scotland, and written *The Zambesi and its Tributaries*. He never saw the country again. During his stay he was photographed on several occasions, but his heroic personality appears cramped by the photographer's studio and conventional day dress. In this photograph the rhinoceros horn is included to symbolize Livingstone's African interest, but it is his tormented expression which conveys the years he had spent in conditions of extreme deprivation and danger, and the unflinching energy which drove him on to bring Christianity to the natives, to stamp out slavery, and to find the source of the Nile. His devotion to the continent was overpowering, and once, when ordered by the British government to withdraw from his exploration of the Zambesi, he wrote: 'I don't know whether I am to go on the shelf or not. If I do, I make Africa the shelf'. For Maull & Polyblank see nos. 14 and 16. See also no. 36.

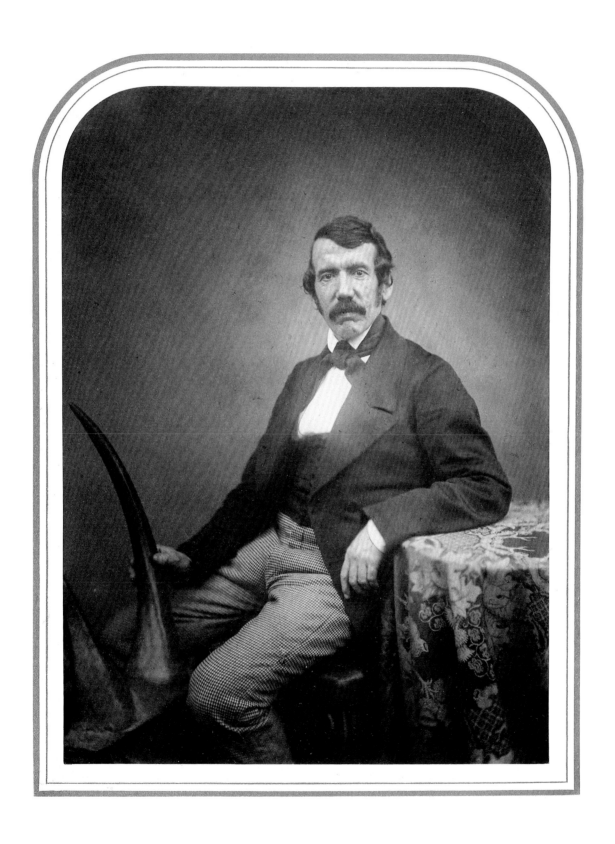

30

Sir Richard Francis Burton 1821–90

Ernest Edwards 1837–1903

Albumen print, on the photographer's printed mount, April 1865
8.7 × 6.8 ($3\frac{3}{8}$ × $2\frac{5}{8}$)
Purchased, *c.*1935 (AX14771)

Explorer, author and translator, Burton was a man of insatiable curiosity, whose exploits in Africa, the Middle East and South America earned him a reputation for great daring. He made the pilgrimage to Mecca in disguise, explored Somaliland, travelled with Speke to discover the sources of the Nile, crossed the Andes, and visited the gold and diamond mines of Brazil.

After a controversial period as Consul in Damascus (1869–71), Burton travelled to Iceland and then, in 1872, was appointed Consul in Trieste, where it was felt he could do no mischief. He remained there for the rest of his life. His later years were made financially more than secure by his translation of *The Arabian Nights*, which was ensured a *succès de scandale* by virtue of his explanatory footnotes. According to a contemporary assessment, 'The whole of his life was a protest against social conventions'.

This photograph was taken for *Portraits of Men of Eminence*, a series begun by the conchologist and antiquary Lovell Reeve, in which photographs of the famous were accompanied by short biographies. It appeared in Volume 3, edited by Reeve's successor Edward Walford, and was published in 1865. It almost certainly dates from April that year when Burton, then Consul in Fernando Po, off the coast of West Africa, came to England to be entertained to a public dinner by Lord Stanley, later Earl of Derby. Burton sits on the floor, wearing Levantine costume, amidst the exotic trappings of the photographer's studio, posed against an elaborate, if not especially appropriate, backdrop. For Edwards see no. 34.

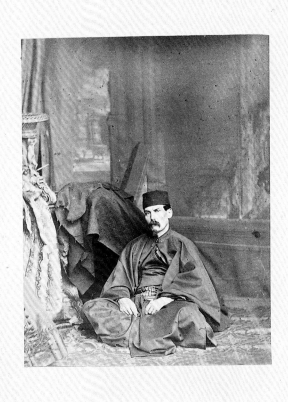

Photographed by Ernest Edwards 20 Baker Street W

31

Thomas Carlyle 1795–1881

Elliott & Fry active 1863–1963

Albumen print, on the photographers' printed mount, *c.*1865
20.2 × 14.6 (3⅜ × 2⅝), arched top
Given by Major-General C.G. Woolner, 1975 (x5661)

The son of a mason from Ecclefechan in Dumfriesshire, the essayist and historian Carlyle, supported by his forceful wife (no. 8), went on to become a figure of towering intellectual authority, 'the sage of Chelsea', so like one of those great men, the 'heroes', whom he revealed in his writings as the makers of history. Handsome and intense, he was painted, sculpted and photographed almost more than any other non-royal figure in the nineteenth century. He seems to have taken pains about his own portraits, just as he was anxious to acquire portraits of anyone he was writing about. One of the earliest Trustees of the National Portrait Gallery, he wrote: 'often have I found a portrait superior in real instruction to half a dozen written biographies . . . or, rather let me say, I have found that the portrait was as a small lighted candle, by which the biographies could for the first time be read'.

The firm of Elliott & Fry (Joseph John Elliott and Clarence Edmund Fry) was based at 55 Baker Street, London, and remained there until the 1960s. Carlyle sat to them at about the time of the completion of his biography of Frederick the Great (1865), shortly before the death of his wife.

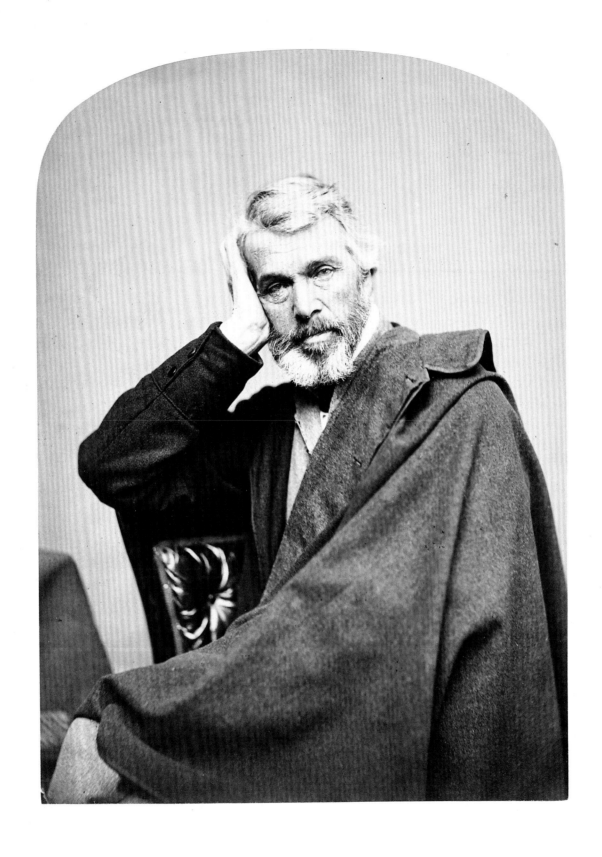

32

Sir John Fowler, 1st Bt. 1817–98

John Jabez Edwin Mayall 1810–1901

Albumen print, hand coloured with oil paint, with remains of the photographer's label on the reverse, *c*.1865
35.2 × 26.7 (13⅞ × 10½), arched top (P326)

As a civil engineer Fowler devoted his life to the railways, and he is best known for his Pimlico bridge, the first railway bridge across the Thames in London, the development (from 1853) of the Metropolitan Railway system, and (with Sir Benjamin Baker) the Forth railway bridge (1883–90), probably the most remarkable piece of engineering to be carried out in the nineteenth century, and one which earned Fowler his baronetcy.

For this photograph, probably taken after the opening of the Metropolitan Railway in January 1863, Baker sat to the American-born photographer, Mayall, who had once been assistant to the daguerreotypist Claudet (no. 4). A highly successful businessman, his mass-produced royal photographs did much to popularize the carte-de-visite format. In this large photograph Mayall combines a somewhat incongruous studio backdrop of a village scene with the parapet of a bridge and a length of railway track, emblems of Fowler's profession. Hand colouring was an 'extra' offered by many of the commercial photographic firms, and shows them consciously emulating the large-format portrait-miniature paintings favoured by the Victorians.

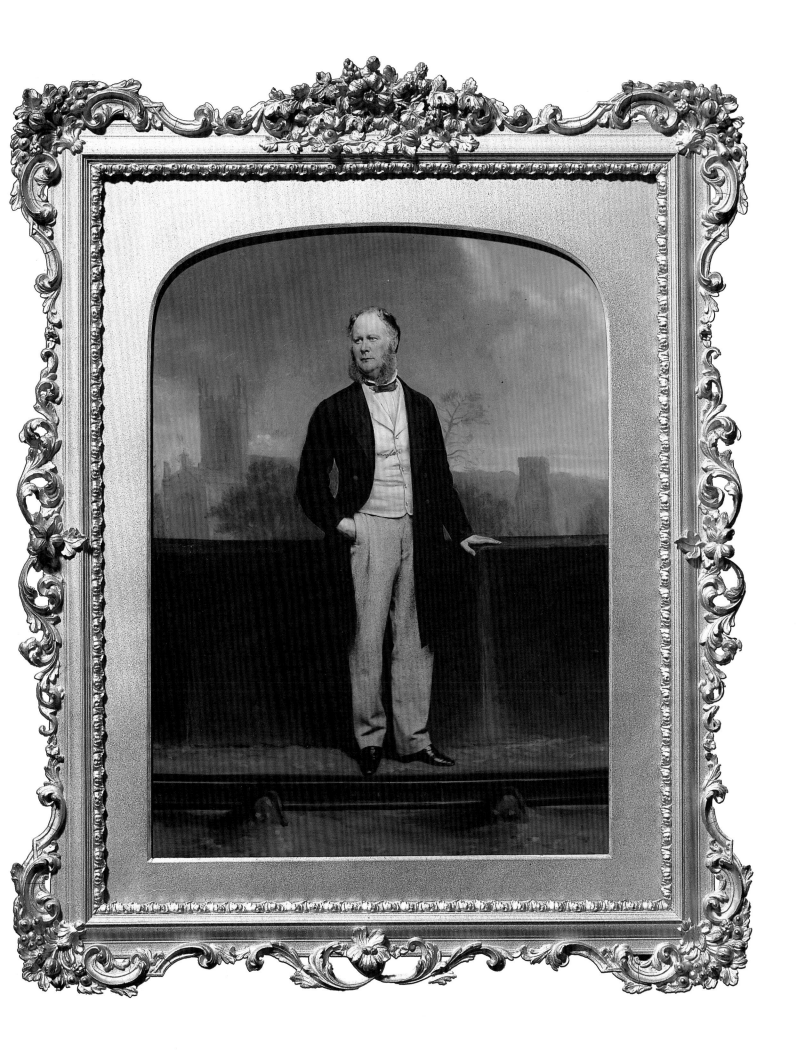

33

Sir John Frederick William Herschel, 1st Bt. 1792–1871

Julia Margaret Cameron 1815–79

Albumen print, signed and inscribed by the photographer on the mount: *From Life taken at his own residence Collingwood/Sir J.F.W. Herschel*; 1867
34 × 26.4 (13⅜ × 10⅜)
Purchased, 1982 (P213)

Sir John Herschel, son of the great astronomer Sir William Herschel, was a man of outstanding scientific and astronomical achievement, and took an interest in photography from its earliest days. He was the friend of Fox Talbot, and an early correspondent of Mrs Cameron, and invented the photographic use of sensitized paper (1839), introduced hyposulphate of soda (hypo) as a fixing agent, and coined the terms 'photograph', 'negative', 'positive' and 'snapshot'. Mrs Cameron's portrait of him, taken at his home Collingwood at Hawkhurst, Kent, is therefore not only one of the most moving images of a great intellect caught in the process of physical dissolution, but an important document in the history of photography. It is, like all her best work, distinguished by its dramatic lighting, soft focus (often ridiculed by her contemporaries), and feeling for character. But it is the *ad vivum* feel which she prized above all, and which she obtained by the use of very large glass plates from which she printed directly without enlargement or retouching. It is this quality which led her, as here, to inscribe 'From Life' on the mounts of her prints. See also no. 28.

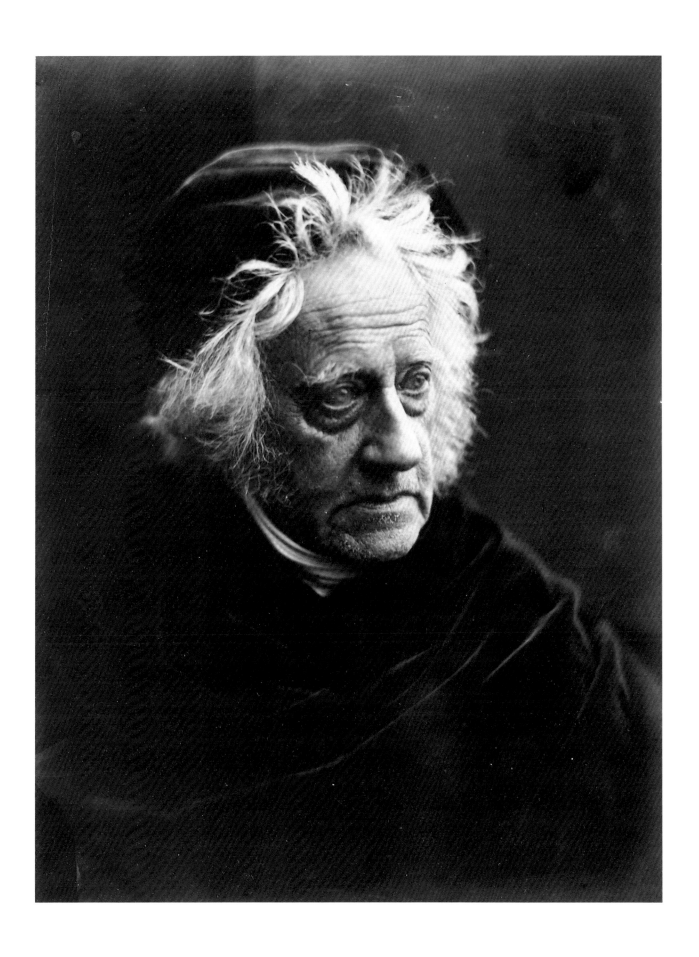

34

Charles Robert Darwin 1809–82

Ernest Edwards 1837–1903

Albumen print, signed and inscribed by ?the photographer on the mount, *c.*1867
28.3 × 23.9 ($11\frac{1}{8}$ × $9\frac{1}{4}$)
Purchased, 1975 (X1500)

No scientist had a greater impact on Victorian attitudes than Darwin, whose theory of evolution, expressed in *The Origin of Species* (1859), destroyed the old biblical myth of creation.

He was photographed by Ernest Edwards for Edward Walford's *Representative Men in Literature, Science and Art* (1868), and is portrayed as a typical Victorian elder, lost in sober contemplation, very different from the young man who sailed on *The Beagle* to South America. For all his eminence Darwin remained modest and polite, judging himself only 'superior to the common run of men in noticing things which easily escape attention, and in observing them carefully'.

Edwards, who had a studio at 20 Baker Street, London, from 1864, specialized in portraiture and topographical work, and he published with H.B. George *The Oberland and its Glaciers Explored and Illustrated with Ice-Axe and Camera* in 1866. He developed an early form of pocket camera, and invented the heliotype (1869), a modified form of collotype reproduction. The first book to be illustrated with heliotypes was Darwin's *The Expression of the Emotions in Man and Animals* (1872). See also no. 30.

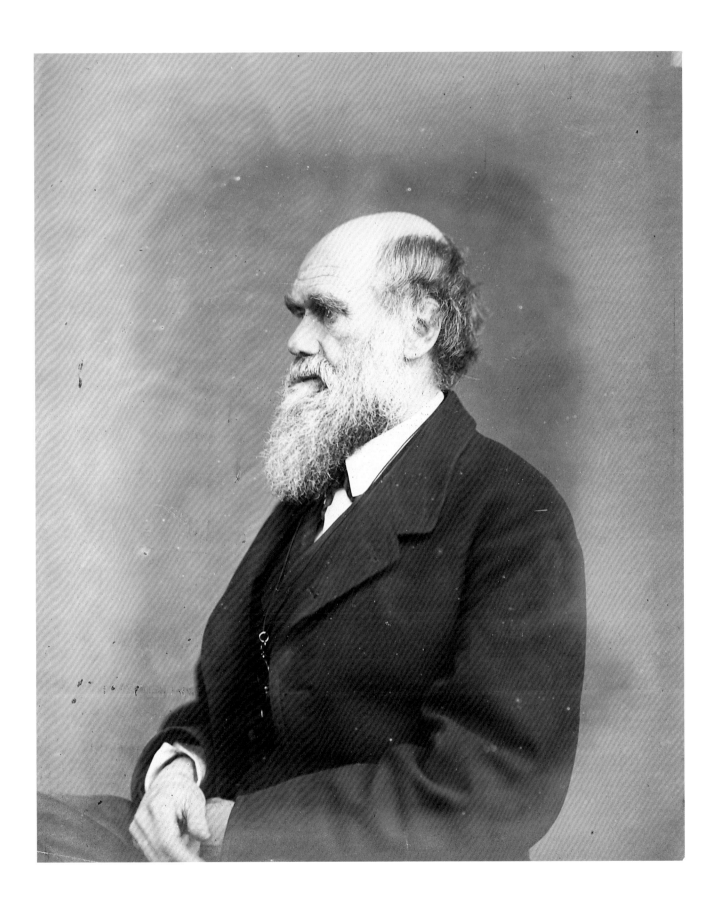

35

Queen Victoria 1819–1901 with her servant John Brown 1826–83

W. & D. Downey active c.1860–early 1900s

Albumen print, inscribed on the mount: *Downey./The Queen./Balmoral. June 1868.*
J.Brown holding the pony.; June 1868
13.7 × 9.8 (5$\frac{3}{8}$ × 3$\frac{7}{8}$)
Purchased, 1975 (P22/4)

Queen Victoria and Prince Albert acquired the lease of the Balmoral estate in 1848, and the castle which they built there on the banks of the River Dee became 'Albert's favourite resort, whence the view is very beautiful'. In her years of widowhood it therefore had special significance for the Queen, and she often suffered 'homesickness for my beloved Highlands, the air – the life, the liberty'.

This photograph, from an album of prints by various photographers of the Queen, her family and servants at Balmoral, is by William and Daniel Downey of Newcastle upon Tyne and Eaton Square, who were much patronized by the royal family, especially the Prince of Wales. The Queen is shown about to go out riding, attended by her faithful servant and companion John Brown. Two months later she was to pay her first visit to Switzerland, travelling incognito as 'the Countess of Kent'. When Brown died the Queen described him as 'my best & truest friend, – as I was his', and organized elaborate tributes to him, much to the disapproval of her family, including a statue by the leading sculptor Boehm at Balmoral, for which Tennyson (no. 21) supplied the inscription:

> Friend more than servant, loyal, truthful, brave:
> Self less than duty even to the grave.

Downney.

The Queen.

Balmoral. June 1868.

J. Brown holding the pony.

36

Sir Henry Morton Stanley 1841–1904

London Stereoscopic Company active 1860–early 1900s

Carbon carte-de-visite, on printed mount, *c*.1872
9 × 5.7 (3½ × 2¼)
Purchased, before 1983 (X27584)

On 16 October 1869 the proprietor of the *New York Herald* ordered his special correspondent H.M. Stanley to 'find Livingstone' (no. 29), who was lost in the interior of Africa. Two years later, on 10 November 1871, he came face to face with Livingstone at Ujiji on the shore of Lake Tanganyika, 'reduced to the lowest ebb in fortune'. Stanley returned to find himself famous; England and America resounded with the story of his adventures, which he published as *How I Found Livingstone* (1872).

This photograph, which first appeared as frontispiece to his book, shows Stanley in tropical kit, the man of action. It was probably taken shortly after his return to London, and was widely published by the London Stereoscopic Company. This carte-de-visite version was produced for promotional purposes by 'E. Moses & Son, Merchant Tailor & Outfitters for all classes' of London and Bradford, and is on the firm's printed mount.

Stanley devoted most of his later life to travel and exploration, and to publishing his experiences, but this workhouse boy from St Asaph ended his career as a Unionist Member of Parliament.

37

Edward Robert Bulwer Lytton, 1st Earl of Lytton 1831–91

Bourne & Shepherd active 1860s–present day

Albumen cabinet prints, on the photographers' printed mounts, 1877
13.6 × 9.9 (5⅜ × 3⅞)
Purchased from the Strachey Trust, 1979 (x13102 [left], x13100 [right])

The only son of the novelist Lord Lytton, Edward Lytton was a distinguished if flamboyant colonial administrator, and one of the century's worst and most prolific poets: 'his massed jewels glitter against no background, and the eye becomes confused and fatigued with their dazzle. Some, also, are unquestionably paste, and many are not his property' (Richard Garnett). By contrast, 'as a prose writer Lytton takes high rank; his minutes and despatches were the admiration of the India Office'.

These photographs were taken in India in 1877, in the year that Lytton as Viceroy proclaimed Queen Victoria Empress of India at Delhi. They are by the leading firm of photographers in India, founded by Samuel Bourne (1834–1912) and Charles Shepherd, which had studios in Simla, Bombay and Calcutta. They show something of Lytton's histrionic tendencies, and his love of dressing up: the one in academical dress (by him is a cast of P.J. Mène's bronze *The Accolade*), the other in his Viceroy's robes.

38

William Ewart Gladstone 1809–98

William Currey active 1870s

Carbon cabinet print, on the photographer's printed mount, 1877
14.3 × 8.5 (5$\frac{1}{2}$ × 3$\frac{3}{4}$)
Given by the executors of the estate of Sir Cecil Beaton, 1980 (X12503)

No English politician has been more intensely loved or more fervently hated than Gladstone. A man of formidable intelligence and energy and of wide interests – he gave the same attention to everything that he put his mind to – he was a force in British politics for more than sixty years, serving as prime minister no less than four times, and equalled as an orator only by Bright (no. 41). He died, according to Lord Salisbury 'a great Christian man'.

He pursued his leisure activities with equal intensity, and his favourite pastime was cutting down trees, a taste which he acquired on the Duke of Newcastle's estate at Clumber. Here he is seen at his Welsh home, his wife's estate of Hawarden Castle, taking a brief respite from wood-chopping. It is a fitting image of a politician in opposition (he was between ministries), taken by the little-known photographer Currey of Bolton and Manchester. Its publication, along with three others from the same sitting, was noticed in *The British Journal of Photography* on 7 September 1877, as affording 'a peep behind the scenes in connection with the private life of this energetic statesman. . . . the expression on the face is . . . perhaps the finest we have ever seen of this gentleman, an immense amount of latent power being apparent, ready to be displayed at a moment's notice'.

CURREY. PHOTO'

HAWARDEN 1877.

ALFRED HAYS,
4, ROYAL EXCHANGE BUILDINGS.
LONDON. Copyright.

39

Benjamin Disraeli, 1st Earl of Beaconsfield 1804–81

(Cornelius) Jabez Hughes 1819–84

Carbon cabinet print, on the photographer's printed mount, 22 July 1878
13 × 9.3 (5⅛ × 3⅝)
Given by Mrs W.O. Manning, 1958 (x665)

Few would have predicted that the young Disraeli, restless, romantic and Jewish, was to become a great statesman. But by sheer ability he gradually asserted his influence on the Tory party, becoming Prime Minister in 1868. He guided the passage of the second Reform Bill, and his diplomatic triumphs included the purchase of the Suez Canal and the Congress of Berlin (1878). Unlike Gladstone (no. 38) he was a debater rather than an orator, possessed a sense of humour, and was, in addition, a prolific novelist, whose *Coningsby* (1844) and *Sybil, or the Two Nations* (1845) are among the earliest political novels in English, and distinguished by their concern for major social issues.

Again, unlike his rival, Disraeli was the intimate friend of Queen Victoria whom he nicknamed 'The Faery', and their relationship amounted almost to a romance. This carefully composed portrait was taken by her command at Osborne on the day that Disraeli was created a Knight of the Garter. The photographer Hughes is first recorded in 1848, as running a daguerreotype studio in Glasgow. He worked subsequently as assistant to Mayall (see no. 32), on the Strand, London, and from 1861 had his own studio at Ryde on the Isle of Wight, where he was extensively patronized by the Queen.

EARL OF BEACONSFIELD, K.G.

PHOTOGRAPHED AT OSBORNE BY COMMAND OF H.M. THE QUEEN,
JULY 22ND 1878.

BY JABEZ HUGHES, RYDE, I.W. WILLIAM

ENTERED AT STATIONERS' HALL.

40

Sir Pierre Louis Napoleon Cavagnari 1841–79 with Afghan Chiefs

John Burke active *c.*1860–1907

Albumen print, signed and numbered 85 in the print and inscribed on the reverse: *85 Major Cavagnarie & Chief Sirdars with Kunar Synd*, May 1879
23.5 × 28.9 (9¼ × 11⅜)
Purchased, 1987 (P330)

The son of one of Napoleon's officers, Cavagnari, a naturalized British subject, became one of the most courageous servants of the Empire, first in India, and later in Afghanistan. In 1879, when this photograph was taken, he negotiated and signed the Treaty of Gandamuck with Afghanistan, and was made a KCB. He was then appointed British Resident in Kabul, but was murdered in the citadel there along with other Europeans on 3 September by mutinous Afghan troops. His head was split open with a blow, just as the citadel's burning roof fell in. His body was never found. Lord Lytton (no. 37), the Viceroy of India, heard of his death 'with unspeakable sorrow', and wrote to Cavagnari's widow that 'every British heart in India feels for you'.

This photograph presumably commemorates the Treaty of Gandamuck, and shows Cavagnari surrounded by the Sirdars. The photographer worked variously in Murree, Peshawar and Rawalpindi in India, and in the Afghan War was employed by the British Army as 'Photographic Artist'.

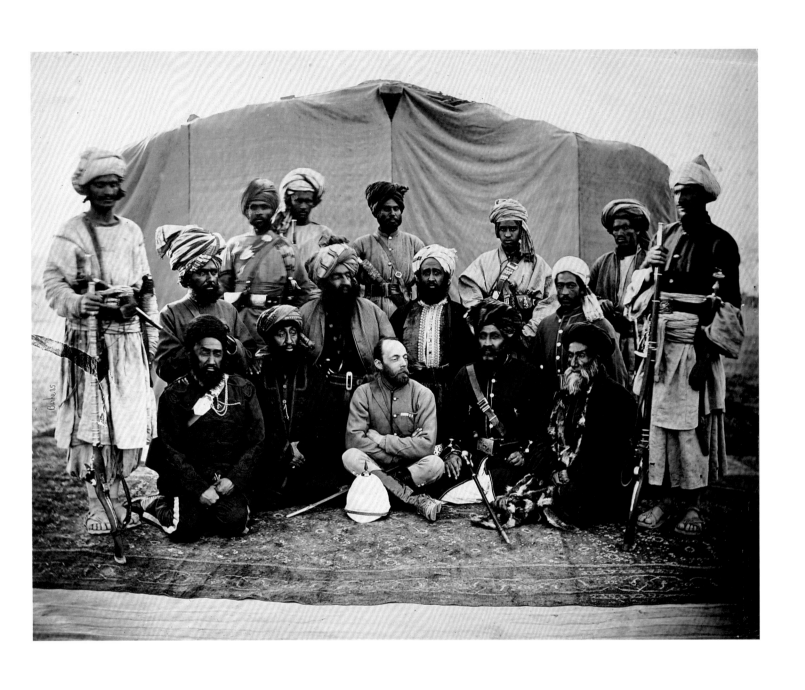

41

John Bright 1811–89

Rupert Potter 1832–1914

Carbon print, September 1879
29.1 × 17.7 (11½ × 6⅞)
Acquired before 1977 (X4323)

Rupert Potter and his daughter Beatrix (better known as the writer and illustrator of the *Peter Rabbit* books) were both keen photographers. His favourite subjects were landscapes, but friendship with Sir John Everett Millais (no. 25) led him to portraiture, and, according to Beatrix, Millais thought that 'the professionals aren't fit to hold a candle to Papa'. So much so that he often used Potter's photographs as the basis for his portraits.

This was the case with the radical orator and Liberal statesman Bright. In the autumn of 1879 he and Millais were both guests of Potter in Scotland for the salmon-fishing, and this photograph was probably taken at about that time, for Millais follows it closely in his portrait of Bright exhibited at the Royal Academy in 1880 (Private Collection). The photograph conveys all those qualities which made Bright, like his associate, Cobden (with whom he led the Anti-Corn Law League), such a powerful representative of the manufacturing classes in British politics, and an advocate of reform. He was an idealist who, in all that he did, felt himself 'above the level of party', and never feared unpopularity, as, for instance, in condemning the Crimean War.

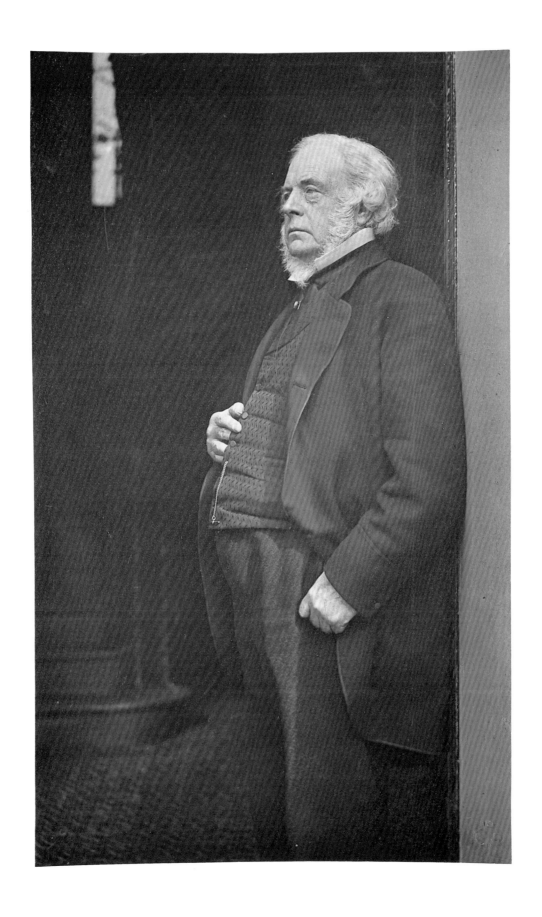

42

Queen Alexandra 1844–1925 when Princess of Wales

Symonds & Co active 1880s–90s

Carbon print, on the photographer's printed mount, August 1880
27 × 35.5 (10⅝ × 14)
Purchased, 1983 (X17460)

Queen Alexandra, 'Alix', was the eldest daughter of the future Christian IX of Denmark, and married the Prince of Wales, later Edward VII, in March 1863. 'Just think,' she said, 'my trousseau will cost more than Papa's whole annual income'. To Charles Dickens (no. 19), who saw her then, she seemed 'not simply a timid shrinking girl, but one with character distinctive of her own, prepared to act a part greatly'. She was very beautiful and had an assured sense of style, and it was inevitable, while Queen Victoria sank in the depths of widowhood, that she and the Prince should become the leaders of fashionable society. She bore her husband's habitual infidelity with stoicism, and, always excessively generous, devoted herself increasingly to charitable works, her family and her dogs. She was also a keen amateur photographer, and had trained at the London Stereoscopic School of Photography in Regent Street.

The Princess is seen here on board the Royal Yacht *Osborne*, in a photograph published by Symonds & Co of Chancery Lane, which epitomizes the elegance and informality of her style. This went unappreciated by the Queen, who thought her 'a distinguished lady of Society but nothing more!'.

Symonds & C? Photographers.

Carbon Print.

H.R.H THE. PRINCESS OF WALES

On Board the Royal Yacht "Osborne."

43

Oscar Fingal O'Flahertie Wills Wilde 1854–1900

Napoleon Sarony 1821–96

Albumen panel print, on the photographer's printed mount, January 1882
30.6 × 18.4 (12 × 7¼)
Purchased, 1976 (P24)

Oscar Wilde, playwright, wit and representative of the London aesthetic movement, arrived in New York on the steamship *Arizona* in January 1882 with 'nothing to declare but his genius'. Early on he called on the photographer Sarony at his studio on Union Square to commission publicity photographs for his series of lectures on 'Art for Art's Sake'. Sarony, who was himself one of the best known of New York's eccentrics, found in Wilde 'A picturesque subject indeed!'. He was the greatest curiosity of the New York season, and wrote home: 'Great success here; nothing like it since Dickens, they tell me'.

Like the great French photographer Nadar (see no. 26), Sarony began his career as a caricaturist, but turned to photography under the influence of his brother Oliver, who was one of England's most successful provincial photographers. He specialized in theatrical sitters, and his work, with its use of painted backdrops and carefully chosen accessories gave him a contemporary reputation as 'the father of artistic photography in America'.

OSCAR WILDE.

Copyright 1882, by N. Sarony.

NEW YORK.

103

44

Horatio Herbert Kitchener, 1st Earl Kitchener of Khartoum and of Broome 1850–1916

O. *Schoefft* active 1880s

Albumen cabinet print, on the photographer's printed mount, signed by the sitter on the verso four times;
between October 1884 and June 1885
14.5 × 10 ($5\frac{3}{4}$ × $3\frac{7}{8}$)
Purchased, 1982 (x15599)

The embodiment of the successful imperialist general, Kitchener served under Wolseley in the relief expedition to Gordon in Khartoum, and subsequently commanded in Egypt and the Sudan. His reputation for invincibility was enhanced by his victories in the Boer War, and at the time of the First World War it was he who converted the small British Army into one of three million men. He went down on HMS *Hampshire* off Scapa Flow.

This photograph was taken in Cairo at a much earlier stage in the Field Marshal's career, by the German photographer Schoefft, who styled himself 'photographe de la Cour au Caire'. Kitchener signed it proudly no less than four times on the verso, giving his rank as 'Major'. It therefore dates from between 8 October 1884 and 15 June 1885, for which short period Kitchener held the rank. He was at that time heavily involved in military intelligence in Egypt, and often worked in disguise. It fell to him to send the first authoritative report of the death of General Gordon on 26 January 1885.

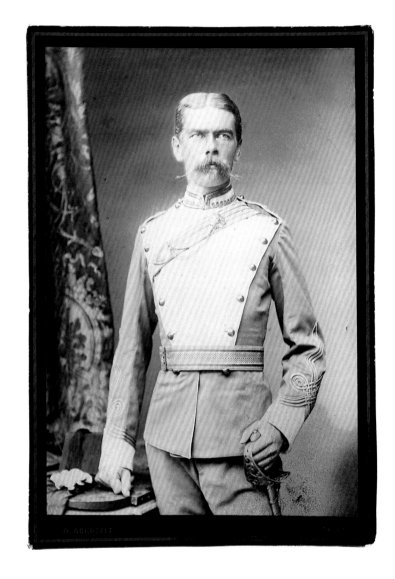

45

Lillie Langtry (Emilie Charlotte le Breton, Mrs Edward Langtry, and later Lady de Bathe) 1852–1929

Henry van der Weyde active 1877–1901

Albumen cabinet print, on the photographer's printed mount, *c.*April 1885
14.5 × 10.3 (5¾ × 4⅛)
Acquired, 1973 (X19877)

'The Jersey Lily' was the daughter of the Dean of Jersey, and by virtue of her first marriage to a wealthy businessman and good looks she became the toast of London society, and an intimate friend of the Prince of Wales (later Edward VII). Her first appearance on stage in 1881 caused a sensation, primarily because of her social position and beauty, and she was not taken seriously as an actress. A New York critic wrote following her début there the next year: 'The difference between Madame Modjeska [the actress Helena Modjeska 1840–1909] and Lillie Langtry is that the first is a Pole and the other a stick'. In 1884 she took over the management of the Prince's Theatre, London, and this photograph shows her in the role of Lady Ormond in the revival of *Peril*, an adaptation of Sardou's *Nos Intimes*, which opened there in April 1885.

The American photographer van der Weyde came to London after the Civil War, in which he had fought, and set up his studio at 182 Regent Street. With Ralph Robinson (see no. 55) he was a founder member of the Linked Ring Brotherhood of those 'who delight in photography solely for its artistic possibilities', but he is best remembered as the creator of the first commercial studio to rely entirely on artificial light. This was provided by a Crossley gas engine which drove a Siemens dynamo, which in turn fed an arc light in a five-foot reflector, giving 4,000 candle-power illumination. This is advertised in the stamp on the mounts of his photographs: 'THE VAN DER WEYDE LIGHT'.

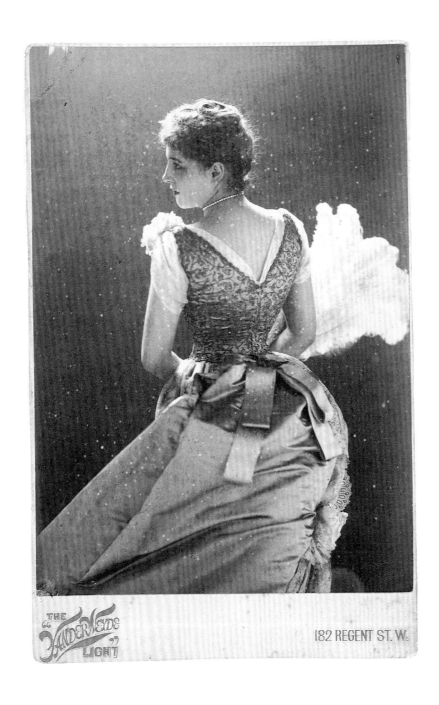

46

James Abbott McNeill Whistler 1834–1903

Unknown photographer

Platinum print, signed by the sitter on the mount in full and with butterfly monogram; summer 1885
17.8 × 11.8 (7 × 4⅝)
Purchased, 1987 (P356)

Restless, volatile and eccentric, the American Impressionist painter Whistler, who chose as his emblem the butterfly, came to London in 1859 and settled in Chelsea in 1863. This photograph was taken in the garden of his studio in the Fulham Road in the summer of 1885, when he and his fellow-American William Merritt Chase were painting portraits of one another. Whistler's painting of Chase is lost, but it showed him 'full-length in frock coat and top hat, a cane held jauntily across his legs . . . the Masher of the Avenues'. In this photograph Whistler himself poses as a 'masher', a dandy and lady-killer, with his mahlstick under his arm, doing duty for a cane, perhaps in parody of his own painting.

In another photograph from this session Whistler appears with Chase and an artist friend, Mortimer Menpes, and it is possible that Menpes took both photographs.

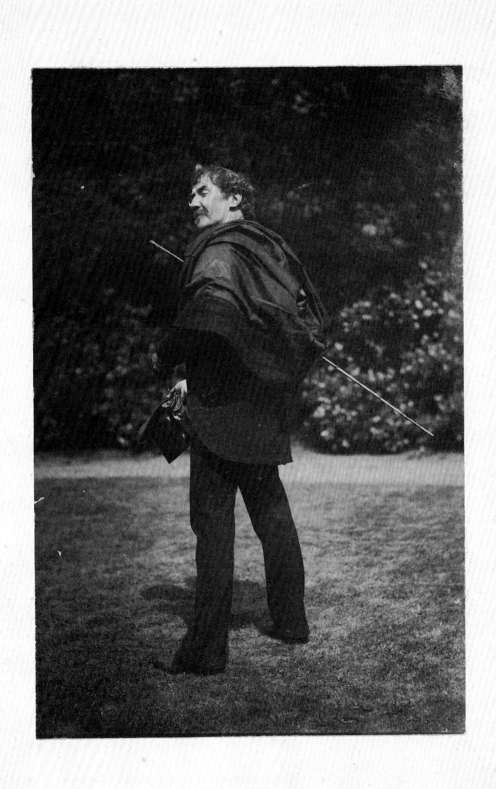

47

John Ruskin 1819–1900

T.A. & J. Green active 1880s

Platinum print, with the photographers' imprint, c.1885
19.7 × 26 ($7\frac{3}{4}$ × $10\frac{1}{4}$)
Purchased, 1987 (P327)

Ruskin – 'the Professor', as he was habitually called – was the first great English art critic and a talented artist, whose voluminous writings greatly influenced contemporary attitudes to art and architecture. Although he once burned a set of Goya's *Caprichos* which he considered hideous, he recognized the genius of Turner and was an early champion of the Pre-Raphaelites, even after his friend Millais (no. 25) had stolen his wife Effie. In 1877 he was involved in a celebrated libel suit with Whistler (no. 46), in which the painter was awarded one farthing damages. In later life he turned to social and political problems, and was a passionate advocate of social reforms, which alienated many of his earlier admirers.

In 1871, following the death of his mother, Ruskin bought the small estate of Brantwood on Coniston Water in the Lake District, and there he spent his declining years. This photograph was 'taken during one of his daily walks' by a firm of photographers from Grasmere, about 1885, at the time that Ruskin was working on his autobiography *Praeterita*, when he was suffering from increasing mental instability, the 'monsoons and cyclones of my poor old plagued brains'.

48

Cardinal John Henry Newman 1801–90

Herbert Rose Barraud 1845–96

Carbon print, on the photographer's printed mount, *c.*1888
24.5 × 17.9 (9⅝ × 7)
Purchased, 1937 (x5406)

Newman, who as vicar of St Mary's, Oxford, was in 1833 a founder member of the Oxford Movement for the establishment of the principles of Anglo-Catholicism in the Anglican Church, came increasingly to doubt the Anglican position, and was received into the Roman Church in 1845. After ordination in Rome, he returned to England to found oratories in Birmingham (1847) and London (1850), and spent the rest of his life in Birmingham working for the revival of Catholicism in England: 'There is no help for it; we must either give up the belief in the church as a divine institution altogether, or we must recognise it in that communion of which the pope is the head . . . to believe in a church is to believe in a pope'. Newman's conversion to Catholicism shook the Church of England – Gladstone wrote that 'it has never yet been estimated at anything like the full amount of its calamitous importance' – and ensured that he remained a celebrity throughout his life. He was made Cardinal in 1879. His vivid writings include the *Apologia pro Vita Sua* (1864), *The Dream of Gerontius* (1866), and hymns, among them 'Lead, Kindly Light'.

The photographer Barraud, who had premises at 263 Oxford Street, London, is best known for his series of volumes of contemporary personalities entitled *Men and Women of the Day*, published annually between 1888 and 1891, in which his highly efficient photographs were accompanied by biographies of the sitters. This portrait of Newman appeared in the volume for 1888, and shows Barraud's ability to fix a personality by the choice of a significant gesture. About 1891 Barraud's finances failed, and he ended his days as manager of Mayall's studio at 73 Piccadilly, London (see no. 32).

49

George Bernard Shaw 1856–1950

Sir Emery Walker 1851–1933

Modern bromide print from the original half-plate glass negative, summer 1888
Given by Emery Walker Ltd, 1956 (x19646)

George Bernard Shaw quit his native Dublin for London in 1876. The next ten years were a period of momentous change for him. He wrote five novels, none of them published, but which were to provide raw materials later for his plays; he became a socialist, and joined the Fabian Society (1884); converted to vegetarianism (1881) – a diet to which he attributed his immense energy; but, above all, by sheer will-power, he conquered his own shy and nervous personality. He forced himself to speak on platforms, in public parks and on street corners, and turned himself into one of the most effective orators, debators and, indeed, wits of the day. 'The years of poverty had ended, and the years of plenty now began'.

This photograph 'at ease in Summer in Battersea Park' by Shaw's friend and fellow-socialist Emery Walker shows him standing confidently in his newly-forged persona. It was taken at about the time of his appointment as music critic of the recently-founded evening paper *The Star*. In the next two years, under the pen-name of Corno di Bassetto, he was to write some of the liveliest music-criticism ever published.

Walker, a friend of William Morris, with whom he worked in founding the Arts and Crafts Exhibition Society, was a process-engraver and typographer, who devoted his life to the improvement of the quality of book production. The Gallery owns some 10,000 of his photographic negatives, most of them reference photographs for book illustrations, but including a number of original negatives from life, like this one, of his friends and associates.

50

Mary Augusta Arnold, Mrs Humphrey Ward 1851–1920

Herbert Rose Barraud 1845–96

Carbon print, on the photographer's printed mount, *c*.1889
24.6 × 17.7 (9⅝ × 7)
Purchased, 1936 (AX5470)

The daughter of Thomas Arnold, Professor of English, for a time Newman's first classics Master at the Birmingham Oratory School (see no. 48), Mrs Humphrey Ward was the granddaughter of Dr Arnold of Rugby and niece of the poet and critic Matthew Arnold. A chronic sufferer from writer's cramp, she was a prolific author, and this photograph was taken shortly after the publication of her best known work, the novel *Robert Elsmere* (1888), an instant best-seller, which popularized her theme: the social mission of Christianity. She put her principles into practice, founding in London in 1890 a settlement for popular Bible teaching and social work which developed into the Passmore Edwards Settlement. She instituted 'children's play hours' and drew attention to the need for special educational facilities for handicapped children. Despite her own taste for politics, she was the foundress of the Women's National Anti-Suffrage League (1908), working instead to bring the views of women to bear on the legislature without the aid of the vote. In the First World War she produced pro-Allied propaganda for America.

This photograph appeared in *Men and Women of the Day* (1889) (see no. 48).

51

Marie Lloyd (Matilda Alice Victoria Wood) 1870–1922

Schloss active 1890s

Albumen panel print, on the photographer's printed mount, signed and inscribed by the sitter:
Yours Always/Marie Lloyd; 1890
18.1 × 29.5 ($7\frac{1}{8}$ × $11\frac{5}{8}$)
Purchased, 1980 (X12456)

The eldest of the eleven children of an artificial-flower maker, Marie Lloyd formed the Fairy Bell Minstrels as a child, and performed in schoolrooms and mission halls. She first appeared on stage aged fourteen, and was in the West End of London before she was sixteen. Though she worked in pantomimes, her name will always be associated with the music hall, and with songs like 'The Boy I love sits up in the Gallery' and 'Oh, Mr Porter'. To much of her material, by look, gesture, or tone of voice, she brought a cheery vulgarity, and both Ellen Terry (no. 9) and Sarah Bernhardt praised her powers of 'significant expression'.

This photograph dates from Marie Lloyd's first visit to America in 1890, and was taken at the Schloss studio at 54 West 23rd Street, New York. The Cockney girl is portrayed as an oriental houri, among all the exotic trappings of a fashionable theatrical photographer, and with a whiff of sexual provocation which anticipates no. 136. It is curiously at odds with the singer of 'I'm one of the ruins that Cromwell knocked abaht a bit'.

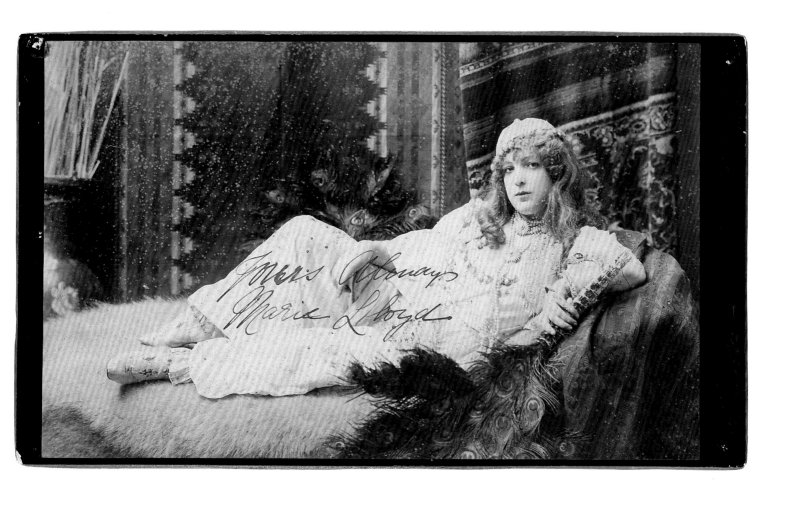

Yours Always
Marie Lloyd

52

Sir Edward Coley Burne-Jones Bt. 1833–98

Barbara Leighton active *c.*1890

Platinum print, 27 July 1890
33.3 × 25.7 ($13\frac{1}{8}$ × $10\frac{1}{8}$)
Given by E.E. Leggatt, before 1922 (X13185)

As an undergraduate at Oxford in the early 1850s Burne-Jones met William Morris and founded with him The Brotherhood, a group of friends who worshipped the Middle Ages, visited churches, read Ruskin and Tennyson, and who in effect constituted a little 'romantic movement' of their own. While still an undergraduate Burne-Jones came to London to meet Rossetti (no. 24), who persuaded him to give up university and to learn to paint. The combined influences of medieval romance and the Pre-Raphaelites dominated the whole of his later career as artist and designer.

This photograph shows Burne-Jones towards the end of his life, when bouts of illness had convinced him that he had not long to live. He is at work in the Garden Studio of his house, The Grange, North End Lane, Fulham, on his vast watercolour *The Star of Bethlehem* (completed early 1891; Birmingham Museum and Art Gallery). Burne-Jones said of his labours on this picture: 'And a tiring thing it is, physically, to do, up my steps and down, and from right to left. I have journeyed as many miles as ever the kings travelled'.

The photographer Barbara Leighton, whose name is recorded in Lady Burne-Jones' *Memorials* of her husband (1904) is otherwise unknown. She may perhaps have been 'the young girl who', as Lady Burne-Jones recalls, 'asked him [Burne-Jones] as she watched him painting "The Star of Bethlehem", whether he believed in it, he answered: "It is too beautiful not to be true"'.

This photograph has in the past been wrongly attributed to Frederick Hollyer (see no. 59), who did however make this platinum print from Barbara Leighton's 15 × 12 inch negative. This belonged to Sir Emery Walker (see no. 49), and is now also in the Gallery's collection.

53

Dame Millicent Garrett Fawcett, Mrs Henry Fawcett 1847–1929

Walery (Stanislas Julian Walery, Count Ostrorog) active 1884–98

Carbon print, on the photographer's printed mount, with a facsimile of the sitter's signature; *c.*1890
25 × 18 (9¾ × 7⅛)
Acquired before 1980 (X9121)

Sister of the pioneer of women's medicine Elizabeth Garrett Anderson, and wife of the blind Liberal statesman Henry Fawcett, Dame Millicent was prominent in the women's suffrage movement from its earliest years in the late 1860s. She worked unremittingly for the cause, but as president from 1897 of the influential National Union of Women's Suffragettes she opposed the militant suffragettes (1905–14), led by Mrs Emmeline Pankhurst and her daughter Christabel. During the 1880s and 1890s, in addition to her work for women, she visited Ireland repeatedly, and was active in opposition to Home Rule, and in 1901 went to South Africa as leader of the ladies' commission of inquiry into Boer concentration camps.

This serene portrait, which appeared in Walery's monthly series *Our Celebrities* (published by Sampson Low & Co.), dates from about 1890, in which year Dame Millicent's daughter Philippa, a student at Newnham College, Cambridge, was placed above the (male) Senior Wrangler (top first class degree) in the mathematical degree examinations, an achievement which materially advanced the cause of higher education for women. Walery's studio was at 164 Regent Street, London. Like Barraud (see nos. 48 and 50), he was a superb technician, and his carbon prints derive much of their fascination from the great clarity of image which he obtained. So sharp indeed was the definition that they often needed cosmetic retouching, and Dame Millicent's complexion owes much of its perfection to the art of the stippler rather than to nature.

54

Thomas Henry Huxley 1825–95

Elliott & Fry active 1863–1963

Albumen cabinet print, on the photographers' printed mount, *c.*1890
14.8 × 10.4 (5¾ × 4)
Acquired, 1973 (X11994)

Huxley was one of the best known and most influential scientists of his day. A Darwinian, many of his ideas were in violent opposition to accepted religious teaching, and he battled throughout his career 'to promote the increase of natural knowledge and to further the application of scientific methods of investigation to all the problems of life', and to rid the world of 'the garment of make-believe, by which pious hands have hidden its uglier features'. He carried out his important researches on fish, reptiles, birds and fossils, but he is above all remembered as a scientific popularizer and spokesman.

Joseph John Elliott and Clarence Edmund Fry established the firm of Elliott & Fry at 55 Baker Street, London, in 1863, and it remained there until 1963. This portrait was taken towards the end of Huxley's life, and conveys by its considered pose and careful lighting both his intellectual curiosity and authority.

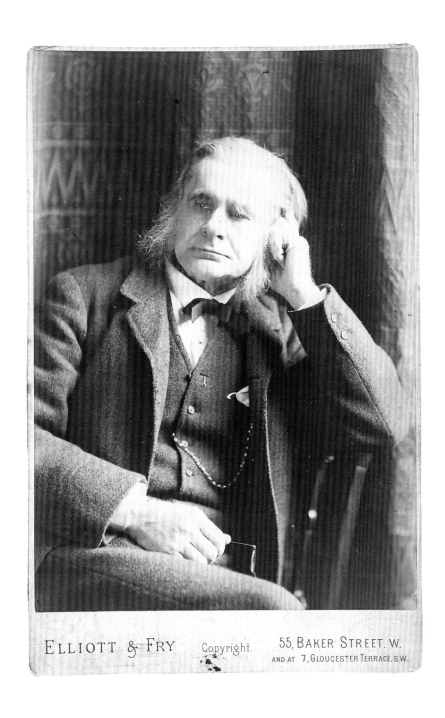

55

Frederic, Baron Leighton of Stretton 1830–96

Ralph Winwood Robinson 1862–1942

Platinum print, with the name of the sitter printed on the mount, *c*.1891
20 × 15.4 (7¾ × 6)
Acquired, 1969 (X7373)

In 1892 Ralph Robinson, elder son of the photographer and writer on photography Henry Peach Robinson, published a volume of fifty-seven portrait photographs entitled *Members and Associates of the Royal Academy of Arts in 1891*. All show the distinguished artists at home or in their studios, rather than in the photographer's studio, an unusual procedure at the time, and this makes the book an especially valuable social document.

Robinson captures Leighton, President of the Royal Academy (1878–96) and the foremost representative of High Victorian academic painting, in the first floor studio of his house at 2 (now 12) Holland Park Road, London. By him stands a small plaster of his sculpture *The Sluggard* (*c*.1882–5); hanging on the wall (top left) is a cast of Michelangelo's 'Taddei' tondo (Royal Academy, London), alongside a group of Leighton's own oil sketches. He holds a figurine of a female torso. At about this time Leighton was working on two large canvases, *And the Sea gave up the Dead which were in it* for Sir Henry Tate (Tate Gallery, London) and *Perseus and Andromeda* (Walker Art Gallery, Liverpool), in both of which his admiration for sculptural forms is readily apparent. Both Ralph Robinson and his father were founder members of the Linked Ring (see no. 45).

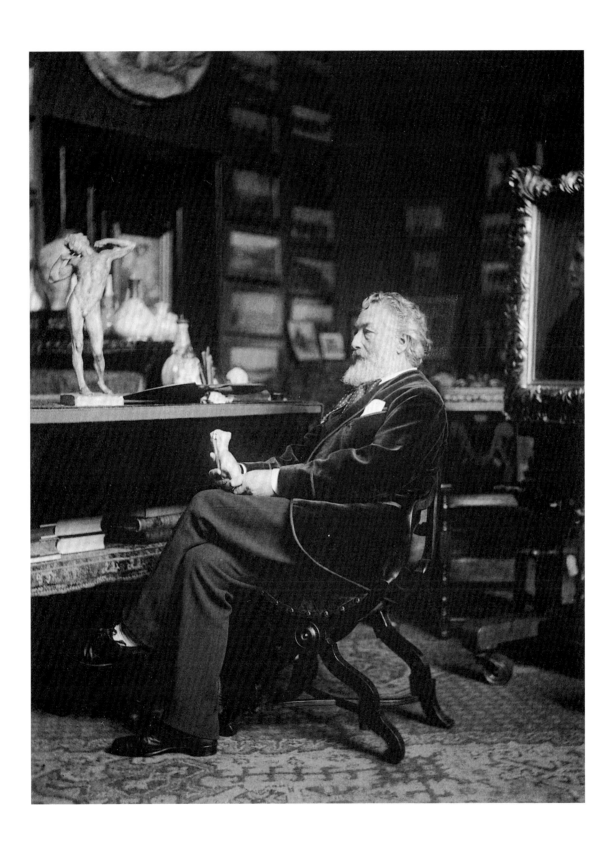

56

Robert Louis Stevenson 1850–94 and his Family

J. Davis active 1890s

Albumen print, with the photographer's blind stamp, *c*.1891
19.2 × 23.4 (7½ × 9¼)
Purchased from the estate of Sir Edmund Gosse, 1919 (X4630)

The sitters are (left to right): an unknown woman; Lloyd Osbourne, Stevenson's stepson and literary collaborator; Mrs Thomas Stevenson, his mother; Isobel Osbourne, Mrs Joseph Strong, stepdaughter and amanuensis; Stevenson; Austin Strong, the Strongs' son; Fanny van de Grift, Mrs Stevenson (formerly Mrs Osbourne), and Joseph Strong, his stepson-in-law.

Throughout his life the Scottish novelist, essayist and poet Robert Louis Stevenson led a wandering gipsy existence. This reflected his longing for the primitive, but was also stimulated by the search for a climate which suited his tuberculosis. In 1891 he settled with his family at Apia in Samoa, where the beauty of the scenery, the climate, and the charm of the native population delighted them.

This photograph was taken by the local postmaster, who also had a photography business, and shows the family on the verandah of the wooden house which Stevenson had built on his four-hundred-acre estate Vailima ('five rivers'). The carefully posed group, grave, and with an air of suspended theatricality, conveys well the atmosphere of this tightly knit community, grouped around Tusitala ('the teller of tales'), hard-working, contented and religious. Lloyd Osbourne, who was collaborating with Stevenson on *The Wreckers* at this time, wrote that

> he [Stevenson] liked too, best of all, I think, the beautiful and touchingly patriarchal aspect of family devotions; the gathering of the big, hushed household preparatory to the work of the day, and the feeling of unity and fellowship thus engendered. . . . We were the *Sa Tusitala*, the clan of Stevenson, and this was the daily enunciation of our solidarity.

The date 1891 is usually associated with this photograph, but it could be a little later. Stevenson died of a brain haemorrhage in 1894.

57

Herbert Henry Asquith, 1st Earl of Oxford and Asquith
1852–1928

Cyril Flower, Baron Battersea 1843–1907

Platinum print, *c.*1891–4
20 × 14.7 ($7\frac{7}{8}$ × $5\frac{3}{4}$)
Purchased, 1982 (AX15687)

Cyril Flower, later Lord Battersea, Liberal MP, ardent huntsman, eccentric and passionate aesthete, took up photography in the 1880s. His friends were his favourite subject, and this portrait of the future Prime Minister Asquith comes from an album of 124 portrait photographs owned by the Gallery, which were taken at Aston Clinton, the family home of Flower's wife, Constance de Rothschild. They are redolent of the social life of the period. Asquith got to know Cyril Flower in the 1880s, and became something of a protégé. Lady Battersea writes of him in her *Reminiscences* (1922), in the chapter entitled 'Prime Ministers I have known', as

> a somewhat spare figure, carelessly dressed, a shapely head with smooth light-brown hair, a fine forehead, rather deep-set grey eyes, a pale complexion, such as one would expect in a hard-working student, a firm mouth that could break into a pleasant smile, no special charm of bearing or manner, but a low agreeable voice and a distinctly refined enunciation.

This photograph was almost certainly taken shortly after the death of Asquith's first wife in 1891, and before his marriage to Margot Tennant (no. 88) in 1894, at about the time he first entered the Cabinet as Home Secretary.

Lord Battersea died in November 1907, and his obituary in *The Times* ends with the announcement: 'In consequence of the death of Lord Battersea, Lord Rothschild's staghounds will not hunt today'.

58

Joseph Chamberlain 1836–1914

Eveleen Myers died 1937

Carbon print, early 1890s
29.1 × 23.7 ($11\frac{3}{8}$ × $9\frac{1}{4}$)
Purchased, 1983 (X19813)

The formidable political boss of Birmingham, Chamberlain entered national politics as President of the Board of Trade in Gladstone's second administration (1880). His strongly-held radical opinions made him the *enfant terrible* of the Cabinet but he appeared to many to be the natural successor to Gladstone. This prize was thrown away when he and John Bright (no. 41) voted against their party on the Irish Home Rule bill (1886). He spent nine years in the political wilderness, until in 1895 this dedicated imperialist was appointed Colonial Secretary in Lord Salisbury's coalition government.

Throughout his career Chamberlain was the delight of caricaturists, and his distinctive features and monocle were known throughout Europe. Eveleen Myers creates a likeness of great concentration – Chamberlain's intense glance fixed by his hypnotic monocle – the image of a political hard-hitter, 'alert, not without a pleasant squeeze of lemon, to add savour to the daily dish'. Born Eveleen Tennant, she was the beautiful daughter of cultivated well-to-do parents, and was painted by Watts and Millais. She married in 1880 F.W.H. Myers, poet and essayist, and a dedicated spiritualist who founded the Society for Psychical Research. In 1888 at their home, Leckhampton House, Cambridge, she set up a studio, and photographed many of her distinguished friends and contemporaries, as well as aesthetically posed genre studies. John Addington Symonds, writing in *Sun Artists* (1891), comments on 'her powers . . . so marked in the direction of humanity'. Her photograph of Chamberlain is probably a little later than this article, but before 1895. Mrs Myers' sister Dorothy Tennant was married to Sir H.M. Stanley (no. 36).

59

Beatrice Stella Tanner, Mrs Patrick Campbell 1865–1940

Frederick Hollyer 1837–1933

Platinum print, with the photographer's stamp on the reverse of the mount, 1893
14 × 8.9 (5$\frac{1}{2}$ × 3$\frac{1}{2}$)
Purchased, 1983 (P229)

One of the greatest actresses of the century, 'Mrs Pat' became on account of her tempestuous moods, devastating wit and pronounced eccentricity, a legend in her own lifetime. She made her début in 1888, and triumphed in the year of this photograph in the role of Paula Tanqueray in the first production of Pinero's *The Second Mrs Tanqueray*. She had a dark, Italian beauty and a rich expressive voice, with a gift for portraying passionate and complex women. Sir Edmund Gosse writing to her in 1895 cites 'the flash and gloom, the swirl and the eddy, of a soul torn by supposed intellectual emotion'. Later roles included Mélisande (1898) and in lighter vein Eliza Doolittle in Shaw's *Pygmalion* (1914): 'I invented a Cockney accent and created a human Eliza'.

Frederick Hollyer took up photography in about 1860, and established a business in the photographic reproduction of works of art (notably the paintings of the Pre-Raphaelites and the drawings of Burne-Jones [no. 52]). As a relaxation he photographed people, and at his studio at 9 Pembroke Square, London, Mondays were reserved for portraiture. His portrait prints, with their limited range of tone and distinctive mounts, have a rare delicacy and beauty. His sitters are unselfconsciously posed and softly lit, their characters revealed with great sympathy and understanding. Hollyer was a member of the Photographic Society and the Linked Ring (see no. 45), and his work was much admired by his contemporaries: 'From a fine Hollyer portrait you study the man as he is . . . these finely modelled heads, set so well in place as regards the decoration of a panel, are also transcripts of personalities – human documents of singular verity . . .'.

60

Queen Victoria 1819–1901 with her Indian servant Abdul Karim

Hills & Saunders active *c.*1859 to the present day

Carbon print, 17 July 1893
42.9 × 57.4 ($16\frac{7}{8}$ × $22\frac{5}{8}$)
Purchased, 1901–2 (P51)

To her great satisfaction Queen Victoria was proclaimed Empress of India in 1876 and thereafter imported an Indian flavour to her court. There was a Durbar Room at Osborne, and, after the death of John Brown (no. 35), she employed as her personal attendant an Indian servant Abdul Karim from Agra. His airs made him, like Brown before, most unpopular in court circles, but the Queen defended him with absolute tenacity, and he remained in her service until her death. In 1888 Abdul Karim refused to continue to wait at table, because in Agra he had been a clerk or Munshi, not a menial, and in 1889 he was created Queen's Munshi. He rapidly graduated, as Prince Albert had done, from blotting the Queen's letters to helping in their composition. He looked after 'all my boxes', and gave his mistress lessons in Hindustani: 'a very strict Master' and 'a *perfect* Gentleman'. He was painted, like the Queen, by Von Angeli.

In this photograph by the Eton firm founded by Robert Hills and John Henry Saunders, the Queen is shown working at her boxes, seated in her garden-tent at Frogmore House, Windsor.

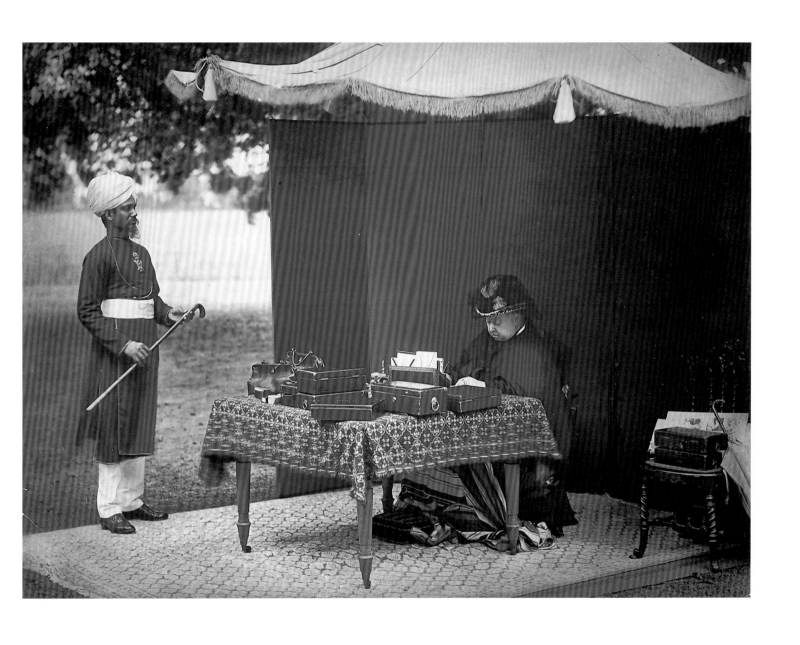

61

Sir Richard Strachey 1817–1908 and his Family

Graystone Bird active 1895–1910

Albumen print, on the photographer's printed mount, *c.*1893
19.3 × 24.1 (7½ × 9½)
Purchased from the Strachey Trust, 1979 (x13122)

The sitters are (left to right): James Beaumont Strachey 1887–1967, psycho-analyst; Giles Lytton 1880–1932, critic and biographer; Oliver 1874–1960, musician, civil servant and author; Ralph 1868–1923; Richard John 1862–1935, soldier; Sir Richard; Jane Maria Grant, Lady Strachey 1840–1928; Elinor, Mrs Rendel 1860–1945; Dorothy 1865–1960, wife of the artist Simon Bussy; Philippa 1872–1968; Joan Pernel 1876–1951, and Marjorie 1882–1962.

As soldier, engineer, botanist and administrator, Sir Richard Strachey devoted his life to the service of India, where he rose to be Head of the Public Works department (1862–5) and Inspector-General of Irrigation (1866). In retirement he pursued his prodigiously wide interests, and was for a time Chairman of the East Indian Railway, President of the Royal Geographical Society, and Chairman of the Meteorological Council. The member of a distinguished intellectual family, many of his own children played a significant part in English social and intellectual life, above all Lytton, who was a leading member of the Bloomsbury Group.

In this photograph by the obscure Bath photographer Bird, whose studio was at 38 Milsom Street, the family are displayed with characteristic eccentricity in perfect symmetry, in imitation of the reliefs of kneeling figures often found on seventeenth-century English tombs. It was probably taken at the Strachey family home of Sutton Court, Somerset, and is part of a large group of Strachey family photographs purchased from the Strachey Trust in 1979.

62

Aubrey Vincent Beardsley 1872–98

Frederick H. Evans 1853–1943

Platinum print, signed, inscribed and dated by the photographer on the mount; summer 1894
13.6 × 9.7 (5⅛ × 3⅞)
Given by Dr Robert Steele, 1939 (P114)

The bookseller and publisher Frederick Evans of Queen Street, Cheapside, London, was the friend and patron of the artist and illustrator Aubrey Beardsley, and instrumental in obtaining his earliest commissions. He was also a gifted and sensitive photographer, whose style was, like that of Hollyer (see no. 59), noted for its purity. He photographed Beardsley in the summer of 1894, perhaps at his home at 144 Cambridge Street, London. He wrote to Evans on 20 August 1894: 'I think the photos are splendid; couldn't be better. I am looking forward to getting my copies. I should like them on cabinet boards, if that's not too much trouble'. Although seriously ill, he was at this time struggling to work on his illustrations to Wagner's *Tannhäuser*:

> I have been suffering terribly from a haemorrhage of the lung which of course left me horribly weak. For the time all my work has stopped, and I sit about all day moping and worrying about my beloved Venusberg. I can think about nothing else – I am just doing a picture of Venus feeding her pet unicorns.

By this date Evans sensed that Beardsley was dying, and this photograph, with its emphasis on the delicate bird-like profile and long etiolated fingers, is a grave and fragile reminder of mortality. Evans exhibited it at the second Photographic Salon of the Linked Ring (see no. 45) in October 1894, where it was displayed mounted on a photographic copy of one of Beardsley's black and white border designs. The illustrator of the *Yellow Book* and *Savoy*, of *The Rape of the Lock* and Oscar Wilde's *Salomé*, whose work aroused such furious controversy, died less than four years later.

63

Queen Victoria 1819–1901 and her Descendants, 'The Four Generations'

Chancellor active 1860s–1916

Panel print, on the photographer's printed mount, 5 August 1899
28.8 × 23.9 (11$\frac{3}{8}$ × 9$\frac{3}{8}$)
Purchased, 1983 (P232)

The sitters are (left to right): Prince George, Duke of York 1865–1936, later George V; Queen Victoria; Edward, Prince of Wales 1841–1910, later Edward VII; and Prince Edward of York 1894–1972, later Edward VIII, and subsequently Duke of Windsor.

Writing to her daughter Princess Victoria, Empress Frederick of Germany, in June 1894, about the birth of Prince Edward of York, a 'fine, strong-looking child', Queen Victoria commented on the birth: 'It is a great pleasure & satisfaction, but not such a marvel'. She added, 'As it is, however, it seems that it has never happened in this Country that there shld be three direct Heirs as well as the Sovereign alive'. The Queen was evidently fond of this idea, and a number of photographs and paintings commemorate 'The Four Generations'. This group by Chancellor of Sackville Street, Dublin, was taken at Osborne House on the Isle of Wight on 5 August 1899, shortly after the Queen's eightieth birthday. Originally a firm of clock-makers, Chancellors turned to photography in the 1860s. The cartes-de-visite from this period bear the name of John Chancellor.

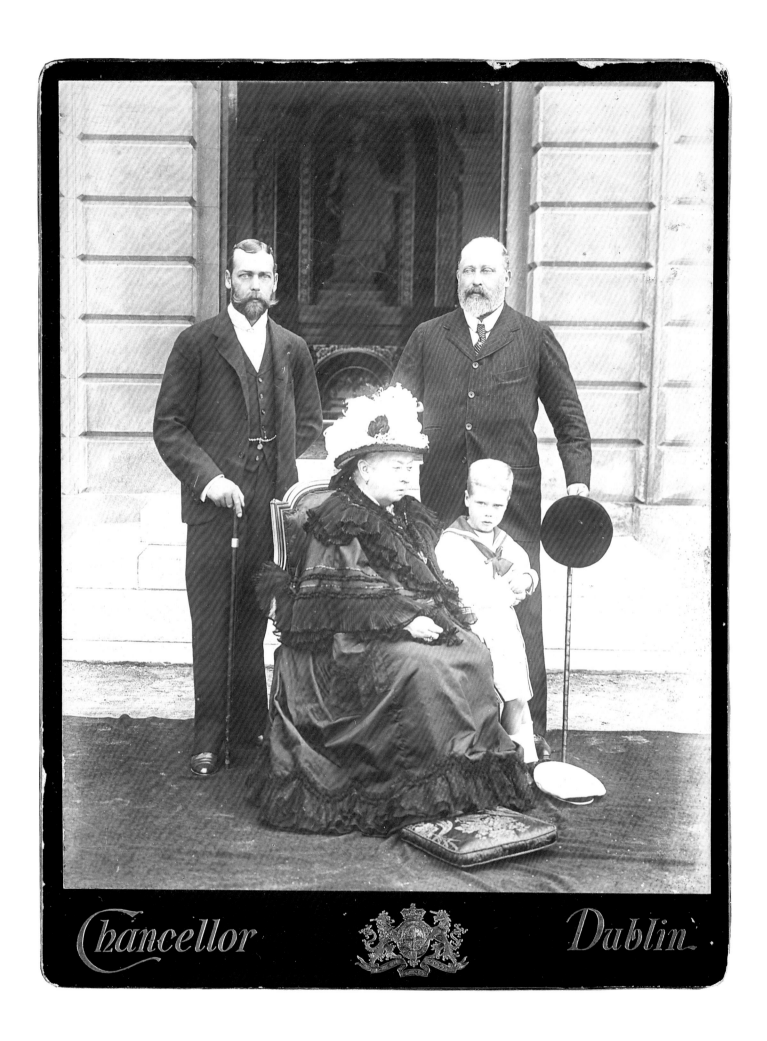

Chancellor Dublin

64

Francis Cowley Burnand 1836–1917

Unknown photographer

Albumen cabinet print, inscribed and dated by the sitter on the mount, 1899
14.2 × 10.2 ($5\frac{1}{2}$ × 4)
Given by the executors of the estate of Lady Partridge, 1961 (x4904)

Burnand pursued a zigzag course from Eton to Cambridge (where he founded the Amateur Dramatic Club), from Anglican theological college to Roman Catholicism, from the Bar to the stage, and finally to the editorship of *Punch* (1880–1906). As a play-wright he has over a hundred popular plays and burlesques to his name, of which *Black-eyed Susan* (1866) is best known. He was co-founder of the periodical *Fun*. He joined the staff of *Punch* in 1863, and was largely responsible for transforming it into a national monument of humour. To the charge that *Punch* in his time was not as good as it used to be, he replied 'It never was'.

This cabinet photograph, an amusing composite of two poses, conveys much of Burnand's genial appearance and gentle humour. On the column (centre) stands a plaster reduction of the Venus de Milo, and the mount is inscribed in Burnand's hand: 'Discussion on the Venus of Milo/Two of a trade never agree/Yours F. C. Burnand June 2 1899'. The photograph was formerly in the collection of the cartoonist Sir Bernard Partridge, who worked for *Punch* throughout most of Burnand's editorship.

65

Virginia Woolf (Adeline Virginia Stephen, Mrs Leonard Woolf) 1882–1941

George Charles Beresford 1864–1938

Platinum print, July 1902
15.2 × 10.8 (6 × 4½)
Purchased, 1983 (P221)

The second daughter of the editor of *The Dictionary of National Biography*, Sir Leslie Stephen, Virginia Woolf possessed an ethereal beauty and a temperament of extreme sensitivity, both of which qualities seem reflected in her novels and in her exquisite historical fantasy *Orlando* (1928). In *Mrs Dalloway* (1925), *To the Lighthouse* (1927) and *The Waves* (1931) she developed the 'stream of consciousness' style which is her main contribution to the development of the English novel. Throughout her career she suffered bouts of mental illness, and eventually took her own life. Despite her apparent fragility, she made a considerable impact on her contemporaries, and could be both mordantly witty and tough. With her sister Vanessa and their brothers Adrian and Thoby, she was at the heart of the Bloomsbury Group, a coterie of intellectuals and artists who dominated English cultural life in the first decades of the twentieth century, and counted among her intimates Maynard Keynes, Lytton Strachey (no. 61), E.M. Forster (no. 120), and the political writer Leonard Woolf, whom she married in 1912.

Beresford, who was a brilliant talker and wit and also an antique dealer, is best known as the model for 'M'Turk' in his friend Rudyard Kipling's stories of *Stalky & Co*. But between 1902 and 1932 this versatile man was a respected commercial photographer with a studio in Yeoman's Row, Brompton Road, London, specializing in straightforward portraits of writers, artists and politicians, many of which were reproduced in periodicals of the time. He photographed Virginia Woolf in the summer of 1902, at a time when she was beginning her literary career, writing reviews for *The Times Literary Supplement*. In addition to prints, the Gallery also owns a large collection of Beresford's negatives.

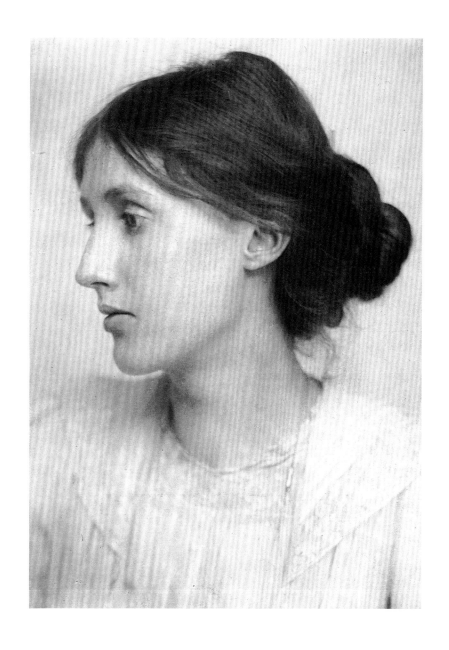

66

Sir James Dewar 1842–1923

Dr Alexander Scott active *c.*1900

Platinum print, 1902
20.1 × 15.3 (7$\frac{7}{8}$ × 6)
Given by Lady Dewar, 1926 (X5197)

Dewar was a dominant figure in experimental science in the late nineteenth and early twentieth centuries. At Cambridge and at the Royal Institution he carried out important work on the liquefaction of gases, and laid the foundations of subsequent advances in atomic physics. He invented a precursor of the 'Thermos' flask, and was, with Sir Frederick Abel, the inventor of cordite (1889). An impatient, indeed choleric man, he is shown here at work in his laboratory in an attitude of intense concentration.

This photograph was given to the Gallery in 1926 by his widow Lady Dewar. It is inscribed in an unknown hand on the back of the mount: 'Prof. Sir James Dewar./ Taken by Dr. Alexander Scott/in 1902/In the Laboratory of/The Royal Institution', but the photographer Olive Edis (see nos. 85, 90), in whose studio this print was possibly made, believed that it was taken by an associate of hers, Ethel Glazebrooke.

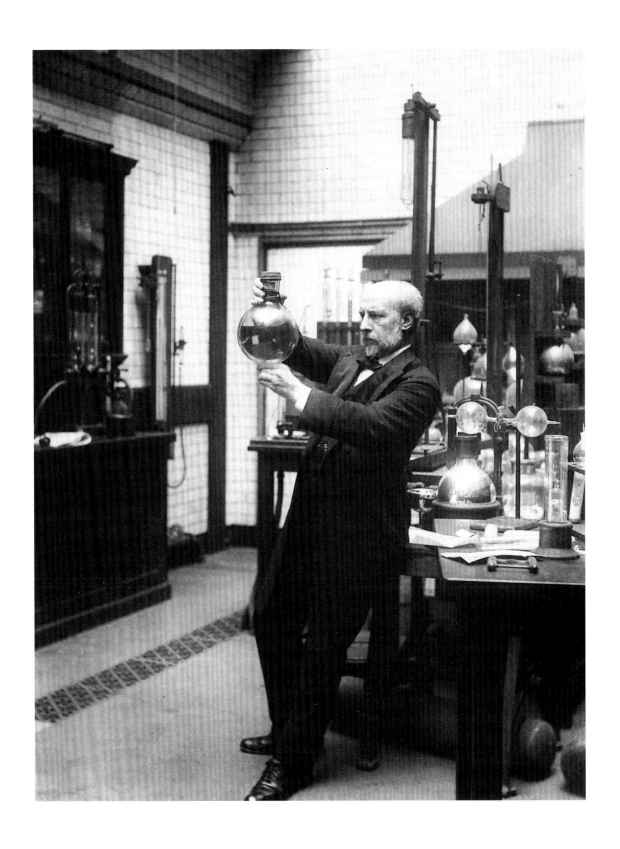

67

Arthur Morrison 1863–1945

Frederic G. Hodsoll active *c*.1900–10

Gelatin silver print, inscribed by the photographer on the mount: *Arthur Morrison by. FG. Hodsoll*, 1902
26.2 × 22 (10⅜ × 8½)
Purchased from St Paul's Cathedral, 1983 (AX25182)

The novelist Arthur Morrison is best known for his 'realist' stories of life in London's East End, first published in *Macmillan's Magazine*, and later collected as *Tales of Mean Streets* (1894). His most widely read work is *A Child of the Jago* (1896), an account of a slum childhood, of gang warfare and violent crime. Morrison's later life, as this portrait suggests, was devoted to collecting and writing about oriental art.

Little is known of Frederic Hodsoll; he was apparently born in England, and went to live in America. According to his own very brief account he 'returned to England from New Mexico after the flood' and 'took up journalistic work for the weekly illustrated papers in London'. He was one of the earliest photographers to use flashlight, and this gives his prints exceptional clarity of detail. It was ideally suited to his favourite subjects: writers in their homes and actors in their dressing-rooms. He worked for *The Sphere* and *The Tatler and Bystander*, where this portrait was reproduced on 24 September 1902, as part of a series called 'Authors in their Rooms'. It comes from one of two albums of Hodsoll's work owned by the Gallery. Many of Hodsoll's sitters are of considerable interest in themselves, but his photographs are especially valuable as evidence of contemporary interior decoration. The albums also contain a number of photographs of spectacular theatrical productions.

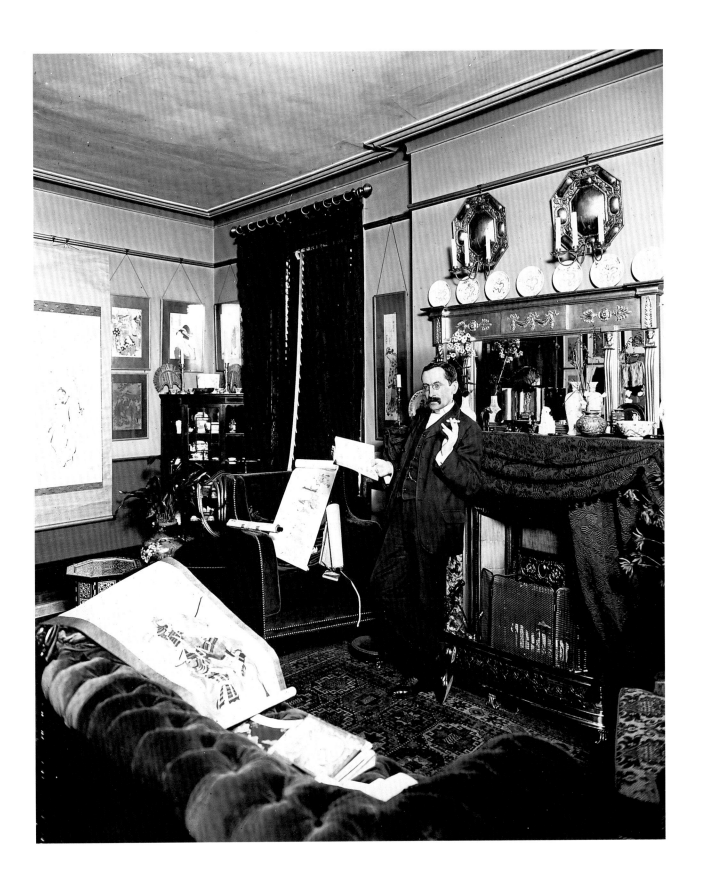

68

Sir Edward William Elgar 1857–1934

Edgar Thomas Holding 1870–1952

Platinum prints, *c*.1905
19.3 × 10.9 (7⅝ × 4½) (left); 19.4 × 11 (right)
Given by the photographer, 1934 (X11905 [left]; X11906 [right])

Less than a month after the death of Elgar, England's greatest composer, the then director of the Gallery, Sir Henry Hake, wrote to one of Elgar's closest friends, A. Troyte Griffith of Malvern, a member of the small group of intimates portrayed in music in the 'Enigma' Variations (1899; 'Troyte', the seventh Variation), to enquire about likenesses of the great man. Through Troyte Griffith's agency the Gallery acquired two of Holding's 'admirable photographs', of which Troyte Griffith wrote:

> These are 'straight' and show every detail of the dress. Two in particular – one full face the other profile – give quite different aspects of the very various Elgar. One may be said to be the Elgar of 'Gerontius' (1900) the other of the Variations or 'Cockaigne' (1901).

They were, according to another letter from Troyte Griffith, taken about the time of *The Apostles* (1903) or a little later. Nothing is recorded of Holding's work as a photographer, and he is best known as a minor landscape painter and watercolourist.

69

Edward Carpenter 1844–1929

Alvin Langdon Coburn 1882–1966

Gum platinum print, signed and dated: *Alvin Langdon Coburn 1906* on the mount; 28 November 1905
28.2 × 22.2 ($11\frac{1}{8}$ × $8\frac{3}{4}$)
Given by Dr F. Severne Mackenna, 1977 (P48)

Edward Carpenter's life was a long reaction against Victorian convention and respectability, both social and sexual. The enduring influences were Socialism and Walt Whitman. At Millthorpe in Derbyshire in 1883 Carpenter built for himself and his working-class friend, Albert Fearnehough, and his family, a cottage with an orchard and market garden. Here he lived for the next forty years, writing, and, for a time, market gardening and making sandals. In 1898 George Merrill succeeded the Fearnehoughs; gardening and sandal-making ceased, and the two men kept open house for the many followers who made the pilgrimage there to meet the prophet of 'sexual liberation', among them E.M. Forster (no. 120). He was 'touched' by Merrill: 'The sensation was unusual, and I still remember it, as I remember the position of a long vanished tooth. It was as much psychological as physical. It seemed to go straight through the small of my back into my ideas, without involving my thoughts'. This experience inspired Forster to write his novel *Maurice*.

Carpenter's own writings include *Towards Democracy* (1883–1902), *England's Ideal* (1885) and *Civilisation, its Cause and Cure* (1889).

The great American-born photographer Coburn, who had studied in New York with Gertrude Käsebier and Edward Steichen (see no. 77), was regularly in London from 1904 onwards, where George Bernard Shaw (no. 49) introduced him to many of the most celebrated and influential men of the day. He finally settled in England in 1912, and mastered the process of photogravure, which he used to illustrate the books in his well-known *Men of Mark* series. This portrait of Carpenter, taken in Bloomsbury, illustrates the emphasis in Coburn's earlier work on mood and broad effects, rather than on contrast and detail.

70

William Strang 1859–1921

James Craig Annan 1864–1946

Photogravure, *c.*1907
15.2 × 19.7 (6 × 7¾)
Purchased, 1988 (P357)

Born in Dumbarton, William Strang came to London to study at the Slade School under Alphonse Legros, and remained there for the rest of his life. A prolific painter of portraits, biblical and subject paintings, he is best known for his portrait drawings in a style based on Holbein, and for his 747 etchings, remarkable for their unity of vision and superb draughtsmanship.

The son of the leading Scottish photographer Thomas Annan, James Craig Annan learned in Vienna the techniques of photogravure printing, and reproduced many of his own photographs in this medium, which allows for exquisite tonal effects. This print was published in America in Alfred Stieglitz's *Camera Work* (July 1907; see no. 77), under the title *The Etching Printer – William Strang, Esq., A.R.A.* It shows Strang minutely examining an etcher's plate, with a printing press in the background, and is a fine example of Annan's ability to unite in his compositions a certain informality with a refined sense of atmosphere and design.

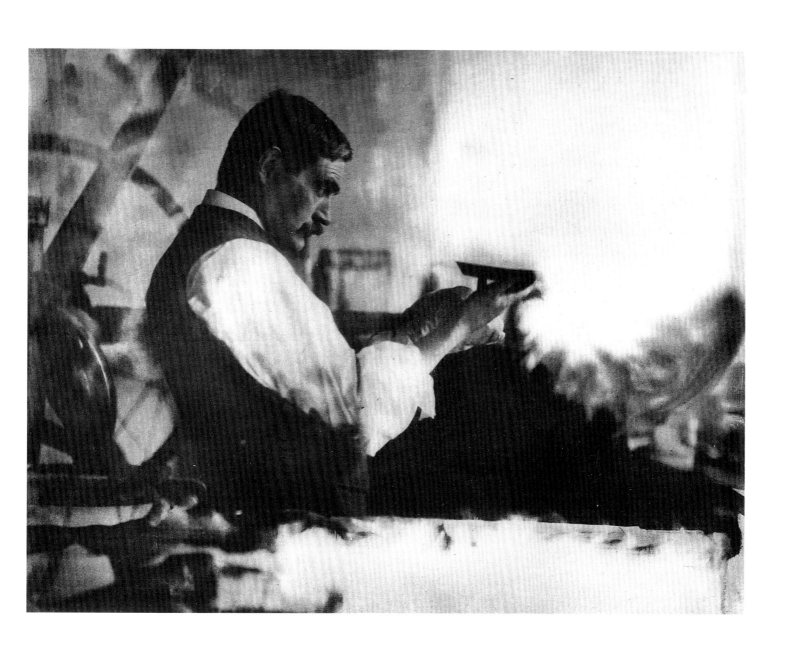

71

Henry James 1843–1916 and his brother William James 1842–1910

Marie Leon active *c.*1901–30

Bromide print, with the photographer's studio stamp on the reverse of the mount, ?1908
20.1 × 15 ($5\frac{7}{8}$ × $7\frac{7}{8}$)
Given by the Royal Historical Society, 1935 (x18720)

Although sometimes said to date from one of Henry James' trips to America, this photograph by the self-styled 'artistic photographer', Marie Leon of 30 Regent Street, London, was almost certainly taken at her London studio, perhaps in 1908 when James' elder brother, William, Professor of Philosophy at Harvard, was in England to deliver the Hibbert Lectures at Oxford.

Born in New York, Henry James was in spirit a European, and settled in England in 1876. His finest novels, among them *The Portrait of a Lady* (1881), *The Wings of the Dove* (1902) and *The Golden Bowl* (1904) all date from after his arrival, and several treat the subject of the impact of European civilization upon American life. At Harvard William James set up the first American laboratory of psychology, and founded in 1884 the American Society for Psychical Research. His *Principles of Psychology* was published in 1890, and *The Varieties of Religious Experience* in 1902. In later life heart disease made him an invalid, and in 1908 he spent some weeks in convalescence with his brother at his home, Lamb House, Rye in Sussex. Henry James wrote on 3 September to Edmund Gosse:

> the summer here fairly rioted in blandness & he (my brother) got 3 or 4 weeks of tranquil recuperative days (he had come to me unwell) largely in my garden.

Although the brothers apparently got on well, there was an underlying ambivalence in their relationship. In 1905, for instance, William heard that he had been elected to the American Academy of Arts and Letters, two months after the election of his younger brother, and he wrote to refuse the honour:

> I am the more encouraged in this course by the fact that my younger and shallower & vainer brother is already in the Academy.

In Marie Leon's photograph the characters of the brothers are cleverly individualized. Neither looks at the camera: William, the philosopher and visionary, stares impassively into space, while Henry, the novelist and critic, leaning affectionately towards his brother, turns to observe what is going on around them. Little is known of Leon's career, but in the later 1920s she moved to 50 Park Road, Regent's Park, styling herself 'Madame' Leon.

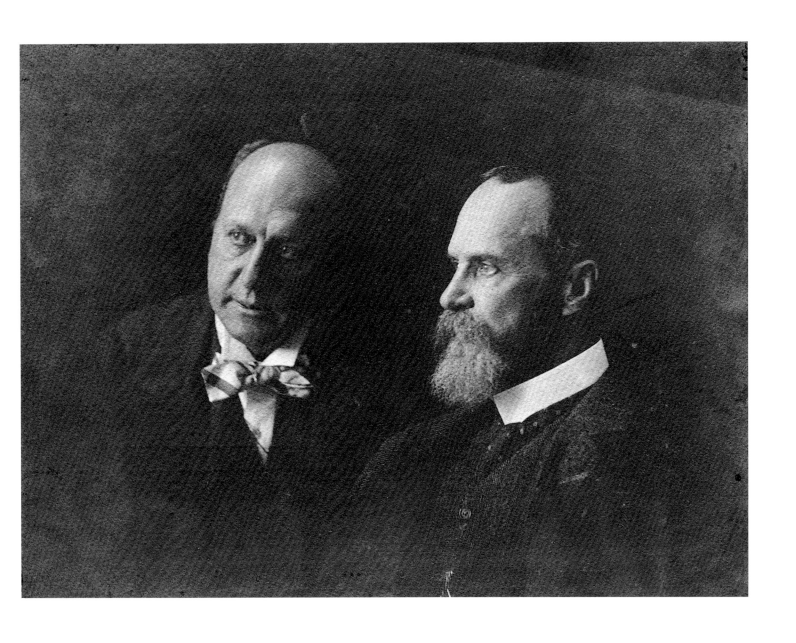

72

Edward VII 1841–1910 in the Paddock, Epsom, on Derby Day

William Booty

Bromide print, 26 May 1909
14.8 × 10.4 (5¾ × 4)
Given by Mrs B. Clarke, the photographer's daughter, 1978 (x7802)

The sitters are (left to right): Alec March, the King's trainer; Prince Arthur, Duke of Connaught 1850–1942; the King; Lord Marcus Beresford 1848–1922, the King's racing manager; Prince Arthur of Connaught 1883–1938; the Duke of York, later George V 1865–1936; and the Earl of Athlone 1874–1957.

Taken by an amateur photographer (who is said to have been at one time manager of the Theatre Royal, Drury Lane, London), this photograph records the moments after the King's colt Minora, ridden by Herbert Jones, won the Derby by a short head. This was the first time the race had been won by a reigning sovereign, and such was the excitement on the occasion that the crowds broke spontaneously into 'God Save the King'.

73

Luncheon Party to French and English Aviators

Sir (John) Benjamin Stone 1838–1914

Platinum print, 15 September 1909
15.4 × 20.2 (6 × 8)
Given by the Library of the House of Commons, 1974 (x32600)

The sitters are: (front row, left to right) Edward Purkis Frost 1842–1922, aviator; Louis Blériot 1872–1936, pioneer aviator; Samuel Franklin Cody 1861–1913, aviator; Alfred du Cros MP, 1868–1946; Frank Hedges Butler 1855–1928, founder of the Aeroplane Club; Col. Harry Stanley Massy 1850–1920, soldier; (back row, left to right) Sir Alliot Verdon-Roe 1877–1958, aviator; Sir George Renwick, Bt. MP, 1850–1931; John Martin 1847–1944, journalist; D. Macnamara; S. Renwick; Captain Sir Reginald Ambrose Cave-Browne-Cave, Bt. 1860–1930, Royal Navy; Thomas Power O'Connor MP, 1848–1929; the Hon. Charles Steward Rolls 1877–1910, Managing Director of Rolls-Royce; Lt.-Col. the Hon. Robert Lygon 1879–1952, soldier; William James Stuart Lockyer 1868–1936, explorer and astronomer.

On 25 July 1909 Louis Blériot became the first person to fly the English Channel, crossing in a time of twenty-seven minutes. The military significance of this feat was appreciated by both the British government and public, and the War Office became for the first time involved in the development of aircraft. On 15 September Sir Benjamin Stone MP gave a lunch party in Blériot's honour at the Houses of Parliament, and the guests included many of the pioneer aviators of the day, among them the American Cody (front row, third from left), bearing signs of a recent crash, who was there against doctor's orders: 'He told his doctor . . . that he should go if he died that night. (Cheers)', as a contemporary report of his speech that day records.

Stone was an enthusiastic amateur photographer, and, as Conservative MP for Birmingham East for fourteen years, he made it his task to photograph every MP as well as servants and visitors to the Houses of Parliament. The Gallery owns two thousand of his photographs, an invaluable record of the comings and goings about Westminster in the early years of this century.

Luncheon Party to French & English Aviators
House of Commons.
Sep 15th 1909

J. Benjamin Stone

74

Hazel Martyn, Lady Lavery c.1888–1935

Baron Adolf de Meyer 1868–1949

Bromide print, after 1910
17.1 × 22.2 (6¾ × 8¾)
Purchased, 1981 (P164)

Adolf Meyer-Watson was created a baron by the King of Saxony in 1901 at the request of the King's cousin Edward VII. It was a device to allow him and his beautiful wife Olga, the god-daughter (and possibly an illegitimate child) of Edward, to attend his coronation in Westminster Abbey. The de Meyers were one of the most glamorous couples in a brilliant and chic international society, and the Baron's aesthetic photographs only made him more desirable. At the outbreak of war, however, the couple, who were suspected of being German spies, hastily left England for America. There the Baron, who was admired and encouraged by Steichen (see no. 77) and Stieglitz, was employed by Condé Nast as photographer for *Vogue* and *Vanity Fair*. He brought to magazine photography not only his social kudos and contacts, but a new sense of style and elegance.

Hazel Martyn married the successful painter Sir John Lavery as his second wife in 1910, and was one of his favourite models. As her obituarist in *The Times* noted: 'he drew her as the colleen on the modern Irish bank notes, and her features thus became as familiar as those of any film star'. In reality Lady Lavery was no 'colleen', and her social position, distinguished features and sophistication made her a natural sitter for de Meyer. This photograph dates from after her marriage, and may have been taken either in London or New York. It was purchased from the sale of de Meyer's own collection.

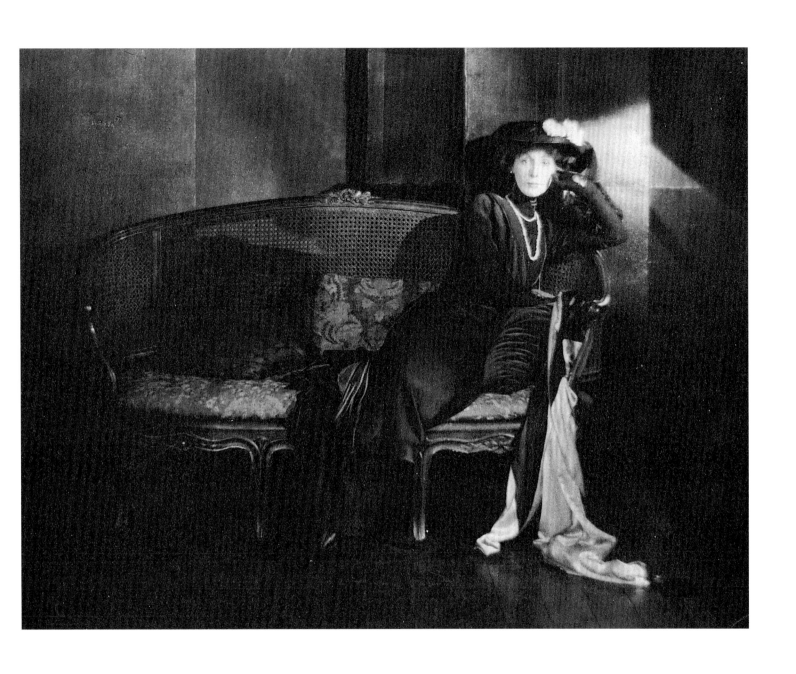

165

75

Robert Falcon Scott 1868–1912

Herbert George Ponting 1870–1935

Toned bromide print, signed and inscribed on the mount: *Captain Scott & his Diary.*
Scott's Last Expedition, 7 October 1911
35.4 × 45.5 (14 × 18)
Purchased, 1976 (P23)

When he was invited by Captain Scott to go as photographer on his ill-fated Antarctic expedition of 1910, Herbert Ponting was already the leading travel photographer of the day and had published his *In Lotus Land Japan* in that year. His work in the Antarctic was a challenge of an altogether different order. Working with the greatest skill and bravery in extremely hazardous conditions, he produced photographs and motion pictures which are both technically and aesthetically superb. He left the expedition before its tragic end because of illness, but devoted the rest of his life to the preservation of records of it.

Scott had set sail in *Terra Nova* in June 1911, and established his expedition's winter quarters at Cape Evans. This photograph shows him in his hut there, at work on his famous journal. He was to set out on his southern sledge journey three weeks later. On 16 January 1912 he arrived at the South Pole, to find the Norwegian Amundsen's flag already there. On the return journey from the Pole Scott and his companions perished, among them the legendary Captain Oates. The last entry in Scott's journal (which was found by a search party eight months later) reads: 'We shall stick it out to the end, but we are getting weaker, of course, and the end cannot be far. It seems a pity, but I do not think I can write any more'.

76

Rupert Chawner Brooke 1887–1915

Sherrill Schell 1877–1964

Glass positive, spring 1913
25.7 × 20.4 (10⅛ × 8)
Given by Emery Walker Ltd, 1956 (P101/e)

According to Henry James (no. 71) the poet Rupert Brooke was 'a creature on whom the gods had smiled their brightest', and he was famous for his great good looks, personal charm and literary promise. His early death in the First World War at Scyros only served to intensify his mythical quality. It was Francis Meynell, the son of the poet Alice Meynell, who suggested to the American photographer Schell that he photograph 'the beautiful Rupert Brooke'. Schell was amused at the idea that any man should be 'beautiful', 'visualizing in spite of myself a sort of male Gladys Cooper or a Lady Diana Manners in tweed cap and plus fours'. But he found Brooke 'a genial, wholesome fellow entirely unspoiled by all the adoration and admiration he had received . . . in short a type of all round fellow that only England seems to produce'.

In the spring of 1913 Schell was living in a flat in St George's Square, Pimlico, and there in the living room, on a foggy day and without any artificial light, he photographed Brooke, who came to him

> dressed in a suit of homespun, with a blue shirt and blue necktie. The tie was a curious affair, a long piece of silk wide enough for a muffler, tied like the ordinary four-in-hand. On any other person this costume would have seemed somewhat outré, but in spite of its carefully studied effect it gave him no touch of eccentricity. . . . His face was more remarkable for its expression and colouring than for its modelling. His complexion was not the ordinary pink and white . . . but ruddy and tanned. His hair, a golden brown with sprinklings of red. . . . The lines of his face were not faultless . . . he had narrowly escaped being snubnosed.

In all Schell took some dozen exposures of Brooke that day (each demanding 'one whole minute without the least change of expression'), and seven glass positives made by Sir Emery Walker (see no. 49) from his negatives belong to the Gallery.

77

Edward Henry Gordon Craig 1872–1966

Edward J. Steichen 1879–1973

Photogravure, 1913
20 × 16.2 (7⅞ × 5⅝)
Purchased, 1983 (P228)

Edward Gordon Craig was the son of the architect E.W. Godwin and the great actress Ellen Terry (no. 9), and his life was lived in or around the theatre. He had abundant natural talent as an actor, but turned early on to stage design. From the first his productions broke with popular pictorial realism, and were distinguished by brilliance, originality and economy of effect. A man of many love affairs and seemingly even more children, in 1905 he left England for good, and took up with the experimental dancer Isadora Duncan; this was the beginning of a rich period in his work, which saw him working with Eleonora Duse in Florence and Stanislavsky in Moscow. In 1911 he published *On the Art of the Theatre*, in which he put forward his concept of a unified theatrical experience controlled by one mastermind, the designer-director.

Edward Steichen was one of the greatest photographers of all time, who after the Second World War was appointed Director of the Department of Photography at the Museum of Modern Art, New York. He had a superb sense of design and, as is seen in his portrait of Craig, he delighted in capturing almost imperceptible forms as they emerged from shadow. For this theatrical subject, he creates an especially theatrical effect: Craig is caught, turning in a moment of unexplained drama, in a shaft of light – a device he used in his own productions. This gravure was published in Alfred Stieglitz's quarterly *Camera Work* in July 1913.

78

David Lloyd George, 1st Earl Lloyd-George of Dwyfor 1863–1945

Walton Adams 1842–1934

Bromide print, *c*.1913
20.6 × 19.4 (8$\frac{1}{8}$ × 7$\frac{5}{8}$)
Purchased from the photographer's grandson, Gilbert Adams FRPS, 1980 (P140/36)

The 'Welsh Wizard' was one of the most eloquent and dynamic figures in British politics of his day. In his twenties he established himself a reputation as a speaker on religious, temperance and political issues, and entered Parliament as the Liberal Member for Caernarvon Boroughs in 1890, a seat which he held until 1945. As Chancellor of the Exchequer he declared war on poverty in his first ('the People's') Budget of 1909, and introduced many social reforms. He succeeded Asquith (no. 57) as Prime Minister in 1916.

This photograph, taken shortly before the First World War, shows Lloyd George as Chancellor, in his prime, and conveys much of that energy and determination which he later brought both to the conduct of the war, and the pursuit of 'a short sharp peace' after it.

The photographer Walton Adams, who worked in Southampton and Reading, and was the co-inventor of the dry plate process, was the father of Marcus Adams (see no. 110).

79

Thomas Hardy 1840–1928

Emil Otto Hoppé 1878–1972

Photogravure, signed by the photographer, *c*.1913–14
28.2 × 20.3 (11⅛ × 8)
Purchased, 1986 (P310)

By the time he was photographed by Hoppé, Thomas Hardy was the doyen of English letters. His great novels – *Far from the Madding Crowd* (1874), *The Mayor of Caster-bridge* (1886), *Tess of the d'Urbervilles* (1891) – were long behind him, his epic drama *The Dynasts* (1904–8) was complete, and he was devoting his time to the writing of lyric poetry. Like his novels, his verses embody a tragic and ironic vision of life, and are written in language which is entirely idiosyncratic, at turns awkward, archaic and intensely poetic.

The photographer Hoppé was born in Munich, and moved to London in 1900, co-founding in 1909–10 the London Salon of Photography. When he photographed Hardy (at the sitter's home, Max Gate, near Dorchester) he was already one of the best known photographers in London, living at Millais' old house at 7 Cromwell Place, London, and working for *Vanity Fair*, *The Sketch*, *The Tatler*, and other periodicals. His compositions show a distinctive simplicity and comparatively restrained use of soft-focus (which must have appealed to editors), and he concentrated on the revelation of character by the most direct means.

80

Dame Adeline Genée 1878–1970

Alice Boughton 1865–1943

Platinum print, signed by the photographer, 1914
19.7 × 14.2 (7$\frac{7}{8}$ × 5$\frac{5}{8}$)
Purchased, 1982 (P206)

In her book *Photographing the Famous* (1928) the New York photographer Alice Boughton reproduces a variant of this delicate photograph of the great ballet dancer and teacher Adeline Genée, and tells how it was taken when Genée was on tour in America:

> During the first year of the war, I photographed Mlle. Genée knitting for soldiers . . . I was obliged to go to the theatre and get what I could between acts. . . I shall always remember the scene – the dancer was standing on her toes in the wings, break-ing in some new ballet slippers and looking like a bit of thistle-down. She was knitting a long woolen stocking with lightning-like rapidity. There was very little light to work by, and as the picture had to be a time exposure I told her to stand on her toes as long as she could and squeak as a signal that the limit was reached. I counted 60 and got it. She then sprang over some rope, followed by her manager who in turn was followed by the Keith [vaudeville theatre] manager, and all three went round and round back of the scene . . . keeping perfect time to the refrain of 'Steam-boat Bill', which was being sung by a 'gent' out front.

Born in Jutland Anina Jensen, Genée came to England in 1897 to dance what became her best known role, *Coppélia*, and soon achieved with her virtuoso footwork and impudent prettiness a reputation unrivalled in this country since Taglioni in the 1830s. Max Beerbohm (no. 82) wrote of her: 'Genée! It is a name that our grandchildren will cherish. . . And Alas! our grandchildren will never believe, will never be able to imagine, what Genée was'.

Alice Boughton

81

Commandant Mary Sophia Allen 1878–1964 with members of the Women Police

Christina Livingston, Mrs Albert Broom 1863–1939

Bromide print, with the photographer's stamp on the reverse, 1916
11 × 14.3 (4⅜ × 5⅝)
Given at the wish of the photographer, 1940 (X6075)

With Margaret Damer Dawson, Mary Allen was the founder in 1914 of the Women Police in London, and their Commandant from 1919 until 1938. She is seen here with members of her force at the British Women's Work Exhibition, held at the Princes Skating Rink, Knightsbridge, London. She later published *Pioneer Policewoman*, *Lady in Blue* and *Women at the Cross-roads*.

Mrs Albert Broom, the first British woman press-photographer, was also a pioneer. A woman of indefatigable energy, she took up photography with a box camera at the age of forty to support an ailing husband, and was official photographer to the Household Brigade until her death: 'I have photographed all the king's horses and all the king's men, and I am never happier than when I am with my camera among the crack regiments of Britain'. Apart from her military work, she specialized in photographs of royalty and political meetings, and the Gallery owns a representative selection of her work, including important photographs of the Suffragettes.

82

Sir Henry Maximillian ('Max') Beerbohm 1872–1956

(Alexander Bell) Filson Young 1876–1938

Toned bromide print, signed with monogram and inscribed by the photographer on the mount: MAX
BEERBOHM, ESQ; WITH APOLOGIES TO ALL CONCERNED FY, 1916
29.7 × 22.4 (11¾ × 8¾)
Purchased, 1975 (X3767)

The caricaturist and humorist Beerbohm married in 1910 the American actress Florence
Kahn, and thereafter the couple lived for most of their time in Italy, not least because
they were poor and it was cheap. In 1915, however, following the outbreak of war,
Beerbohm felt compelled to return to England, and there he remained until 1919. This
photograph, taken at that time, is conceived as an *hommage à Whistler*, for Beerbohm's
pose, indeed the whole composition, follows closely that painter's *Arrangement in Grey
and Black, No.2: Portrait of Thomas Carlyle* (1872–3; City Art Gallery, Glasgow).
Beerbohm caricatured both artist and sitter in his 'Blue China' (Tate Gallery, London),
published in *Rossetti and His Circle* (1922), but, while one suspects that he had little
time for the egocentric Scots historian (no. 31), Whistler (no. 46), as the first of the late
nineteenth-century dandy-aesthetes, was to some extent a role-model for him.

Whether it was Beerbohm or Young who suggested the parody – the photographer's
inscription implies that it was his idea – the image is the perfect vehicle for Beerbohm,
urbane, aesthetic and gently facetious, and shows the author of the ironical and fantastic
Zuleika Dobson, in the guise of the self-absorbed and deadly serious 'sage of Chelsea'.

Young worked at this time from 124 Ebury Street, London, and despite the evident
distinction of the few known examples of his photographic work – mainly portraits
and topography – is better known as a writer. His first published work, written under
the pseudonym 'X.Ray', was *A Psychic Vigil* (1896), but he also wrote novels, poetry,
and works on art, music, the Navy, motoring, famous trials (including that of Dr Crip-
pen), and a two-volume study of Christopher Columbus. He ended his career as Adviser
on Programmes to the BBC, and his last book was *Shall I Listen? Studies in the Adventure
and Technique of Broadcasting* (1933). His portrait of Beerbohm was published in
Photograms of the Year (1916), plate 11.

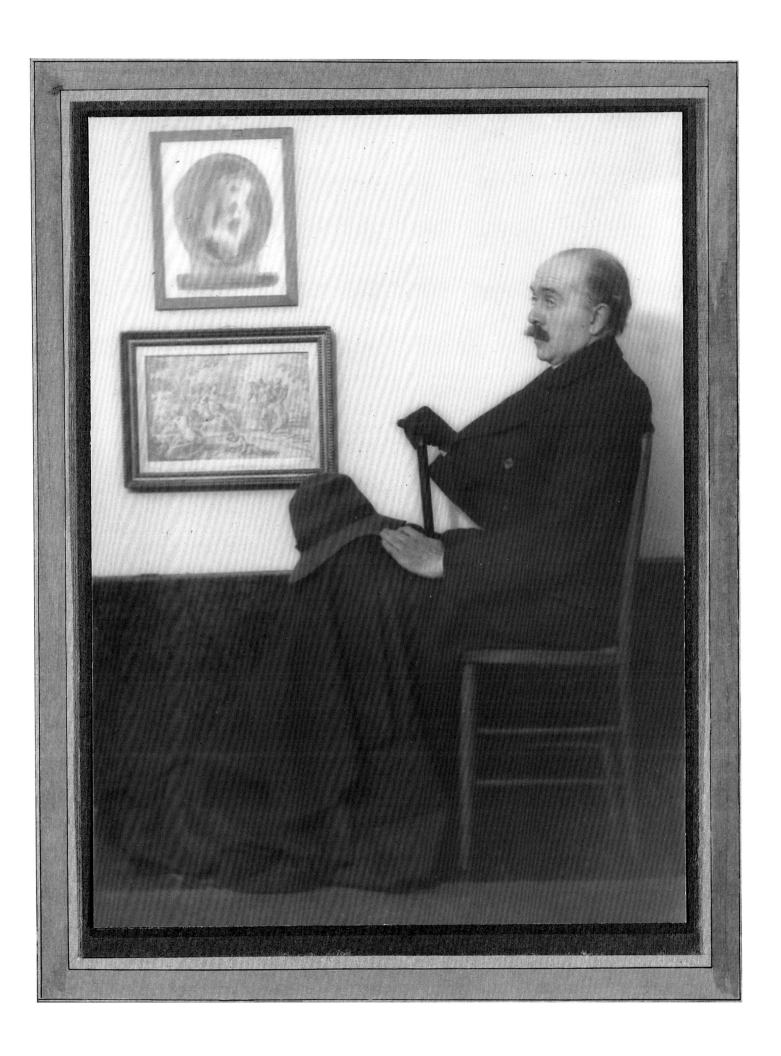

83

Isaac Rosenberg 1890–1918

London Art Studios active *c.*1915

Bromide print on postcard mount, signed and inscribed by the sitter *Kind Regards/Rosenberg/1917*, and
with the studio's blind stamp, *c.*1917
12.8 × 7.8 (5 × 2$\frac{7}{8}$)
Purchased, 1983 (P230)

The son of Jewish Russian *émigrés*, Isaac Rosenberg grew up in Whitechapel, London,
where his father worked as a pedlar and market-trader. Early on he learned to paint
and began to write poetry, and in 1911 another Jewish family paid for him to go to
the Slade School of Art, where he was a contemporary of Mark Gertler. A year later
he published at his own expense *Night and Day*, a collection of his poems, and as a
result received encouragement from the poets Ezra Pound and Gordon Bottomley.
Another volume, *Youth*, appeared in 1915. That year, in opposition to his parents' paci-
fist views, he enlisted in the army, and was killed in action in 1918. As both poet and
painter he was a figure of striking originality. His poems written in the trenches are
experimental in character, starkly realistic and coloured by his urban Jewish background.
A painted self-portrait, richly coloured and emotionally charged, belongs to the Gallery.
As a poet he was slow to gain recognition, and it was not until the publication of the
Collected Works (1937) that his importance was generally accepted.

This modest photographic postcard is of a type that many a soldier would have
given to his family and friends, and is a notably unidealized image of the young Private
and poet who hated Rupert Brooke's 'begloried sonnets' (no. 76).

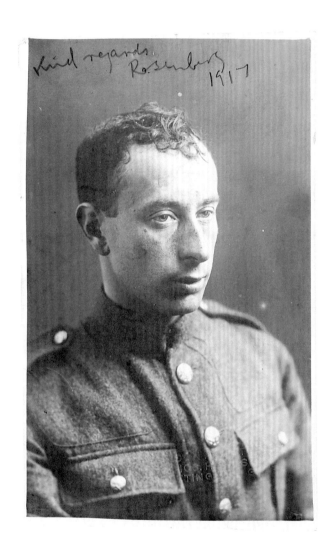

84

Yvonne Gregory, Mrs Bertram Park 1889–1970

Bertram Park 1883–1972

Bromide print, with the photographer's blind stamp, 1919
20.6 × 14.5 (8 × 5¾)
Given by Mrs June Mardall, daughter of the sitter and the photographer, 1977 (X11824)

The photographer Yvonne Gregory (see no. 97) married Bertram Park in 1916, and together they set up in business at 43 Dover Street, London, with the financial backing of Lord Carnarvon, the Egyptologist. Marcus Adams (see no. 110) trained with them and ran their Nursery Studio for children; Paul Tanqueray (see no. 96) also had premises in the same street, as did Hugh Cecil (see no. 103) and Bassano (see Introduction, fig. 1). Park was one of the most successful society photographers of the day. He was an *aficionado* of the soft-focus lens, and specialized in elegant portraits of society beauties posed against dark backgrounds, with the use of flattering back-lighting, influenced by Baron de Meyer (see no. 74).

In this photograph Yvonne Gregory attitudinizes in the 'dazzle' costume which she wore to the Chelsea Arts Club Dazzle Ball held at the Royal Albert Hall in London in 1919, and is posed against a 'dazzle' background. The Ball took its theme from dazzle-painting, a form of sea-camouflage which had been developed by the British during the war. It was intended not to hide ships, but to break up their outline and bewilder the enemy by the use of bold and eccentric designs. It is ironic that after the war it should be adopted by the world of fashion.

85

Nancy Witcher Langhorne, Viscountess Astor 1879–1964

Olive Edis, Mrs E.H. Galsworthy 1876–1955

Platinum print, with the photographer's blind stamp on the mount, 1920
20.1 × 11.4 (7⅞ × 4⅜)
Given by the photographer, 1948 (X339)

A beautiful and impetuous divorcee from Virginia, Nancy Langhorne came to London in 1904 and, rejecting several other suitors, married the immensely rich Waldorf (later 2nd Viscount) Astor. By nature religious, she was converted to Christian Science in 1914, which ever after she preached with missionary zeal. In 1919 her husband, on inheriting the peerage, was forced to vacate his seat in Parliament. She won the ensuing by-election, and was the first woman to take a seat in the Commons. She showed little reverence for proceedings there, and was a frequent interrupter; so much so that on one occasion, when she claimed to have been listening for hours before making her interjection, a member exclaimed: 'Yes, we *heard* you listening!'. This photograph was taken at the Astors' London home, 4 St James's Square, and shows Lady Astor in uncharacteristically reflective mood.

Olive (Mary) Edis, a niece of the architect Sir Robert Edis, took up photography in 1900, and set up her studio at Sheringham in Norfolk. She later had studios in Farnham, Surrey, and Ladbroke Grove, London, and was particularly interested in portraiture, photographing many of the leading figures of her day. In 1919 she toured the battlefields of France and Flanders to record the work of the British Women's Services for the Imperial War Museum (see Introduction, fig. 11). In 1948 she presented some 250 of her photographs – richly-toned platinum prints and autochromes – to the Gallery. See also no. 90.

86

David Herbert Lawrence 1885–1930

Nickolas Muray 1892–1965

Silver print, with the photographer's stamp on the reverse, ?1923
24.1 × 19.4 (9½ × 7⅝)
Purchased, 1982 (P208)

Towards the end of 1919 the novelist D.H. Lawrence scraped together enough money for him and his wife to leave England. He was by nature hyper-sensitive, and though his early novels such as *The White Peacock* (1911) and *Sons and Lovers* (1913) had won him a certain acclaim, he felt acutely the charges of indecency against *The Rainbow* (1915). The rest of his life he spent in wandering. In 1923–5 he was in New York, where *Women in Love* had been privately printed in 1920, and was photographed by the Hungarian-born Muray at his fashionable studio on MacDougal Street in Greenwich Village, for *Vanity Fair*. According to the photographer, he was taken there 'bodily' by Mabel Dodge, heiress and eccentric, and a well-known patroness of the arts. Muray found him

> unkempt; his hair was disheveled [*sic*], as was his attire. The shirt he wore was three sizes larger than he needed, and he looked as if he had borrowed it from a poor uncle. Nor have I ever seen a person more shy . . . There wasn't a single smiling picture, but he wasn't the smiling type.

Muray studied photography and lithography in Budapest, and came to the United States in 1913, where he worked at first as a colour-printer and colour-print processor. He soon however made a name for himself as a leading fashion photographer, and in the 1920s was noted for his portraits of literary personalities. He was one of the great party-givers of the period, a fencing champion and an officer in the Civil Air Patrol, and he must have found Lawrence's brooding presence a shade disconcerting.

189

87

Augustus Edwin John 1878–1961

John Hope-Johnstone 1883–1970

Bromide print, May 1922
10.5 × 8 (4⅛ × 3⅛)
Purchased, 1979 (P134/10)

Augustus John was the best known British painter of the generation after Sickert, and combined in his work virtuoso draughtsmanship with a highly personal use of colour. His genius was for landscapes and portraits, but he was always drawn to large-scale imaginative paintings which were beyond him. Addicted to beautiful women, alcohol and the gipsy life, he was a legendary bohemian, and as early as 1932 T.E. Lawrence described him as 'in ruins'.

In 1911 John took as tutor to his children Romilly and Robin, John Hope-Johnstone, an equally wayward figure who 'was very unfortunate in combining extreme poverty with the most epicurean tastes I have ever known' (Romilly John). He lived by his wits, working for a time as co-editor of *The Gramophone* with Compton Mackenzie, and editor of *The Burlington Magazine*, until sacked by Roger Fry. A brilliant conversationalist, flamboyantly dressed, he was a relentless self-improver, and his interests were omnivorous.

Not surprisingly, Hope-Johnstone parted from the John household after less than a year, absconding with some of John's paintings, but after the war he re-engaged himself as Robin John's philosopher and guide. In 1922 the pair were staying with the writer and refugee from Bloomsbury, Gerald Brenan, at his house at Ugijar in southern Spain, where it was Hope-Johnstone's 'intention to master the art of photography', importing 'several hundred weight of photographic materials'. According to Brenan, 'most of the photos he took with such care and preparation faded away at the end of a few months because he omitted to fix them properly. Even in his photographic work he was negative and self-destructive'.

This delicate but intense head of John was taken in May that year when he was visiting the household in Ugijar, and is from an album of Hope-Johnstone's photographs taken at that time, mainly of Brenan, John and his family. John wrote home that they were 'very bad ones, and he's [Hope-Johnstone] very slow about it, changing his spectacles, losing bits of his machine and tripping over the tripod continually'.

88

Emma Alice Margaret ('Margot') Tennant, Countess of Oxford and Asquith 1864–1945

Howard Instead active *c*.1918–35

Bromide print, 1920s
28.6 × 16.5 (11¼ × 6½)
Purchased, 1983 (AX24999)

The wife of a Prime Minister (no. 57) who possessed 'a modesty amounting to deformity', Margot Asquith was a very different spirit. 'Unteachable and splendid', she was energetic, opinionated, impetuously generous, and a master of the *bon mot*. A passionate idealist, with a crusading passion to right wrongs, she once wrote: 'When I hear nonsense talked it makes me physically ill not to contradict'. It is questionable whether these qualities were entirely welcome in the wife of a Prime Minister, but they made her one of the leading personalities of the day. One of the independent group known as 'the Souls', she was also a writer on a wide range of intellectual and aesthetic themes, as exemplified by her *Lay Sermons* (1927). She also produced volumes of memoirs, including her *Autobiography* (1920), and a novel.

Margot Asquith's features were as idiosyncratic as her personality, and this portrait, though Instead worked in the prevailing soft-focus idiom of the 1920s, conveys the force of both. Seen at full length and from below, as if on stage, she looks down her formidable nose and turns as if to address an unseen audience.

This print is from an album of Instead's work, which mainly comprises portraits of theatrical figures. Little is known of his career, but, according to Cecil Beaton, 'he started life as a painter, but became a photographer instead', making 'delightful Chelsea-ish compositions'. He worked freelance for *Vogue* around 1918–20. His first studio was at 30 Conduit Street, London. He subsequently moved to 5 Vigo Street nearby, and in the 1930s to the Chenil Studios on the King's Road.

89

Eugene Arnold Dolmetsch 1858–1940

Herbert Lambert 1881–1936

Toned bromide print, lettered: *ARNOLD DOLMETSCH, c.1925*
15 × 17.6 (5⅞ × 6⅞)
Given by the photographer's daughter, Mrs Barbara Hardman, 1978 (P108)

Born in France of Bohemian origin, Arnold Dolmetsch trained as a musical-instrument maker with his father, and came to England about 1883. With the encouragement of Sir George Grove (of dictionary fame), he began his investigations into early English instrumental music and the way it was played. This led to the making of lutes, virginals, clavichords, harpsichords, recorders, viols and violins, which became his life's work. In 1925, close to the time of this photograph, he founded at Haslemere, Surrey, where he lived, an annual summer festival of early music. Here he, his family and friends attempted to recreate historically authentic performances, but not for their own sake: 'This music is of absolute and not antiquarian importance; it must be played as the composer intended and on the instruments for which it was written with their correct technique; and through it personal music-making can be restored to the home, from which two centuries of professionalism have divorced it'.

Herbert Lambert worked from 32 Milsom Street, Bath, but also had a studio in Bristol, and at 125 Cheyne Walk, London, where, according to his trade label, he was 'during the early part of each month for the purpose of taking a limited number of camera portraits by appointment'. He was appointed managing director of Elliott & Fry (see no. 54) in 1926. He specialized in portraits of musicians, publishing his *Modern British Composers* in 1923. His book *Studio Portrait Lighting* is dedicated 'To my friend Marcus Adams [see no. 110]. A master of the art herein treated'. This print, which shows Dolmetsch playing one of his own lutes, is part of a collection of Lambert's work donated to the Gallery by his daughter. It shows his own mastery of lighting, and ability to create a harmonious atmosphere which is almost audible. The Holbeinesque lettering is a characteristic touch.

ARNOLD DOLMETSCH

90

James Ramsay MacDonald 1866–1937

Olive Edis, Mrs E.H. Galsworthy 1876–1955

Autochrome, ?1926
21.5 × 16.4 (8½ × 6½)
Given by the photographer, 1948 (X7196)

The illegitimate son of a Scottish farm-girl, MacDonald, who was born in a two-roomed 'but and ben' at Lossiemouth in Morayshire, worked his way up through the Socialist ranks to become the first Labour Prime Minister of this country in 1924. His initial ministry was short-lived, and in 1929 was followed by a two-year term, which was brought to an abrupt end in August 1931 by the country's devastating financial crisis. On the fall of the Labour government, MacDonald, who was an ingenuous and dedicated man, immediately accepted the proffered premiership of a Government of National Unity, thereby alienating his former colleagues, and creating a breach with his party which was never to be healed.

This autochrome was probably taken in 1926, for it shows MacDonald wearing the robes of an LL D. of the University of Wales, an honorary degree which he was awarded in that year. As early as 1912 Olive Edis was using the Lumière autochrome plate, which had been introduced in 1907, and her work in this medium reveals a subtle sense of colour and atmosphere. She also patented her own autochrome viewer, of which there is an example in the Gallery's collection. See also no. 85.

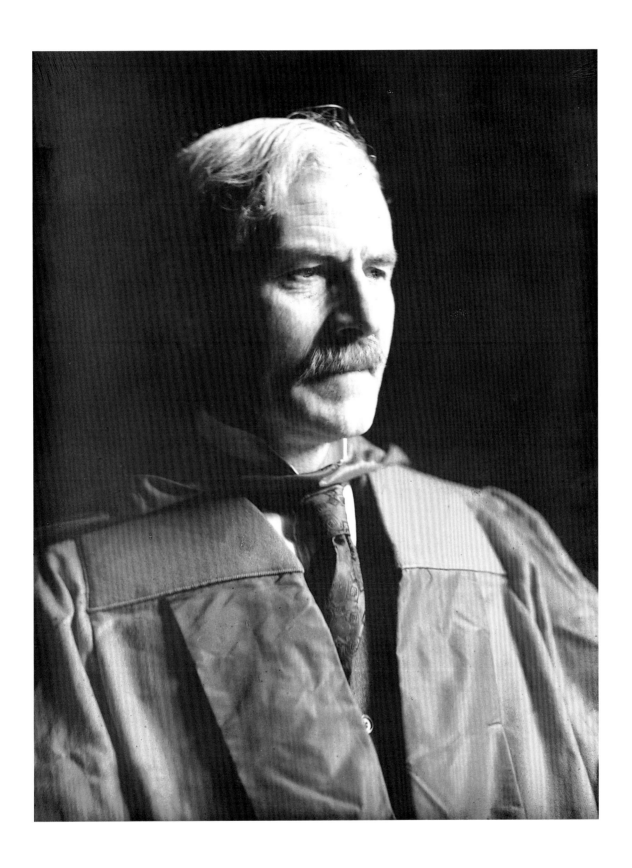

91

Sir William Turner Walton 1902–83

Sir Cecil Beaton 1904–80

Bromide print, with the photographer's stamp on the reverse, 1926
29 × 23.9 ($11\frac{3}{8}$ × $9\frac{3}{8}$)
Purchased, 1978 (P55)

In 1919, while still an undergraduate at Oxford, the composer Walton, a tall, shy boy from Oldham, was taken up by the aesthetes Osbert and Sacheverell Sitwell, who persuaded him to forsake academia, and to pursue the natural bent of his genius: 'If it hadn't been for them, I'd either have ended up like Stanford [the composer, Sir Charles Villiers Stanford], or would have been a clerk in some Midland bank with an interest in music'. He shared his life with them and their poetic sister Edith (no. 92) for the next fourteen years. In 1923 came the first public performance of *Façade*, his witty and satirical setting of Edith's avant-garde poems, written in metres echoing the rhythms of waltzes, polkas and foxtrots. It caused a furore, and from that time Walton was an *enfant terrible*.

The ambitious young photographer Cecil Beaton (no. 94; see also nos. 92 and 115) attended a later performance of *Façade* at the Chenil Galleries in April 1926, but 'felt too restless to settle down. . . . There were too many distractions – arty people moving about and arty people in the outer room talking loud'. Nevertheless, sensing an opportunity, he photographed the young composer at about this time, and included his portrait in his first one-man show (1927). In the introduction to the catalogue Osbert Sitwell praised Beaton as 'a photographic pioneer', adding, 'if the race of mortals were to perish from this earth, and nothing remain of the wreck except a few of Mr. Cecil Beaton's photographs, there is no doubt that those who succeed us would pronounce this past set as one of extraordinary beauty'. With his usual assured sense of design, Beaton sets Walton's angular profile against a 'Cubist' background which the photographer had himself painted, and which he used, with improvised adaptations, in other photographs of this period.

92

Dame Edith Louisa Sitwell 1887–1964

Sir Cecil Beaton 1904–80

Bromide print, 1927
22.5 × 17.6 ($8\frac{7}{8}$ × $4\frac{1}{8}$)
Given by Lawrence Whistler, 1977 (X4082)

In December 1926 Cecil Beaton (no. 94) met the poetess Edith Sitwell for the first time. He found her: 'a tall graceful scarecrow, really quite beautiful with a lovely, bell clear voice and wonderful long white hands'. She was a natural sitter, and the more exaggerated the pose the more she enjoyed it. The next year Beaton travelled to Renishaw Hall in Derbyshire to photograph the whole Sitwell family. They were delighted with the results, Edith writing: 'I simply can't tell you what excitement there is at Renishaw about the marvellous photographs – or what joy and gratitude. We are all, including mother, half off our head with excitement. . . '. This portrait dates from that time, and exemplifies that element of refined fantasy, evocative of past ages, which he brought to his portraits of this dedicated bohemian and her eccentric family.

This print was given to the Gallery by Lawrence Whistler. It had previously belonged to his brother the illustrator and mural-painter Rex, a close friend of both Beaton and the Sitwells, whose own work has affinities with the archaic, aristocratic yet pastoral tone of Beaton's photograph. For Beaton, see also nos. 91 and 115.

93

Sir Henry Malcolm Watts Sargent 1895–1967

Elsie Gordon active 1920s

Bromide print, inscribed on the reverse by the photographer: *Malcolm Sargent –/a brief (v unusual)/*
interval of repose/taken at Llandudno/in 1927; 1927
6.3 × 10.7 (2½ × 4⅛)
Given by Dr Jonathan Harvey, 1984 (x20656)

Sir Henry Wood spotted Malcolm Sargent's talent in 1921, when as pianist, composer
and conductor the young man was organizing concerts in Leicestershire. He invited him
to London to conduct at the Promenade Concert season of 1921, and from that time
his career as a conductor accelerated rapidly. The next decade was a period of unremit-
ting hard work and, indeed, pleasure, for Sargent liked to relax after a concert by dancing
until dawn. It ended with a complete nervous breakdown in 1932, though two years
later he was back at work with renewed vigour.

In his career Sargent conducted many first performances of British works, among
them Walton's (no. 91) *Belshazzar's Feast* (1931) and *Troilus and Cressida* (1954), and
achieved international recognition as an artist, though in England he never fully escaped
charges of superficiality. He won an enduring place, however, in the public's affection,
above all for his conducting of *Messiah*, for his long association with the Promenade
Concerts and the Huddersfield Choral Society, and for his charm and dashing
appearance.

Little is known of Elsie Gordon, an amateur photographer, who in the 1920s mixed
in musical circles, and took numerous snapshots of musicians, either at rehearsal or
relaxing. The Gallery owns some sixty of her prints, including a group of rare photo-
graphs of the pianist and composer Percy Grainger.

94

Sir Cecil Walter Hardy Beaton 1904–80

Curtis Moffat 1887–1949 and *Olivia Wyndham*

Bromide print, signed by both photographers on the original mount, *c*.1928
28.9 × 24 (11⅜ × 9½)
Purchased from the executors of the estate of Sir Cecil Beaton, 1980 (x20034)

In August 1927 Cecil Beaton became a major contributor to *Vogue*, and in November of the same year his first one-man exhibition at the Cooling Galleries on Bond Street established him as a significant photographic figure. With professional recognition came social success for this socially avaricious young man. In 1928 he designed clothes for the Dream of Fair Women Ball at Claridges and the charity matinée *A Pageant of Hyde Park* at Daly's Theatre, and much of his social life and that of his set seems to have revolved around dressing-up. Noël Coward (no. 101) alludes to this in his song 'I've been to a marvellous party' which includes the couplet:

Dear Cecil arrived wearing armour
Some shells and a black feather boa.

In this photograph Beaton's improvised costume anticipates the torn clothes and sexual ambiguity of pop-music stars of the 1980s, and the prevailing tone is of self-dramatizing decadence.

The American photographer and interior designer Moffat worked with Man Ray (see no. 99) in Paris, before opening a studio at 4 Fitzroy Square, London. Beaton thought this high bohemian 'a gentle, quiet, easy-going man with velvet eyes and enormous charm', and his portrait photographs, printed on low-key papers and mounted on coloured papers, 'sensationally original'. For Moffat's assistant Olivia Wyndham, Beaton evidently had less time, for she 'was never mistress of her camera'. See also nos. 91, 92 and 115.

95

John Oliver Havinden 1908–87

Self-portrait

Modern bromide print from the original composition, 1930
25.4 × 20.3 (10 × 8)
Purchased from the photographer, 1987 (P350)

Brother of the designer Ashley Havinden, John Havinden began his photographic career in Australia, before returning to London in 1929, where, with the backing of Madame Yevonde (see no. 106), he set up Gretton Photographs (1930), a studio for commercial and colour photography. Until he abandoned photography in 1938, Havinden produced a considerable volume of advertising work, much of it for Crawford's Agency (of which his brother was a director), for clients such as HMV and Standard Cars. Precise, stark, with a strong feeling for underlying abstract forms, his work parallels in photography the modernist tendency in British art of the period.

This self-portrait is a characteristic blend of the figurative and abstract, in which the German word 'FOTO', is spelled out across Havinden's features, part in modernist sanserif type and part in the form of his spectacles. The allusion is to *Foto-Auge* ('photo-eye'), a book published in Germany in 1929 to mark the Stuttgart 'Film und Foto' exhibition, at which Cecil Beaton (no. 94) was the only British photographer to be exhibited.

96

Gertrude Lawrence (Gertrude Alexandra Dagma Lawrence Klasen, Mrs Richard Stoddart Aldrich) 1898–1952

Paul Tanqueray born 1905

Modern bromide print from the original half-plate negative, 1932
45.7 × 35.6 (18 × 14)
Given by the photographer, 1983 (x29700)

Noël Coward (no. 101) first met the most brilliant of his leading ladies in 1913 when she was a child-performer: 'Her face was far from pretty, but tremendously alive. She was very *mondaine*, carried a handbag with a powder-puff and frequently dabbed her generously turned-up nose. . . . I loved her from then onwards'. Her first great success was in Charlot's revue *London Calling* (1923), written by Coward, and in 1929 he created *Bitter Sweet* with her in mind. They starred together in *Private Lives*, an immediate success on both sides of the Atlantic, and thereafter she spent most of her time in New York. She was appearing triumphantly on Broadway in *The King and I* at the time of her death.

Paul Tanqueray was, like Angus McBean (see no. 116), a pupil of Hugh Cecil (see no. 103), and set up his own studio in London at 139 Kensington High Street in 1924, moving to 8 Dover Street in 1930. He specialized in society and theatrical portraiture, working especially for *Theatre World*. He photographed Gertrude Lawrence against a background of skyscrapers evocative of New York, painted by his studio assistant Ida Davis, and caught both her wit and romantic allure.

97

Sir John Gielgud born 1904

Yvonne Gregory 1889–1970

Bromide print, 20 January 1933
28.8 × 20.6 ($11\frac{1}{4}$ × $8\frac{1}{4}$)
Purchased from Gilbert Adams FRPS, 1980 (P140/31)

Sir John Gielgud made his stage début at the Old Vic in 1921 as the Herald in *Henry V*. The foremost Shakespearian actor of the time, he is equally at home in Chekhov, Wilde or Pinter. Only Hollywood has shown him ill-at-ease. This photograph by Yvonne Gregory (no. 84) records his first great popular success: as Richard II in Miss Gordon Daviot's romantic comedy *Richard of Bordeaux*, which he also directed. This opened at the New Theatre, London, in February 1933, and ran for over a year. Gregory portrays him in costume, and the photograph was taken shortly before the play opened, presumably as part of the advance publicity. She stresses Richard's pride, deploying the fullness of his robes to give an effect of majestic height. Gielgud's performance was evidently more complex. According to the critic of *The Illustrated London News* he built up:

> a living character – courageous, impetuous, stubborn, impractical in his dreaming, well-intentioned, devoted, capable of blind follies and injustices, a man whose conscience is the foe of his office – that has the seeds of inevitable tragedy in his soul.

98

Amy Johnson 1903–41

J. Capstack active 1930s

Toned bromide print, signed on the print by the sitter: *Amy Mollison*, and on the mount
by the photographer; *c.*1933–5
20 × 14.6 ($7\frac{7}{8}$ × $5\frac{3}{4}$)
Purchased, 1982 (X17127)

The intrepid daughter of a Hull herring-importer, Amy Johnson trained as a secretary, but developed a consuming passion for flying. With no more experience than a flight from London to Hull, on 5 May 1930 she set out to fly solo to Australia in a tiny Gipsy Moth. She landed in Port Darwin nineteen days later. Though not a record time, her flight was an astonishing achievement, and aroused universal enthusiasm. She was awarded a CBE, the *Daily Mail* made her a gift of £10,000, and the children of Sydney raised the money for a gold cup. Other record long-distance flights followed: across Siberia to Tokyo (1931), to Cape Town (1932), and, with her husband J.A. Mollison, to New York (1933). She divorced Mollison in 1938, and in 1939 joined the Air Transport Auxiliary. She was lost, presumed dead, over the Thames estuary on 5 January 1941, when ferrying a plane with material for the Air Ministry.

In this portrait of Johnson in flying gear the Blackpool photographer Capstack attempts an effect of film-star glamour. He also photographed her in allegorical vein as a personification of 'Speed'.

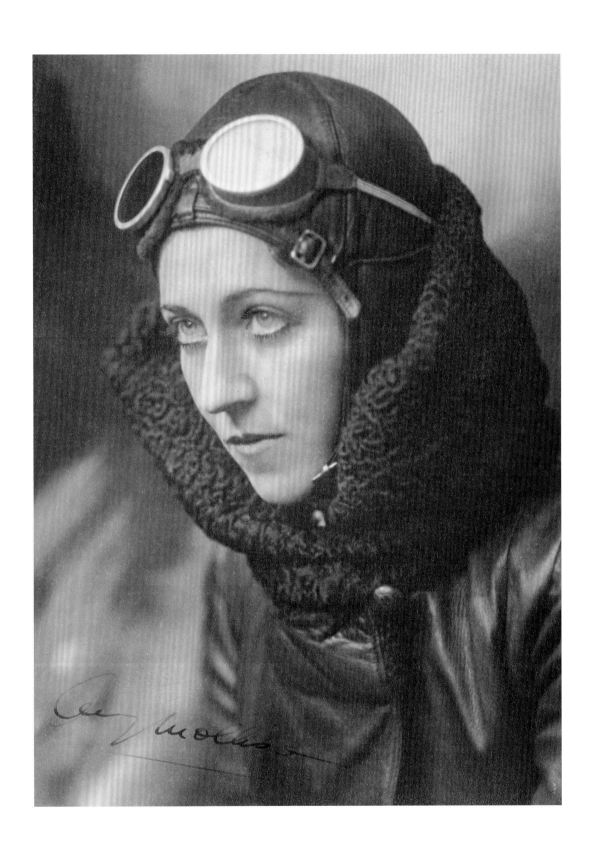

99

Aldous Leonard Huxley 1894–1963

Man Ray 1890–1976

Bromide print, signed and dated by the photographer, and signed on the reverse, with the
photographer's stamp, 1934
29.5 × 23.5 ($11\frac{5}{8} × 9\frac{1}{4}$)
Purchased, 1988 (P359)

Of formidable intellectual descent – he was the son of the writer Leonard Huxley, grandson of T.H. Huxley (no. 54), great-grandson of Dr Thomas Arnold, and nephew of Mrs Humphrey Ward (no. 50) – Aldous Huxley, while still an undergraduate of Balliol College, Oxford, was taken up by Philip Morrell and his wife Lady Ottoline. At their home, Garsington Manor, this virtually blind young man was introduced to the up-and-coming writers and artists of the day. In 1921 he published his first novel *Crome Yellow*, to an extent based on his experiences with the Morrells, the first of a succession which were to make him something of a hero with the young. *Point Counter Point* (1928) was a best-seller in England and America, and his utopian fantasy *Brave New World* appeared in 1932. In 1938 he settled in America, where his eye-sight improved and he published *The Art of Seeing* (1942). His later interest in psychedelic drugs such as LSD led to *The Doors of Perception* (1954), which again brought him a cult following.

The American Man Ray (born Emmanuel Rudnitsky in Philadelphia) was one of the century's leading experimental photographers. He lived for much of his career as an *émigré* in Paris, and there photographed many of the leading writers and artists of the day. He was one of the first photographers to reject 'soft focus', and, under the influence of Dadaism, laid great stress on spontaneity. According to a contemporary, Huxley was so tall that he had to 'fold himself and his legs, like some gigantic grasshopper, into a chair', and Man Ray, in this otherwise simple portrait, makes something of this effect.

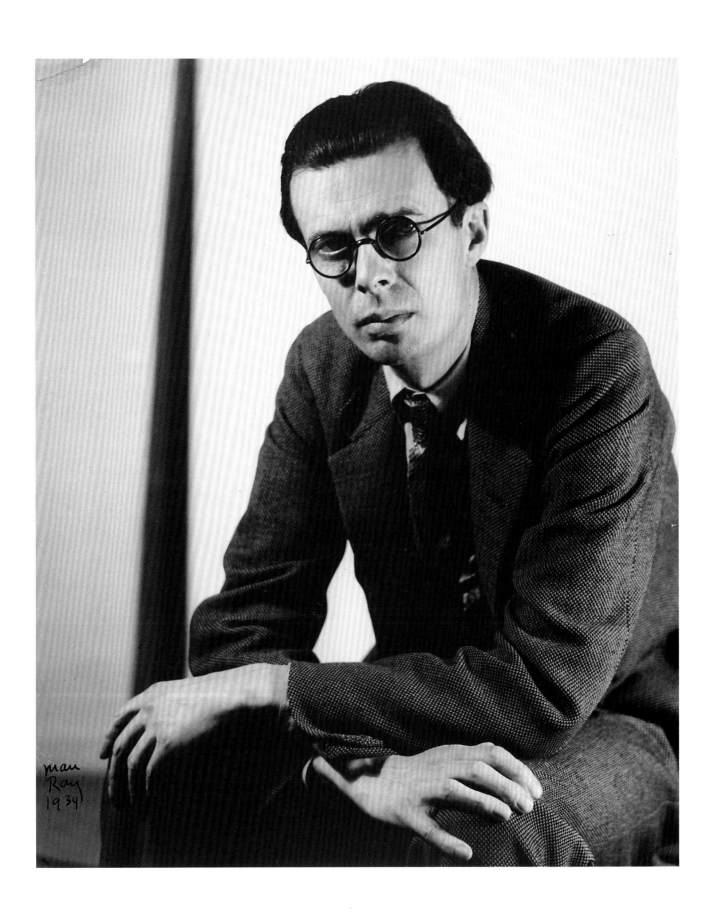

man
Ray
1934

100

Ben Nicholson 1894–1982

Humphrey Spender born 1910

Bromide print, *c.*1935
20.3 × 16.2 (8 × 6⅜)
Purchased from the photographer, 1977 (P42)

Throughout his life Ben Nicholson, the son of the painter and graphic artist Sir William Nicholson, was fascinated, both as painter and sculptor, by the artistic possibilities of still-life. The 1930s were a period of exploration and experimentation for him, as his paintings edged towards sculpture: towards abstract forms and textured surfaces. In 1932 he visited the Paris studios of Brancusi, Braque and Arp, with his future wife, the sculptor Barbara Hepworth. In 1934, while a member of Unit One, which he had founded with Paul Nash (no. 113), he met Piet Mondrian, and produced the first of his series of 'white reliefs', with which his name is especially associated. In these he created a form of abstracted still-life of great purity and harmoniousness, in which basic geometrical shapes are united in subtly modulated planes.

Humphrey Spender, brother of the writer Stephen Spender, made his reputation in the 1930s working as a photo-journalist for *The Daily Mirror* and *Picture Post*, and as official photographer to Mass Observation (see no. 112). He photographed Nicholson at The Mall Studios in Hampstead in this period, though in a style which is the antithesis of reportage. His portrait is, like Nicholson's own work, a painstakingly contrived study in formal and spatial relationships, in which the artist appears in a moment's ambiguity to become part of one of his own compositions.

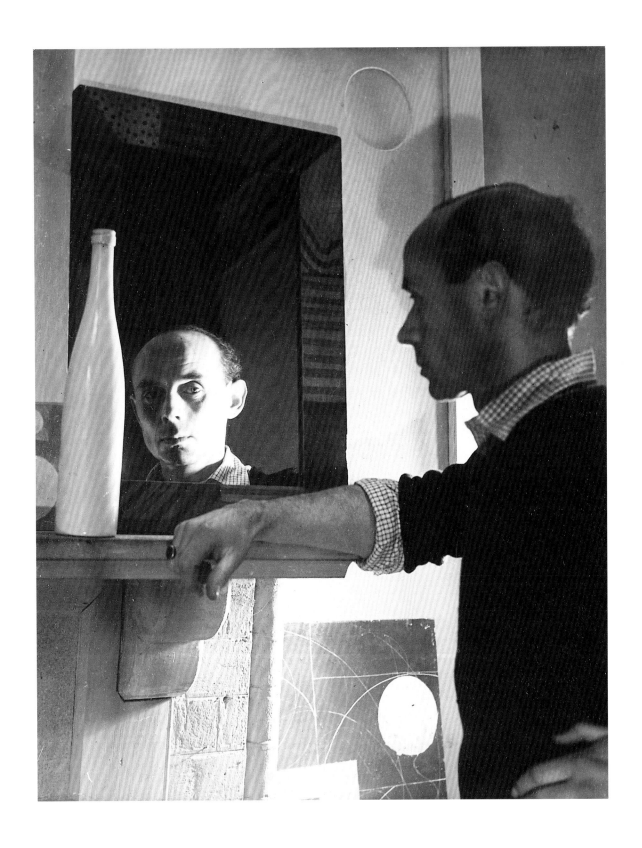

IOI

Sir Noël Peirce Coward 1899–1973

Horst P. Horst born 1906

Modern platinum/palladium print, signed by the photographer on the front
and reverse of the mount, summer 1935
45.3 × 35.4 (17$\frac{7}{8}$ × 13$\frac{7}{8}$)
Given by the photographer, 1989 (P419)

Noël Coward, 'the Master', was in every sense a man of the professional theatre, an actor, playwright, lyricist, composer and producer, who began his career aged twelve, playing Prince Mussel in *The Goldfish*, as one of a 'star cast of wonder children'. In 1924 *The Vortex*, his controversial play about drug addiction, took London and New York by storm. There followed a string of successes – *Hay Fever* (1925), *This Year of Grace* (1928), *Bitter Sweet* (1929) and *Private Lives* (1933) – which established Coward as, in Arnold Bennett's phrase, 'the Congreve of our day'. As a song-writer he could be touching and witty by turns, equally at home with the sentiments of 'I'll see you again' as with 'Mad Dogs and Englishmen'. As a performer, whether of the spoken word or song, on the stage, in cabaret, or, latterly, on television, his trademarks were staccato speech, perfect diction and timing, and a brittle wit.

The American photographer Horst was born in Germany; he studied architecture in Hamburg, and with Le Corbusier in Paris. As a photographer he was the protégé of Hoyningen-Huene in the *Vogue* studios in Paris (1932–5), and since 1935 has worked with *Vogue* in New York. Between 1952 and 1970 the Horst Studio was on East 55th Street. He is known above all as a fashion photographer, but during the 1930s produced a series of portraits, which are distinguished, like Coward himself, for their perfectionist pursuit of style. Horst first met Coward in Paris on a summer morning in 1935, after an all-night session at *Vogue*:

> We talked and sat and had a drink, and I asked if I could photograph him (it was the time of *Private Lives*). The next day he came to the studio, immaculately dressed. I started to photograph him and had to tell him, 'Don't pose so much. Look at me'. Actors! Theater people always know what the best angle is and I wanted to get him out of that.

The next year he photographed Coward again, this time in New York with Gertrude Lawrence (no. 96), on the set of Coward's *Tonight at 8.30*.

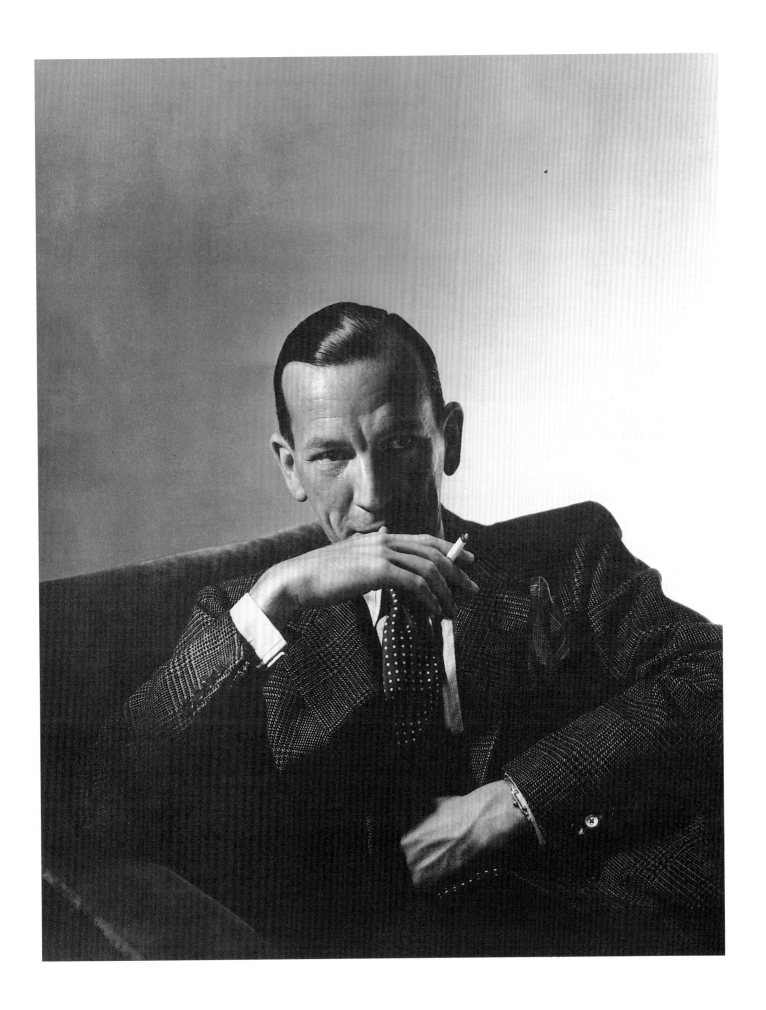

102

Bessie Wallis Warfield, Duchess of Windsor 1896–1986

Dorothy Wilding Studio 1893–1976

Bromide print, 1935
29.1 × 20.2 (11⅜ × 7⅞)
Given by Mrs Susan Morton, the photographer's sister, 1976 (X25936)

When George V died on 20 January 1936 his son Edward VIII (no. 103) came to the throne with the firm hope that he could make Wallis Warfield his queen. Born in Baltimore, Maryland, an early marriage ended in divorce, and she then married an Anglo-American Ernest Simpson with a shipping business in England. He brought her to London, where her good looks, vivacity and stylishness won her a place in society, and the love of the Prince of Wales. Her husband resigned himself to a divorce, and a decree nisi was granted in October 1936. But the Prime Minister Baldwin felt that a marriage between the King and a divorcee would be impossible, and Edward, faced with a choice between the throne and Mrs Simpson, chose 'the woman I love'. He abdicated on 11 December, and the couple were married in France in June the following year. As Duke and Duchess of Windsor they lived for the rest of their lives in almost permanent exile in France – the Duchess was ostracized in England – as part of the international set, and dedicated exponents of 'the Windsor style'.

Dorothy Wilding was the most successful woman photographer of her day with studios in Bond Street, London (from 1924) and New York (from 1937), and her work is elegant and flattering. In her autobiography, appropriately entitled *In Pursuit of Perfection* (1958), she recalls that this photograph was taken when she was away from her studio 'gardening in my little country cottage at Petersham. . . . there are times when you have to let go to keep yourself fresh and at the top of your form'. The photograph was actually taken by her assistant Marion Parham who 'was like salt to my egg and butter to my bread'. When 'the four o'clock appointment – Mrs Simpson' turned up at the studio accompanied by the Prince of Wales she initially caused great consternation, but Parham was soon 'on the job'. The Prince was ordered to bring the Cairn terrier from the car, 'and, dutifully, he did so'. Ironically, Dorothy Wilding was chosen as the first woman royal photographer – for the coronation of George VI in 1937. This print is an unretouched proof.

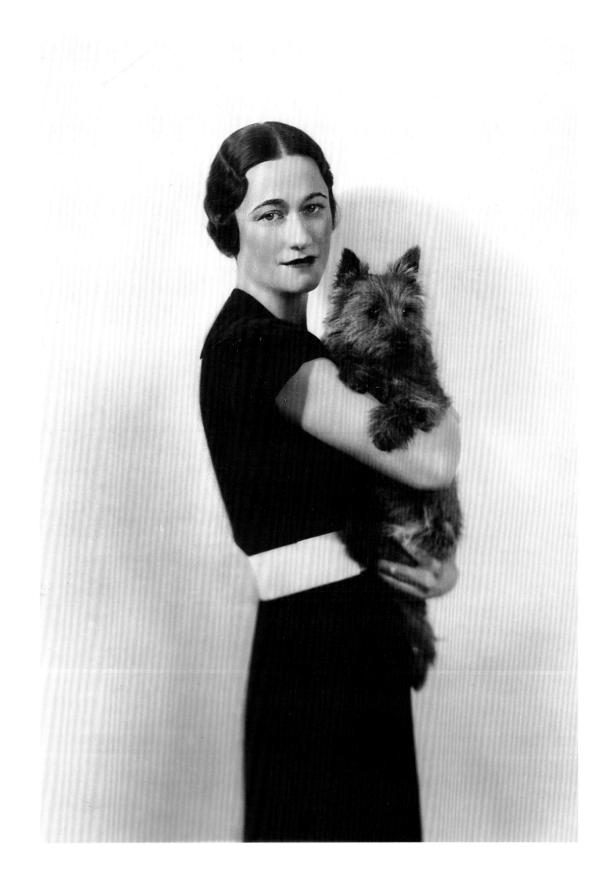

103

Edward, Duke of Windsor 1894–1972

Hugh Cecil born 1889; active 1912–40

Toned bromide print, with the photographer's imprint, 1936
37.5 × 29.8 (14¾ × 11¾)
Purchased, 1979 (P136)

Good-looking, charming, an intrepid sportsman, Edward VIII, as Prince of Wales, was the object of almost universal adulation, dubbed 'the world's most eligible bachelor'. He had however a more sensitive side. This found its most positive expression in a concern for social causes and the poor, but at other times could make him appear spoiled or rootless. A series of affairs with married women ended in his *grande passion*, Mrs Simpson (no. 102). His decision to marry her, in the face of establishment opposition, led to his abdication, only eleven months after he had succeeded to the throne.

Hugh Cecil (born Hugh Cecil Saunders) was, according to Cecil Beaton, a 'retiring and elusive personality' who became interested in photography while at Cambridge. He first set up as a professional portrait photographer in Victoria Street, London, in 1912, moving to the more fashionable Grafton Street in 1923, where his studio was decorated in the most opulent style. Though influenced by de Meyer (see no. 74), his use of light was unique: 'I believe in swamping my studio with light to secure the utmost luminosity in all directions and in this respect follow the best traditions of cinema lighting'; however, for his sitter's face he used a softer, entirely reflected, light. In 1936 Cecil was chosen to take this, the official accession photograph of Edward VIII, which was used as the basis for the short-lived issues of postage stamps. He kept his studio going until the outbreak of war, but increasingly turned his attention to his 'inventions', one of which was the 'photomaton', a forerunner of the photo-booth.

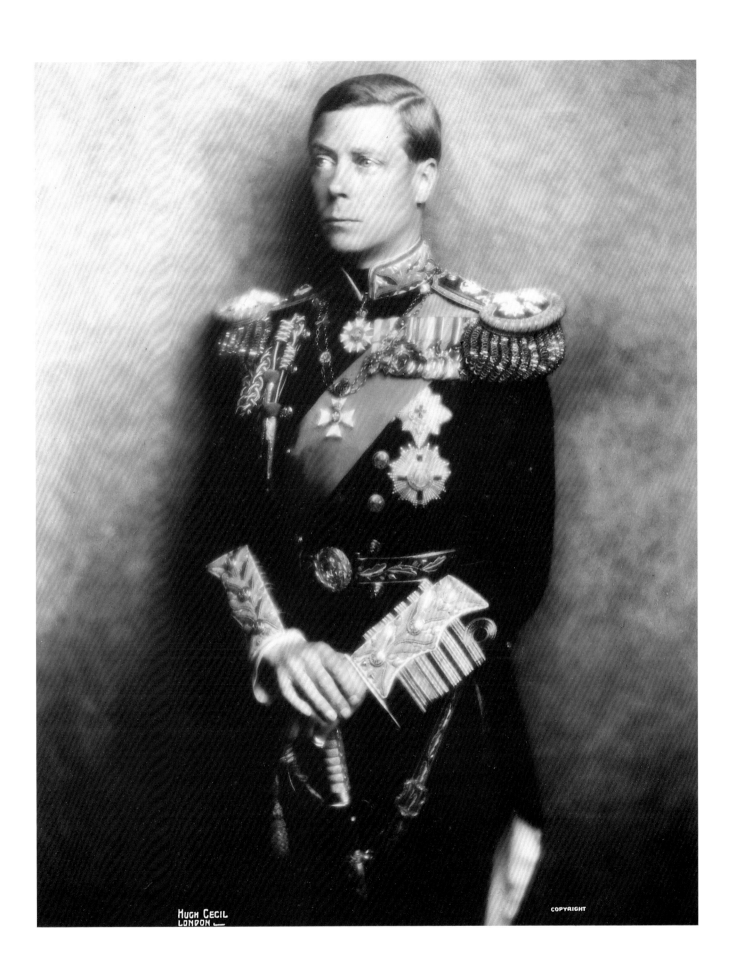

104

Patrick Maynard Stuart Blackett, Baron Blackett 1897–1974

Lucia Moholy FRPS AICA 1894–1989

Modern bromide print, signed on the reverse, 1936
40.1 × 31 ($15\frac{3}{4}$ × $11\frac{3}{4}$)
Purchased from the photographer, 1979 (P127)

One of the greatest scientists of the century, Blackett's influence extended far beyond the laboratory into military strategy and national politics. In his early career he worked with Lord Rutherford in Cambridge on atomic theory, and photographed the first visible evidence of the disintegration of the nitrogen atom. From 1935 he served on the committee formed to advise on defence which pressed for the development of radar, and was director of naval operational research during the war. His dissentient views on the uses of atomic energy, expressed in *The Military and Political Consequences of Atomic Energy* in 1948, the year he won the Nobel Prize for physics, led to his expulsion from government circles, until in 1964 Harold Wilson appointed him scientific adviser to his newly created Ministry of Technology, with the aim of creating for the first time a scientific and technological policy for the country. At his insistence support for the computer industry was made a priority.

Born Lucia Schulz in Prague, Lucia Moholy was married in the 1920s to the Hungarian painter and photographer László Moholy-Nagy, and created with him the first experimental photograms. She moved to London in 1934, where she worked as freelance photographer and lecturer, and produced a series of portraits which are remarkable as character-readings. They are generally close-ups, unaffected in style, informal, with a minimal use of props. Blackett was a powerful, dominant personality, and much of his nervous energy and impatience is conveyed by his concentrated stare, directed away from the camera, and the urgency with which he seems to draw on his cigarette. In 1939 Lucia Moholy published with the newly-founded Penguin Books *A Hundred Years of Photography*, the first history of photography in English.

105

Dorothy Mary Crowfoot Hodgkin born 1910

Ramsey & Muspratt active *c*.1930–80

Bromide print, with the photographers' imprint on the reverse of the mount, *c*.1937
37.8 × 30.1 (9$\frac{7}{8}$ × 7$\frac{7}{8}$)
Given by Mrs Jane Burch, daughter of Lettice Ramsey, 1988 (P363/13)

In the 1940s Dorothy Hodgkin carried out pioneering work on the structure of penicillin, and in 1964 was awarded the Nobel Prize for chemistry for her work on the structure of Vitamin B^{12}. In 1969 she established the chemical structure of insulin, and continues to work on its description. In 1965 she was admitted to the Order of Merit, only the second woman after Florence Nightingale (no. 17) to receive this honour. In addition to her scientific work, she has been a prominent worker for international peace and understanding.

The Cambridge firm of Ramsey & Muspratt was founded by Lettice Ramsey (1898–1985) and Helen Muspratt (born 1907) in about 1930. According to Ramsey 'She [Muspratt] had the know-how, I had the connections'. From their studio came a succession of unaffected portraits of the intellectual and literary luminaries of Cambridge of the pre-war years, 'a unique chronicle of youth with its eye on futurity'. Muspratt extended the business to Oxford in 1937, while Ramsey stayed on to become a notable Cambridge character. This photograph is one of a group of prints donated to the Gallery by Lettice Ramsey's daughter. It was taken in the mid-1930s, shortly before the sitter's marriage to Thomas Hodgkin, writer on African affairs.

106

Louis Francis Albert Victor Nicholas Mountbatten, 1st Earl Mountbatten of Burma 1900–79

Madame Yevonde 1893–1975

Vivex print, signed by the photographer, *c*.1937
48 × 32.5 ($18\frac{7}{8} \times 12\frac{3}{4}$)
Given by the photographer, 1971 (X26400)

The great-grandson of Queen Victoria and the uncle of Prince Philip, Lord Mountbatten enjoyed a meteoric naval career, which took him from midshipman at Jutland in 1916 to First Sea Lord in 1955, and included the legendary command of HMS *Kelly*, and Supreme Command of the Far East during the Second World War. In 1947 he was appointed by the Attlee government to supervise the transfer of power in India from the British Raj, and was the last Viceroy and the first Governor-General of the new dominion. He was assassinated by Irish terrorists. A patrician figure, with considerable personal magnetism, he was handsome, courageous, possessed of a powerful analytic intelligence, intensely ambitious and excessively vain. Many of these qualities are conveyed by this photograph, which shows him, against a starry background, in the robes of the Royal Victorian Order. Mountbatten had been appointed naval ADC to Edward VIII (no. 103) in 1936, and in February 1937 the new king George VI chose him for the same post, appointing him at the same time GCVO.

Madame Yevonde (Yevonde Cumbers), who was married to the playwright Edgar Middleton, opened her first studio in 1914 at 92 Victoria Street, London, just before the outbreak of the First World War. She was an energetic exponent of the cause of women photographers. In 1933 she moved to Berkeley Square, and, unlike many of her contemporaries, enthusiastically embraced colour photography – notably the Vivex carbro colour process – which she insisted should be treated 'with proper respect'. In her autobiography *In Camera* (1940) she recalls her reaction: 'Hurrah, we are in for exciting times – red hair, uniforms, exquisite complexions and coloured finger-nails at last come into their own'. She had a vivid imagination, and her work ranges from the stylish and chic, through the ruritanian to the surreal, as exemplified in her series of 'Goddesses'. This print is one of a collection of her work donated by her to the Gallery.

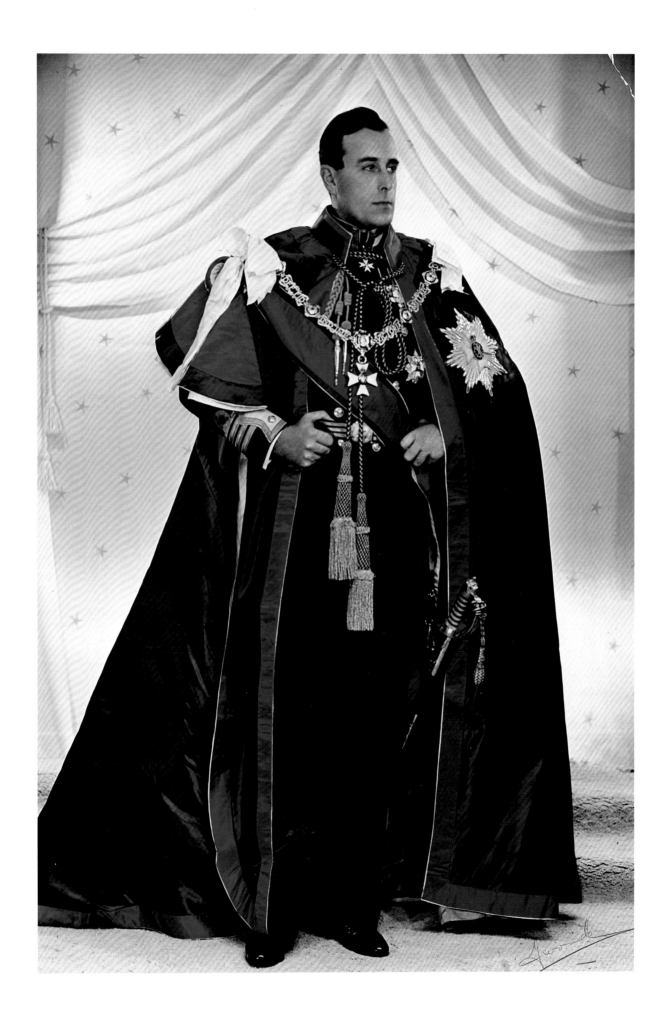

107

Christopher William Bradshaw Isherwood 1904–1986 and Wystan Hugh Auden 1907–73

Louise Dahl-Wolfe 1895–1989

Toned bromide print, 1938
25×20.6 ($18\frac{7}{8} \times 12\frac{3}{4}$)
Given by the Trustees of the Britten Estate, 1981 (X15194)

Christopher Isherwood and W.H. Auden first met at preparatory school in Surrey, and became lifelong friends, literary collaborators, and, as Stephen Spender writes, 'intermittently' lovers. In 1937 Auden was in Spain, where he had volunteered to drive an ambulance for the Republican side in the civil war, but in the following year from January to July he and Isherwood travelled together in China to report on the Sino-Japanese war. Jointly they produced *Journey to a War* (1939), in which their sympathy for the occupied Chinese is fully expressed both in prose and in some of Auden's greatest poetry. The two returned from China by way of America, and this detour changed their lives, for it was then that they decided to leave England and live in America.

It was on that visit, in the summer of 1938, the year before their removal to New York and the publication of Isherwood's *Goodbye to Berlin*, that they were photographed in Central Park by the American photographer Louise Dahl-Wolfe. Though she is best known for her fashion photography which rivals that of Beaton, Horst or Avedon, she has also produced a significant body of portraiture, and has written:

> It is easy to learn the technique of the camera by oneself, but by working in design I learned the principles of good design and composition. Drawing from the nudes in life class made me aware of the grace and flow of line, body movements, and the differences in the way a male poses from that of a female.

This print belonged to the composer Benjamin Britten (no. 120).

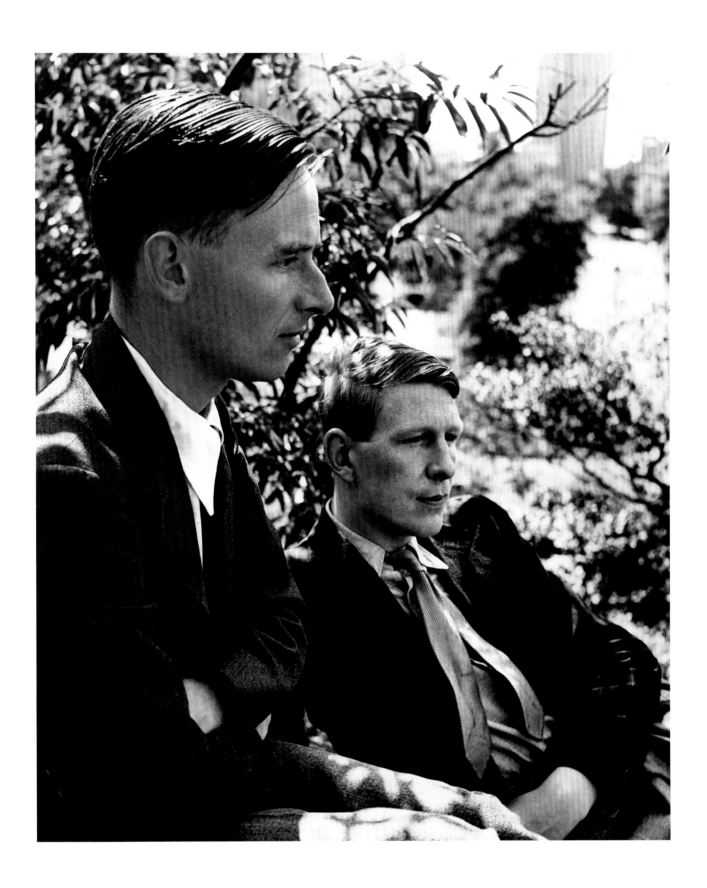

108

George Douglas Howard Cole 1889–1959 and his wife Dame Margaret Isabel Postgate Cole 1893–1980

Howard Coster 1885–1959

Modern bromide print from the original half-plate negative, 1938
38.4 × 24.8 ($15\frac{1}{8}$ × $9\frac{3}{4}$)
Given by the Central Office of Information, 1974 (x10859)

Although he never played a part in parliamentary politics, the 'dark, dynamic presence' of G.D.H. Cole, author of *The World of Labour* (1913), was one of the moving spirits of British Socialism for fifty years. In 1918 he married a colleague from the Fabian Research Department, Margaret Postgate, and the couple were united in the Socialist cause, though always took pains to point out that they were not a 'partnership' on the lines of Beatrice and Sidney Webb. Together they published *The Intelligent Man's Review of Europe To-day* (1933), *Condition of Britain* (1937), and no less than twenty-nine detective stories. Independently Cole was a prolific writer producing a stream of books on social theory and labour history, and an inspiring lecturer, who, as Professor of Social and Political Theory at Oxford became the doyen of PPE (Politics, Philosophy and Economics). According to his wife he was a 'strong Tory in everything but politics'.

Howard Coster, self-styled 'Photographer of Men', opened his first London studio off the Strand in 1926, working first for *The Bookman* and then *The Bystander*. He photographed most of the leading (predominantly) male figures of the day, and the Gallery owns 8,000 of his original negatives as well as many vintage prints. This photograph was taken at the Coles' bookish house in Hendon in 1938. The armchairs are covered in appropriately Socialist fabrics designed by William Morris.

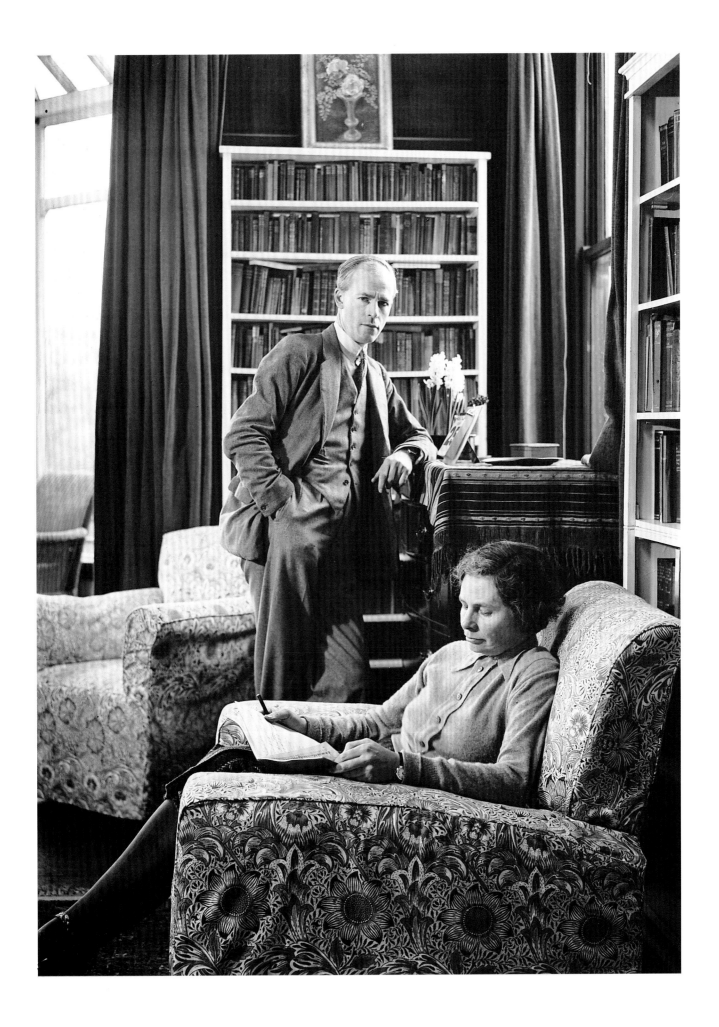

109

Edris Albert ('Eddie') Hapgood 1908–73

Fred Daniels 1892–1959

Bromide print, 1939
41.2 × 30.4 (16¼ × 12)
Purchased from Mrs Nancy Eckart, the photographer's widow, 1988 (P385)

The England soccer full-back Eddie Hapgood, the outstanding defensive player of his day, joined Arsenal Football Club, one of the great professional teams in Great Britain, at the age of nineteen. Between 1927 and 1944 he played 396 times for Arsenal's first team; he won five Football League championship medals and two Football Association Cup winner's medals. He played for England 43 times (including 13 war-time international competitions), captaining his team on 34 occasions. When his playing days were over he managed the Blackburn and Watford soccer clubs.

Fred Daniels was a film-stills photographer at Elstree Studios, and later at the Pinewood and Denham studios, where he did much work for the collaborative team of director Michael Powell and screenplay writer Emeric Pressburger, on such films as *49th Parallel* (1941), *The Life and Death of Colonel Blimp* (1943) and *Black Narcissus* (1947). This portrait was taken in connection with Hapgood's role in the film *The Arsenal Stadium Mystery* (1939), directed by Thorold Dickinson.

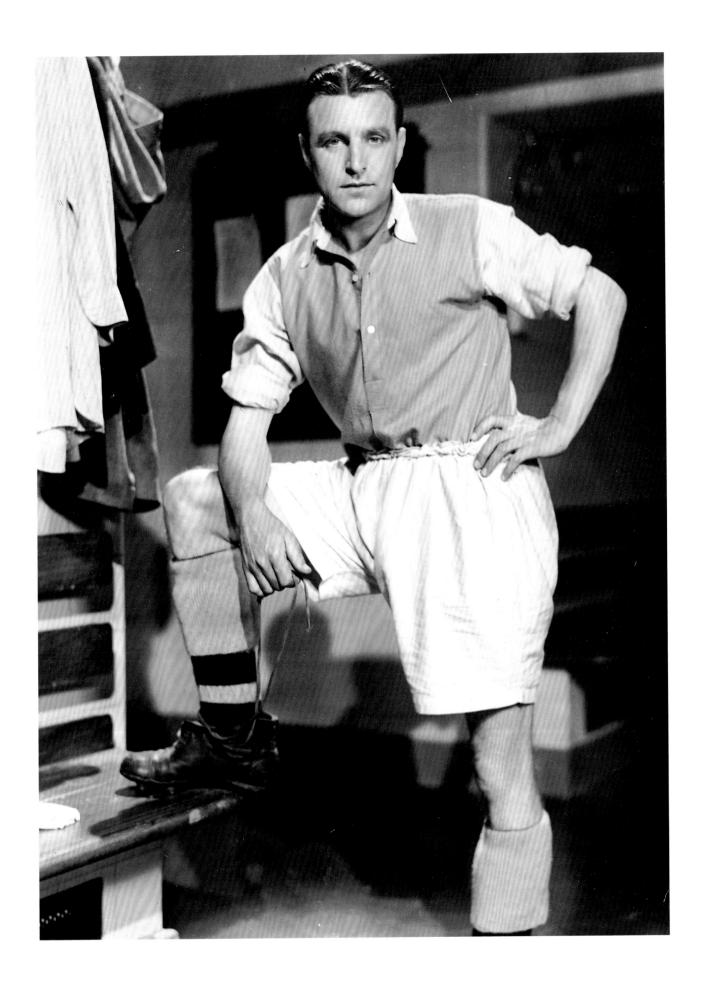

110

George VI 1895–1952 and his Family

Marcus Adams 1879–1959

Toned bromide print, 1939
34.9 × 26 (14 × 10¼)
Purchased from Gilbert Adams FRPS, the photographer's son, 1980 (P140/13)

The sitters are (left to right): Her Majesty The Queen born 1926, when Princess Elizabeth; George VI; Queen Elizabeth, later Queen Elizabeth The Queen Mother born 1900; Princess Margaret, later Countess of Snowdon born 1930.

The shy and sensitive younger brother of Edward VIII (no. 103), George VI had been prepared from birth for a life of public service, but not for the throne. Undoubtedly the abdication of his brother was both a shock and a blow to him, and he came to the throne a man who had 'never seen a State Paper'. The whole of his reign was over-shadowed by the Second World War, and the after-effects of it, and he brought to the monarchy at a crucial time innate good sense, great courage, and an unswerving sense of duty. In this he was supported by his wife and children, and the Royal Family became in the war years a powerful symbol of national unity and stability.

Marcus Adams first trained as an artist, but soon turned to photography, serving his apprenticeship with his father Walton Adams (see no. 78). In 1919 he was invited by Bertram Park (see no. 84) to join his studio in Dover Street, London. There he specialized in child photography, which Park found uncongenial, creating the Nursery Studio. All his work, whether of children or adults, proclaims his perfectionism, and is characterized by a feeling of harmonious informality. This royal group, taken at Buckingham Palace shortly before the outbreak of war, posed considerable technical problems for Adams. It had to be photographed with a very wide aperture, which put the background out of focus. He therefore took a second photograph of the background alone, bleached out the background in the first negative, bound the two negatives together, and printed from his double negative. The recalcitrant corgi Dookie was lured into the composition with a biscuit placed on the king's shoe. According to Adams, 'It took a day to do the job. Reproductions of this picture ran into millions'.

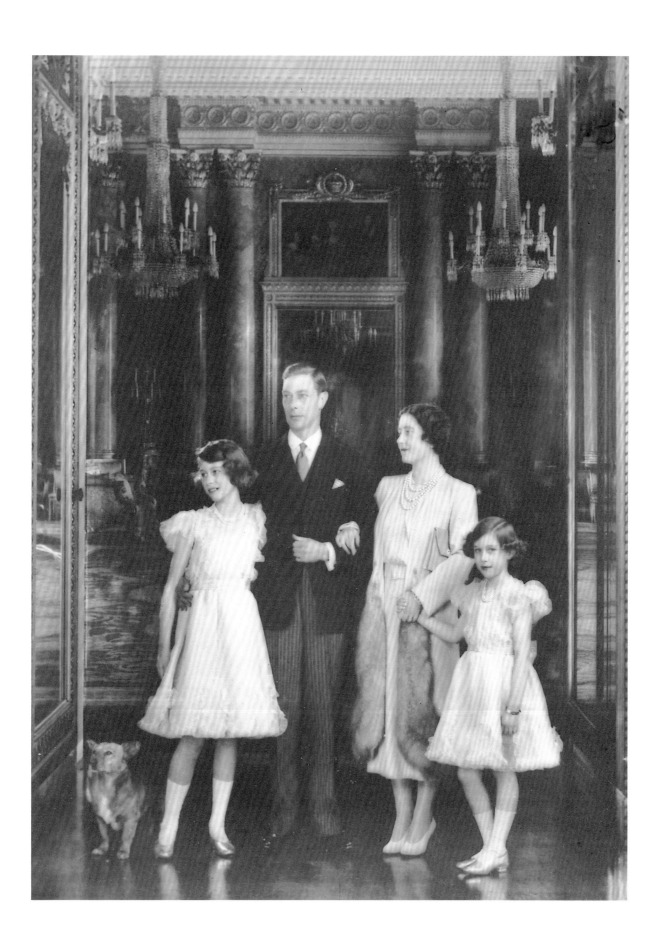

III

Sir Winston Leonard Spencer Churchill 1874–1965

Walter Stoneman 1876–1958

Bromide print, 1 April 1941, 3 p.m.
27.5 × 20.9 (10⅞ × 8¼)
Given by the photographer, 1942 (X6140)

From Omdurman and the Boer War to his state funeral in 1965, Winston Churchill's life is virtually synonymous with the major events in modern British history. The son of Lord Randolph Churchill, he naturally gravitated to politics, after brief but eventful episodes as a soldier and then as a journalist, and for the next fifty years was one of the dominant figures in the House of Commons. A vociferous and eloquent enemy of appeasement, he succeeded Chamberlain as Prime Minister in 1940, and became Britain's leader and inspiration in her 'darkest hour'.

Walter Stoneman took up photography in the 1890s and was still working at his studio in Baker Street, London, at the time of his death. As chief photographer and eventually chairman of J. Russell & Sons Ltd, photographers to the Gallery's National Photographic Record (see Introduction), he photographed some 7,000 distinguished sitters on the Gallery's behalf. Stoneman styled himself 'the Man's Photographer', explaining that, 'Women do not make beautiful photographs. Men have more character in their faces', and was himself something of a character. His work for the Record – mainly head-and-shoulders portraits taken in the studio – rarely goes beyond the documentary, but this portrait of Churchill at three-quarter-length in the historic surroundings of the Cabinet Room at 10 Downing Street, shows Stoneman rising for once above the mediocre, his latent talent stirred by a man who was, to use Churchill's own phrase, 'walking with destiny'. This photograph was not commissioned as part of the National Photographic Record but presented to the Gallery by Stoneman. Sensing its historical significance, he recorded not just the date but the hour it was taken.

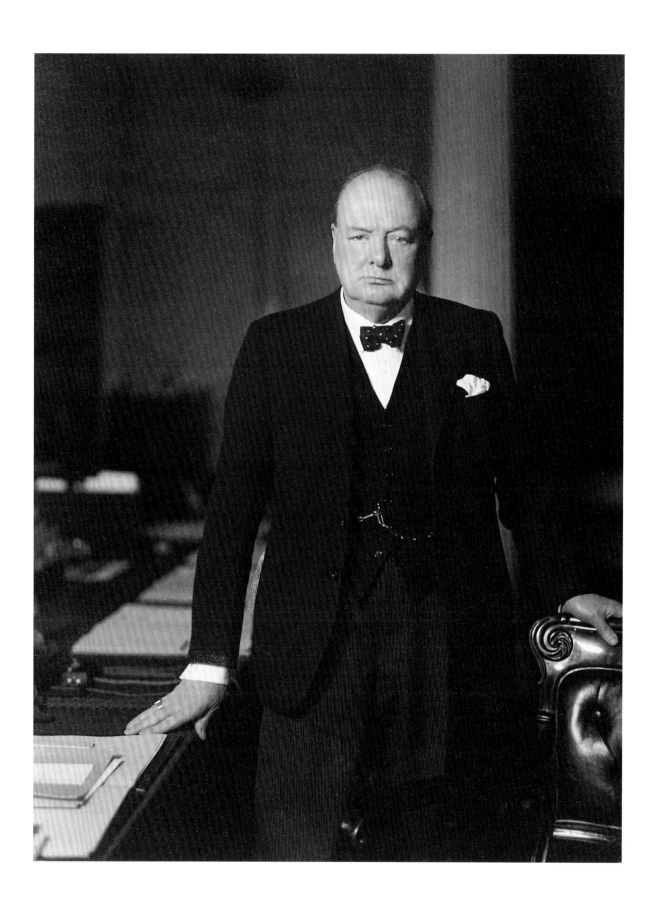

112

Humphrey Jennings 1907–50

Lee Miller 1907–77

Bromide print, *c*.1942
39 × 37.1 (15$\frac{3}{8}$ × 14$\frac{5}{8}$)
Purchased from Miss Charlotte Jennings, the sitter's daughter, 1980 (P156)

One who 'survived the theatre and English literature at Cambridge', Jennings seems very much the 1930s intellectual dilettante, dabbling in poetry, radical politics, theatre design and painting. In 1936, with Roland Penrose and André Breton, he set up the International Surrealist Exhibition in London, and in the following year helped to found Mass Observation, an organization dedicated to exploring the unconscious collective life of England, researching such subjects as the 'shouts and gestures of motorists' and the 'anthropology of football pools'. But it is as a maker of short documentary films that he is best remembered, first working for the GPO Film Unit in the early 1930s, and later the Crown Film Unit. The war acted as a catalyst on his talent, and in films such as *London Can Take It* (1940), *Listen to Britain* (1942), *A Diary for Timothy* (1944–5), but above all *Fires Were Started* (1943), he evolved a symbolic film language which was both popular and extraordinarily powerful.

The beautiful American Lee Miller came to London in 1937 with an impeccable pedigree. In New York she had modelled for Steichen (see no. 77); in Paris she was the assistant and mistress of Man Ray (see no. 99), and modelled for Hoyningen-Huene and Horst (see no. 101); with her brother she had her own photographic studio in New York, numbering among its clients *Vogue*, Helena Rubenstein and Saks of Fifth Avenue. Between 1940 and 1945 she was head of *Vogue*'s London studio, and took many of her most distinguished photographs as its war correspondent in France, Germany and Russia. In 1947 she married the painter and art critic Roland Penrose.

This portrait, which appeared in *Vogue* in 1942 is a typically sophisticated arrangement of light and shade, of velvety textures, all treated with a cool sensuousness.

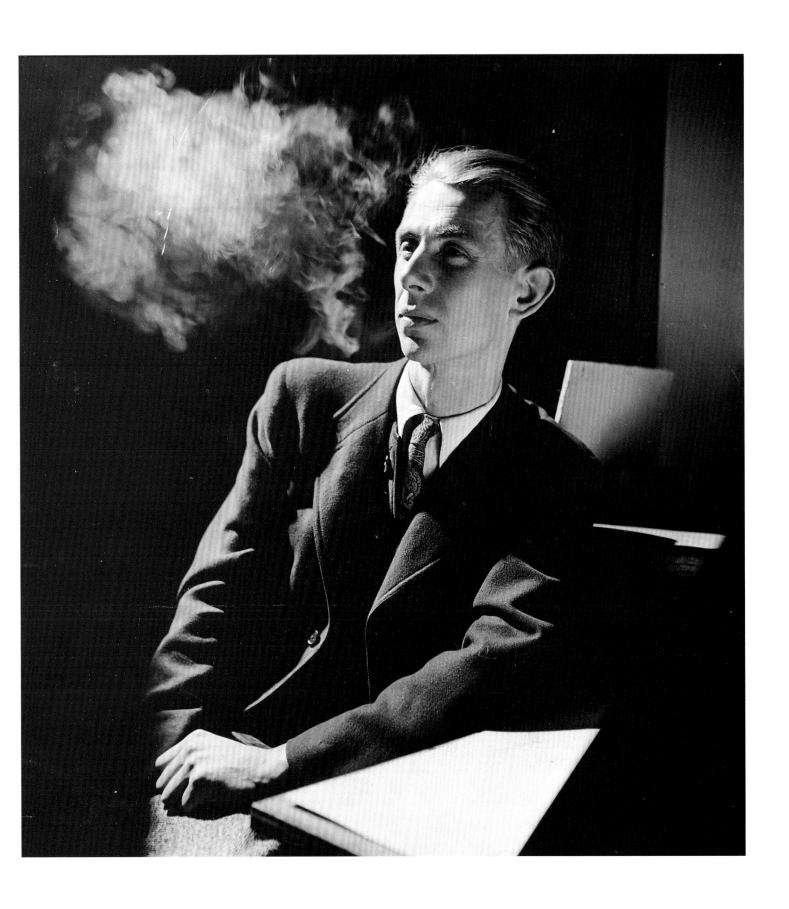

113

Paul Nash 1889–1946

Felix H. Man 1893–1985

Bromide print, 1943
19.1 × 23.3 ($7\frac{1}{2}$ × $9\frac{1}{8}$)
Given by the photographer, 1980 (X11807)

Poised between European Modernism and a profound devotion to nature, Paul Nash's work as a painter, watercolourist and engraver has a symbolic quality which evokes the rhythms and forms that lie beyond local time and place. At the Slade School (1910–11) he made friends with Ben Nicholson (no. 100), but, unlike Nicholson, with whom he was later to found Unit One (1933), he never adopted pure abstraction, preferring 'a different angle of vision', based on the dramatic possibilities of the deep space and distorted perspectives of Surrealism. Some of his most powerful work was produced as an official war artist in both world wars.

Felix H. Man (born Hans Baumann in Freiburg im Breisgau) began his photographic career working as a photojournalist in Munich and Berlin in the 1920s. In 1934 he emigrated to England, bringing with him the latest technique and equipment – cameras with ultra-fast lenses, the most light-sensitive film – which gave him an ability to seize the possibilities of 'available light'. Working for *The Daily Mirror*, *Lilliput*, and as chief photographer of *Picture Post* (1938–45), he made an art of what he called 'the live-portrait', unposed, in which

> the sitter was made to feel at ease and comfortable in his own surroundings, by not giving him any direction nor interfering with his normal activities, but preserving the atmosphere of his normal way of life. At the same time a personal contact had to be established and the photograph had to be taken at the critical moment reached through long and close observation with the utmost concentration.

Man photographed Nash at work at 106 Banbury Road, Oxford, where he had moved in 1939. He holds a version of his *Landscape of the Vernal Equinox* (Private Collection) painted in the first half of 1943: a view of Boars Hill, Oxford, overlooking Bagley Woods, with Wittenham Clumps in the distance. Of this painting Nash wrote, 'Call it, if you like, a transcendental conception; a landscape of the imagination which has evolved in two ways: on the one hand through a personal interpretation of the phenomenon of the equinox, on the other through the inspiration derived from an actual place'. Nash painted this view on numerous occasions about this time; another treatment can be seen in the background. This photograph is one of a group of Man's work, presented to the Gallery by the photographer in 1980.

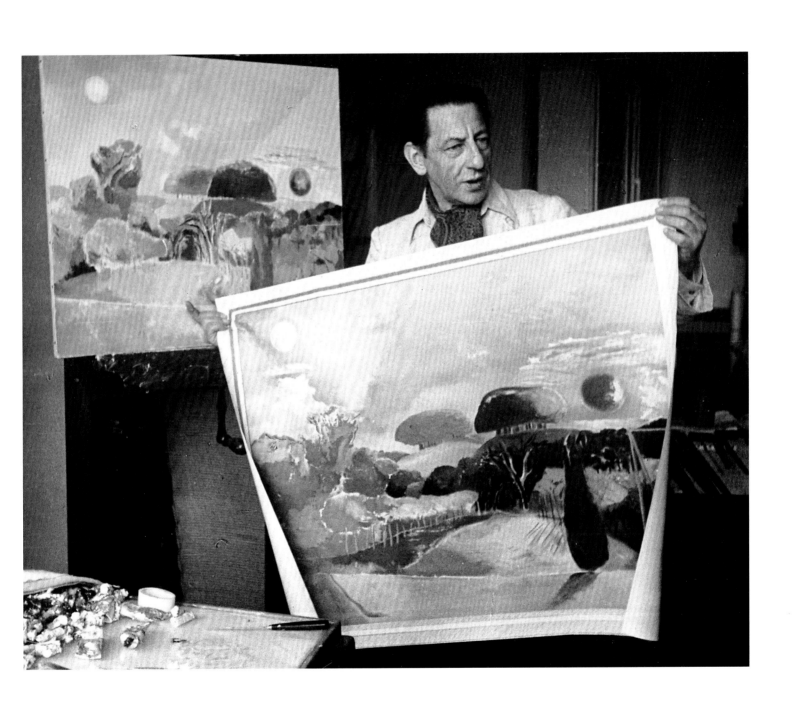

243

114

Richard Howard Stafford Crossman 1907–74

Bill Brandt 1904–83

Bromide print, 1945
23.5 × 19.1 (9¼ × 7½)
Purchased from the photographer, 1982 (P188)

Intelligent, energetic and inconsistent, Richard Crossman was not an easy colleague. He lacked team spirit and defied regulations, whether at the Ministry of Economic Warfare (1940–5), where he organized the British propaganda effort against Hitler; or as Harold Wilson's Minister of Housing and Local Government (1964–6) and Lord President of the Council (1966–8), or as editor of the *New Statesman* (1970–2). Throughout his life, however, he fought for open government, that parliamentary democracy should not be 'a sham, a gaily-painted hoarding behind which are kept hidden the government and the machinery of the state'. Appropriately, at the very end of his life he succeeded in publishing – against opposition from the then Labour government – his *Diaries of a Cabinet Minister*, which gave an unidealized behind-the-scenes view of politics.

Bill Brandt studied in Paris with Man Ray (see no. 99) before returning to London in 1931, where he began to document in photographs the manners and mores of inter-war society, at a time when photographic reportage was almost unknown in England. Towards the end of the war, however, his style changed completely, and he adopted a more self-consciously formal and aesthetic manner (see no. 117). This portrait of Crossman, working at this desk in the last year of the war, when he was assistant head of the Psychological Warfare Division, is one of Brandt's last works in the early style. It was published in *Harper's Bazaar* in September 1945.

115

Quintin McGarel Hogg, Baron Hailsham of St Marylebone
born 1907

Sir Cecil Beaton 1904–80

Bromide print, 1945
24.6 × 19.6 (9⅝ × 7⅝)
Given by the photographer, 1970 (x14094)

Lord Hailsham is the son of the 1st Viscount Hailsham, Lord Chancellor (1928–9 and 1935–8), and grandson of the philanthropist Quintin Hogg, pioneer of the polytechnic movement. He first entered Parliament as MP for Oxford City in 1938, in the year his father ended his second period of office as Chancellor, and has himself been Lord Chancellor for two periods (1970–74 and 1979–87), in the second of which he saw his own son enter Parliament.

He was photographed by Cecil Beaton as 'a leader of the Tory Reform Group' in 1945, at the collapse of what had seemed a promising ministerial career. In April that year he had been appointed Joint Parliamentary Under-Secretary of State for Air, but the appointment lasted only a matter of months, for Churchill (no. 111) resigned as leader of the wartime coalition government in May, and was defeated by Atlee in the July general election. This photograph was published in American *Vogue* on 1 September that year, accompanying an article by Harold Nicolson on Hogg (as he then was), Aneurin Bevan and Peter Thorneycroft (now Lord Thorneycroft), beginning: 'These three men are ones to watch, since theirs are among the more forceful and rebellious younger minds in the defeated Conservative and the victorious Labour Parties'.

Beaton's compositions often seem inspired theatrical improvisations on hastily-gathered materials, remote in place and time. For the politician, however, at the moment of defeat, he adopts a different solution. The bare table, trunk, the cupboard doors, have a stubborn presence, indifferent to the sensitive young man, his hat by his side, who is about to get up and leave the room. The great American photographer Irving Penn credits this image as a major influence on his work.

116

Hughes Griffiths ('Binkie') Beaumont 1908–73 with Angela Baddeley 1904–76 and George Emlyn Williams 1905–87, in Terence Rattigan's *The Winslow Boy* ('Binkie Pulls the Strings')

Angus McBean born 1904

Bromide print, signed by the photographer on the mount, 1947
38 × 29.7 (15 × 11¾)
Purchased from the photographer, 1977 (P59)

At the age of twenty-eight 'Binkie' Beaumont founded with his associate H.M. Tennent the firm of theatrical producers H.M. Tennent Ltd. Beaumont was from the beginning the moving spirit behind the company, but, even after Tennent's death in 1941, he did nothing to publicize his own name. His firm, however, dominated the West End theatre for almost twenty years, and during that period Beaumont had the power to make or break the career of almost any actor. From the start he had the friendship and support of John Gielgud (no. 97) and Noël Coward (no. 101), and this, combined with his exceptional managerial skills and perfectionism, resulted in a run of highly successful productions. Above all, the firm of Tennents became a byword for superbly dressed comedies with starry casts.

Angus McBean began his career in the theatre as an odd-job man, making masks and building scenery, but turned to full-time theatre photography in 1936, and, as 'one-shot' McBean, was virtually official photographer to Tennents. His work is characterized by its wit and imagination, and, as he himself puts it, 'the use of surrealism for its fun value'. In this characteristically inventive photograph Beaumont is shown as puppeteer, manipulating Angela Baddeley as Catherine Winslow and Emlyn Williams as Sir Robert Morton, in the first production of Rattigan's *The Winslow Boy*, which had opened at the Lyric Theatre, Shaftesbury Avenue, in May 1946. It is the perfect image of Beaumont who all his life cultivated anonymity, and yet was a domineering personality, one in whom, according to Tyrone Guthrie, 'the iron fist was wrapped in fifteen pastel-shaded velvet gloves'. It was published in *The Tatler and Bystander* in August 1947.

117

Graham Greene born 1904

Bill Brandt 1904–83

Bromide print, with the photographer's stamp on the reverse of the mount, 1948
34.2 × 29.1 (13½ × 11⅝)
Given by the photographer, 1982 (X22429)

The novelist Graham Greene, who was awarded the Order of Merit in 1986, sees his work as divided into two distinct streams: the serious novels, works of moral and religious enquiry, such as *Brighton Rock* (1938), *The Power and the Glory* (1940), and *The Heart of the Matter* (1948), and 'entertainments', fast-moving psychological thrillers including *Stamboul Train* (1932), *A Gun for Sale* (1936), *The Confidential Agent* (1939), *The Third Man* (1950), and, in lighter vein, *Our Man in Havana* (1958). To his readers the distinction is less material, for both styles of work are recognizably facets of the same personality. As a youth Greene habitually played Russian roulette; later on he was converted to Roman Catholicism, and his whole *œuvre* seems to constitute a meditation on the meaning and purpose of life in a mind which is both intensely religious and profoundly sceptical.

Greene was photographed by Brandt at about the time of the publication of *The Heart of the Matter*, in which the central character, the well-meaning, ineffectual colonial administrator (and Roman Catholic) Major Scobie destroys himself. The act itself is violent and apparently meaningless, but Greene draws from it a profound spiritual truth. The photograph shows the author, against a background of skylights, in his flat in St James's, London. Brandt, working in his later analytical manner (see no. 114), draws from the architecture of this most sociable area of London – the home of so many gentlemen's clubs – a more anguished landscape of the mind. The photograph was first published in *Lilliput* in November 1949, and later in *Harper's Bazaar* in March 1950.

118

John Desmond Bernal 1901–71

Wolfgang Suschitzky born 1912

Bromide print, 14 April 1949
29.5 × 24.8 ($11\frac{5}{8}$ × $9\frac{3}{4}$)
Purchased from the photographer, 1985 (P304)

From his days as an undergraduate the physicist Desmond Bernal was nicknamed 'Sage', and he was a polymath, with an infectious delight in new ideas. Before the war he played a major role in the development of crystallography, and was one of the founders of molecular biology, working on the structures of sex hormones, water, proteins (with Dorothy Hodgkin, no. 105), and viruses. During the war he worked as adviser to Lord Mountbatten (no. 106) at Combined Operations, on the development of artificial icebergs as aircraft carriers, and on the scientific planning for the invasion of Europe. Afterwards, as professor at Birkbeck College, London, he had a vision of his laboratory as an 'Institute for the Study of Things', but it never fully materialized. Bernal's extreme left-wing views made him unpopular in the climate of the cold war, and he was largely deprived of the necessary funds for his research. A frequent visitor to the Soviet Union, he was a friend of Khruschev, and, most controversially, a supporter of the agriculturist Lysenko. He was awarded the Lenin Prize for peace in 1953.

Wolf Suschitzky was born in Vienna, where his father had opened the first Socialist bookshop in 1900, and studied at the Austrian State School for Photography. Like many of his contemporaries, he was deeply influenced by the *Foto-Auge* exhibition of 1929 (see no. 95). He came to London in the 1930s, where he produced a series of documentary photographs of the West End, and worked as a photo-journalist. From the late 1930s onwards he has worked as a film cameraman on documentary and feature films, and, increasingly, commercials. Shortly after the war he was a founder member of DATA, the first film co-operative. He photographed Bernal at his microscope in his laboratory at Birkbeck College, in the cold war years when he was fighting against diminishing resources and for world peace.

119

Henry Moore 1898–1986

Yousuf Karsh born 1908

Bromide print, signed by the photographer on the mount, 1949
99 × 74.9 (39 × 29½)
Given by the photographer, 1984 (P251)

Universally recognized as one of the greatest sculptors of the century, Henry Moore is above all renowned for his monumental seated and reclining figures – predominantly female – usually benevolent in character and lyrical in mood. In them he reveals a remarkable feeling for the relationship between the human form and the forms of landscape, and has said: 'I would rather have a piece of my sculpture put in a landscape, almost any landscape, than in the most beautiful of buildings'.

The photographer Karsh was born in Turkish Armenia, and emigrated to Canada in 1924. He opened his studio in Ottawa – the city which is inextricably associated with his name – in 1932, and from that time specialized in portraiture. At the request of the Canadian government he has photographed many of the most important and celebrated figures in the world. He is equally at home with royalty, politicians, writers, artists, and religious leaders, and he approaches each of his sitters in a spirit of enquiry, but also, it seems, of veneration. He photographed Moore 'on a bitterly cold and rainy morning in 1949' in the sculptor's studio at Hoglands, his home in Perry Green, Hertfordshire, at a moment of transition in Moore's career.

In the background of the portrait is the full-size plaster model for Moore's *Family Group* (1948–9), the first of his large works to be conceived as a bronze, in other words, not carved directly from the material. It was made for a school in the New Town of Stevenage in Hertfordshire (later casts are in the Tate Gallery, London, and the Museum of Modern Art, New York). Installed in September 1950, it caused considerable local and national controversy, Moore's old adversary Sir Alfred Munnings commenting: 'Distorted figures and knobs instead of heads get a man talked about these foolish days'. Moore's sculptures, and especially his expressive use of 'holes', were frequently the butt of anti-Modernist mockery. He said to Karsh: 'The first hole made through a piece of stone . . . is a revelation. A hole can have as much shape and meaning as a solid mass.' The photographer adds: 'I glanced up at the family group, here pictured, and began to understand a little better what he meant'.

120

Edward Morgan Forster 1879–1970, Edward Benjamin Britten, Baron Britten of Aldeburgh 1913–76, and Eric Crozier born 1914, at work on the libretto of *Billy Budd*

Kurt Hutton 1893–1960

Bromide print, with the stamp of *Picture Post* and Kurt Hutton on the reverse, 1950
19.5 × 14.2 ($5\frac{1}{2}$ × $7\frac{5}{8}$)
Given by the Trustees of the Britten Estate, 1981 (X1522)

In 1948 at the first Aldeburgh Festival Benjamin Britten heard E.M. Forster lecture in the Baptist Chapel there on the poet George Crabbe whose tale of Peter Grimes formed the basis of Britten's first opera (1945). In his talk Forster reflected on how he might have treated the libretto for the opera had it been his to write. This was not wasted on Britten, and when he was commissioned to write an opera for the Festival of Britain (1951), he turned to Forster. The novelist was then in his seventies, with virtually no dramatic experience. Together they decided to make an opera of Herman Melville's story *Billy Budd, Foretopman* and, in collaboration with the producer and experienced librettist Eric Crozier, they created one of the best (and most faithful) librettos ever to be based on a literary masterpiece. Britten's score itself is a work of great psychological subtlety, and when the opera was first performed at Covent Garden in December 1951, the drama of the 'handsome sailor' destroyed by evil was recognized as a work of tragic insight.

Born Kurt Hubschmann in Strasbourg, the photographer emigrated to Britain in 1934, adopting the name 'Hutton' in 1937. As a photo-journalist he had worked under Felix H. Man (see no. 113) in Berlin, and in London he was soon adopted by *Weekly Illustrated* and later by *Picture Post*. His secret lay in his sympathy with his subjects, and it is possible to feel in this photograph of the three men entirely absorbed in their project, all the excitements and frustrations of collective literary composition. It was taken at Britten's home, Crag House, overlooking the seafront at Aldeburgh, in the early part of 1950, when Forster's friendship with Britten was at its most excited. Later, relations were less easy, and Forster confided to his diary in December that year: 'I am rather a fierce old man at the moment, and he is rather a spoilt boy, and certainly a busy one'. This print is one of a group of 108 photographs of, and relating to, Benjamin Britten presented to the Gallery in 1981.

121

John Christie 1882–1962

Cornell Capa born 1918

Bromide print, with the stamp of *Life* magazine and the photographer on the reverse,
and inscribed and dated; 23 July 1951
34 × 26.3 ($13\frac{3}{8}$ × $10\frac{3}{8}$)
Purchased, 1988 (P358)

John Christie could seem impossibly eccentric, but in reality he had an extraordinary
ability, by virtue of his energy and enthusiasm, to reconcile the ideal with the practical.
In the 1920s at Glyndebourne, his house in Sussex, he installed a cathedral organ (buying
up an organ company in the process), and began to give concerts, and when in 1931
he married the operatic soprano Audrey Mildmay he decided to build an opera house
there. Thus Glyndebourne Opera was founded. Public reaction was incredulous, but,
with his conductor Fritz Busch and the producer Carl Ebert, the opening season (1934)
proved a triumphant success. The years which followed had many ups and downs, and
it was not until 1950, the year before this photograph, that support from the John Lewis
Partnership ensured the future of Glyndebourne and its festival. Its name is now known
internationally as the home of country-house opera, and above all for productions of
Mozart.

Cornell Capa (born Kornel Friedmann in Budapest), brother of the photographer
of war Robert Capa, emigrated to the United States in 1937, and spent most of his career
as a photo-journalist working for *Life* magazine. Capa founded the International Center
of Photography in New York in 1974, and remains its director. His subject is people,
and he tackles them with directness and vitality, so that, as in the case of Christie, they
almost burst from the picture space. This photograph, taken as part of a session for
Life magazine, shows Christie teasing a favourite pug. His son Sir George Christie, the
present Chairman of Glyndebourne, has described it as 'extremely characteristic. He
liked to bring the worst out of his pugs and he achieved this unfailingly'.

259

122

Joan Collins born 1933

Cornel Lucas born 1923

Modern c-type colour print from the original transparency, 1951
39 × 31 (15$\frac{3}{8}$ × 12$\frac{1}{2}$)
Given by Pinewood Studios, 1986 (X27871)

The daughter of a theatrical agent, Joan Collins went into show-business in her teens, and her good looks and good sense have carried her triumphantly through the vicissitudes of a long career. From the 1950s to the 1970s her sultry charms made her a popular leading lady in a variety of British and international films, and from 1981 she has acted in the television soap-opera *Dynasty*, which has made her the most famous, and imitated, actress in America. Her autobiography *Past Imperfect* appeared in 1978. In the same year she produced and starred in the film of her sister Jackie's novel *The Stud*, and *The Bitch* followed in 1979. She has recently herself written a best-selling novel. With her indomitable glamour, voice like 'a pout made audible', and the ability to laugh at herself, she has become a cult figure on both sides of the Atlantic.

Cornel Lucas, after studying photography at the Regent Street and Northern Polytechnics, went into the film industry in 1937 as a laboratory technician, and turned to full-time photography in 1942. From 1946 to 1959 (when he left films to concentrate on fashion and advertising photography), he worked for Rank, Columbia and Universal Studios as a stills photographer, in a period when the 'star' system dominated the industry. To the British film studios and their stars he brought the glamour of Hollywood, and his female subjects have an aura of utopian gorgeousness. His portrait of Joan Collins, which was commissioned by Pinewood Studios, was taken at the very beginning of her film career.

123

Sir Eduardo Luigi Paolozzi born 1924

John Deakin 1912–72

Bromide print, signed and inscribed on the reverse, 24 September 1952
30.1 × 26 ($11\frac{7}{8}$ × $10\frac{1}{4}$)
Purchased, 1985 (P296)

Eduardo Paolozzi, born in Scotland of Italian parents, is recognized as one of the leading British print-makers and sculptors. For him 'all human experience is one big collage', and his work is infused with a fascination with popular culture – he was a prominent member of the Pop Art movement – as well as modern industrial technology. A recent exhibition at the Gallery, based around new portrait sculptures of the architect Richard Rogers (no. 140), however, conclusively revealed another strain in his work: his debt to, and veneration for, the academic tradition of Western art, and, in his own words, 'that form of teaching scathingly dismissed by more recent generations as Ecole des Beaux Arts'. This latest synthesis finds its most majestic expression in his monumental self-portrait bronze *The Artist as Hephaestus* (1987), which stands at 34–36 High Holborn, and which portrays the artist in his complex role as man, machine and myth. The Gallery owns a smaller version of this entitled *Self-portrait with Strange Machine*.

John Deakin was from 1948 until his death a familiar Soho character, and, according to George Melly, 'a vicious little drunk', a liability to his friends, who included Francis Bacon (no. 141) and Daniel Farson (see no. 124). He was, nevertheless, an inspired photographer, whose work has an unflinching documentary quality, stripped of any trace of sentiment or humour. Until his behaviour became intolerable, he worked for *Vogue*, where his portrait of Paolozzi was published in March 1953. It shows the sculptor when a member of the Independent Group of young artists, architects and critics, 'who were more interested in discussing helicopters and proteins than prospects for the Royal Academy', and illustrates Deakin's understanding that a close-up, though it may well show more detail, also lends emphasis to broad sculptural forms.

124

Cyril Vernon Connolly 1903–74 and Lady Caroline Blackwood born 1931

Daniel Farson born 1927

Bromide print, inscribed on the reverse: *Outside Wheelers*, early 1950s
17.8 × 17.8 (7 × 7)
Purchased from the photographer, 1985 (P290)

Daniel Farson's photographic career began immediately after the Second World War in Germany, when he was posted to the American Air Corps newsletter *Stars and Stripes*, and later at Cambridge he ran and illustrated his own magazine *Panorama*. In the 1950s he worked for *Picture Post* and *Harper's Bazaar*, and in 1951 discovered Soho. There, while pursuing a career as a journalist and as one of the first British television personalities, in an atmosphere of perpetual hangover, he took a series of photographs of the denizens of this bohemian haunt – forties diehards and some brilliant newcomers – which are redolent of the period. Cecil Beaton designated his photographs 'anti-artistic', and certainly their style is generally spare and documentary, though to this double portrait of two writers he brings a faintly sinister note of unspecified drama. It was taken outside the fish-restaurant Wheeler's in Old Compton Street, described by Farson in his *Soho in the Fifties* (1987). In the post-war years it represented luxury, and to the artistic set of Francis Bacon (no. 141) and Lucian Freud it became both dining-room and club. According to Farson: 'Over the years the staff shared our triumphs and disasters, observed our high spirits and furious arguments, and became our friends. In return, we provided a sort of cabaret'.

Connolly, who is best known for his *bon mot* 'imprisoned in every fat man a thin one is wildly signalling to be let out', was an unsparing observer of the literary scene and of himself. He wrote in *The Unquiet Grave* (1944) that 'the true function of a writer is to produce a masterpiece and that no other task is of any consequence', and his whole life can seem like a commentary on his failure to produce that masterpiece. He was nevertheless a distinguished editor of *Horizon*, and as a leading book reviewer for *The Sunday Times* his opinions had a lasting influence on a younger generation. The novelist and critic Lady Caroline Blackwood is the daughter of the 4th Marquess of Dufferin and Ava. She was a favourite model, and at the time of this photograph the wife of the painter Lucian Freud. She subsequently married the American poet Robert Lowell, who wrote of her 'moon-eyes', 'bulge-eyes bigger than your man's fist', eyes which are familiar from the hypnotic portraits of her by Freud.

125

Bertrand Arthur William Russell, 3rd Earl Russell 1872–1970

Ida Kar 1907–74

Toned bromide print, with the photographer's studio stamp on the reverse, 1953
24.1 × 19.4 (9½ × 7⅝)
Purchased from Victor Musgrave, the photographer's widower, 1981 (X13796)

Both as philosopher and social reformer Russell was indisputably one of this century's major intellects. He was closely associated with the Bloomsbury Group, and early on established his reputation as a philosopher with the *Principia Mathematica* (1910–13). As a writer and lecturer he was an ardent pacifist, and the first president of the Campaign for Nuclear Disarmament (1958), which he split in 1960, to form the more militant Committee of 100, dedicated to civil disobedience in pursuit of its ends. He lived for nearly a hundred years, retaining his mental vigour to the end. His high-pitched voice, precise and pedantic delivery and whinnying laugh were much parodied. He won the Nobel Prize for literature in 1950.

Born in Armenia, educated in Egypt and Paris, Ida Kar had her first studio in Cairo in the war years, and there experimented with Surrealism. In 1944 she married Victor Musgrave, director of the avant-garde Gallery One, and came to London, where she worked as a portrait photographer, contributing to numerous newspapers and magazines, including *The Sunday Times*, *The Tatler*, and *Vogue*. Her photographs, all taken by natural light, are marked by what Colin MacInnes described as her 'gift . . . to woo and win intimacy without any loss of courteous deference. . . . an Ida Kar portrait is at once identifiable by its purity and distinction'. She photographed Russell, as he made notes in his diary, in the studio of the sculptor Epstein (no. 128), where he was sitting for his bust. In the background is the plaster of what is probably the sculptor's bust of the actor Terence O'Regan, also dating from 1953.

126

Maurice Harold Macmillan, 1st Earl of Stockton 1894–1986

Arnold Newman born 1918

Bromide print, signed, inscribed and dated: *MP. and Minister Harold McMillan, London 1954*; 1954
33.6 × 26.3 ($13\frac{1}{4}$ × $10\frac{3}{8}$)
Purchased, 1976 (P44)

Born into the family publishing house, Harold Macmillan first entered Parliament as MP for Stockton-on-Tees in 1924. He was something of a rebel, and had to wait sixteen years for a government job – until Churchill, another rebel, recognized his qualities. Elected leader of the Conservative Party in succession to Anthony Eden in 1957 in the aftermath of the Suez crisis, 'Supermac', as he came to be known, set about restoring confidence both in his party and the country. A hatred of poverty drew him to policies of economic expansion and social benefits; he restored the relationship between Britain and America, strove for *détente* between the West and the Soviet Union, felt the 'wind of change' blowing in Africa and the need for decolonisation, and attempted to forge a new relationship with Europe. Behind a studied 'Edwardian' manner lay a subtle and, when necessary, ruthless intelligence, which enlivened his later role as distinguished elder statesman.

Arnold Newman was born in New York, studied at the University of Miami, and trained as a photographer in Philadelphia. He opened his first studio in Miami Beach in 1942, moving to New York in 1946, and has established himself as one of America's leading portraitists. His exhibition *The Great British* was shown at the Gallery in 1979, and revealed a style which though restrained is none the less inventive. He studies his sitters in advance, and depicts them in a setting which is not just symbolic, but also symptomatic, of their life and work. Macmillan is photographed as Minister of Housing, and Newman makes great play with the impedimenta of office which surround the successful minister, who had just achieved his target of 300,000 new houses in a year.

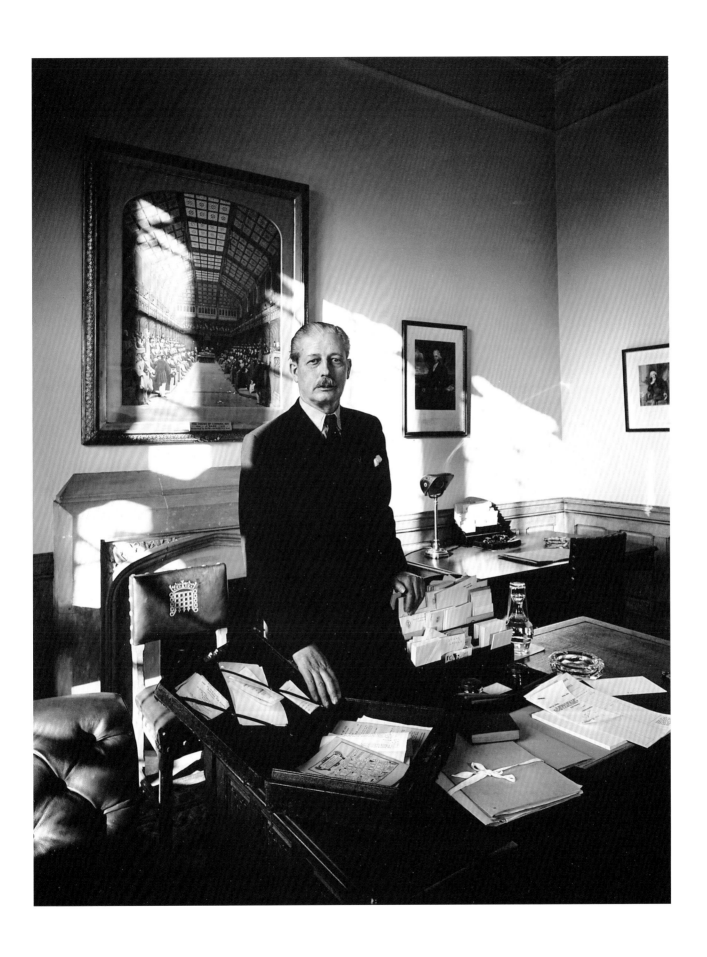

127

Thomas Stearns Eliot 1888–1965

Kay Bell Reynal 1905–77

Bromide print, signed on the reverse, 1955
34 × 26.7 (13$\frac{3}{8}$ × 10$\frac{1}{2}$)
Purchased, 1982 (P205)

Kay Bell took up photography as the result of a dare in 1943. She was working as an associate editor for *Vogue* in New York, and was given a camera by the then art director. Two years later she set up a studio in an Eastside townhouse, and there, working with a hand-held camera by natural light, she produced fashion photographs and portraits which are marked by their elegance and informality. In 1947 she married the publisher Eugene Reynal, and through him came into contact with many of the leading writers of the day, often photographing them 'after lunch', as she put it, in relaxed and less guarded moments.

The poet, playwright and critic T.S. Eliot sat to her in May or June 1955, when staying with his American publisher Robert Giroux, on his way to Boston to visit his two ailing sisters. He was by that time the 'elder statesman' of British letters, in whose work can be traced a spiritual quest which leads from the apparently despairing *Waste Land* (1922) to the religious fulfilment of the *Four Quartets* (1935–42). With characteristic prudence he gave three poetry readings on the trip – just enough to pay for it – and, with less circumspection, went to see his old friend Ezra Pound, 'il miglior fabbro' who had revised *The Waste Land*, and who was incarcerated in an asylum in Washington. On a visit the previous year Pound had criticized Eliot's Christianity as 'lousy', but this year things went better, and Pound wrote to Ernest Hemingway: 'Possum [Eliot] more relaxed this year . . . last year rather edgy'.

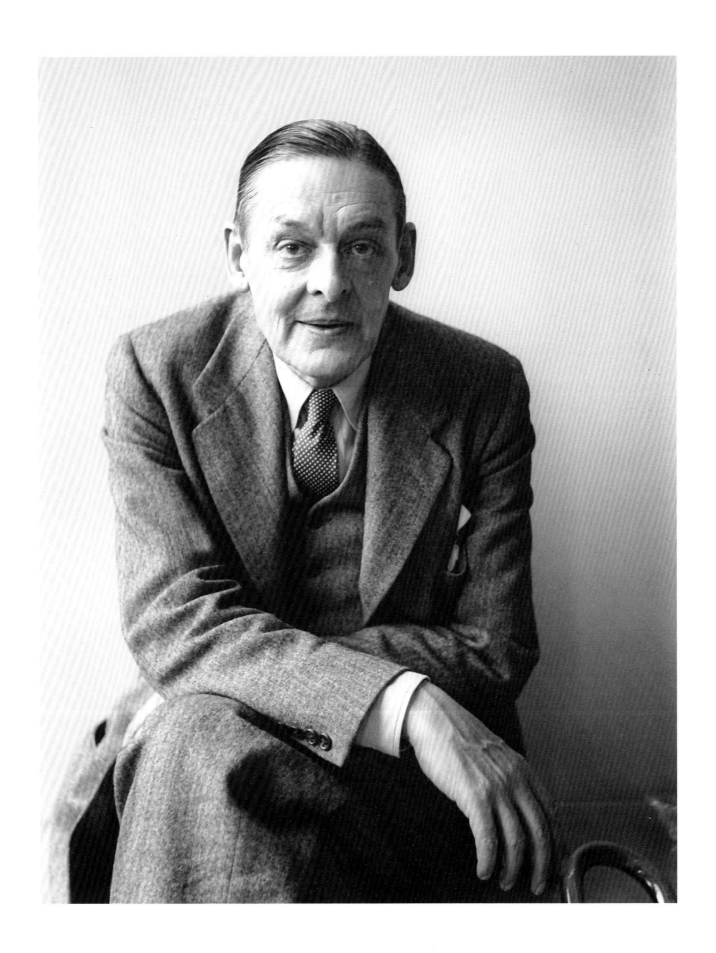

128

Sir Jacob Epstein 1880–1959

Geoffrey Ireland born 1923

Silver print, with the photographer's stamp on the reverse of the mount, February 1956
43.7 × 40.4 (17⅜ × 15⅞)
Purchased from the photographer, 1980 (x8496)

Jacob Epstein was born in New York of well-to-do Jewish *émigré* parents, and first studied sculpture there. In his early twenties he travelled to Europe in search of new influences, and settled in London, in Camden Town, in 1905. His career could seem to be a long series of public scandals, for his major works reveal a fascination with primitive art and themes of sexuality and procreation which were certain to shock. His nude figures symbolizing the stages of human life on the British Medical Association building in the Strand (1907–8) were later emasculated; his tomb of Oscar Wilde (1909–12; Père Lachaise Cemetery, Paris) wreathed in plaster, straw and tarpaulin by the cemetery authorities; later works like his monumental sculpture *Genesis* (1929–30) became side-show attractions. By contrast, his expressive portrait busts were always in demand.

The photographer Geoffrey Ireland was born in Lancaster, and studied at the Royal College of Art, London, where in 1953 he was appointed tutor in graphic design. He was later Head of Photography at the Central School of Art and Design. In 1953 he began work with Epstein on a book on his recent sculpture (published in 1958 as *Epstein: A Camera Study of the Sculptor at Work*), and this photograph is reproduced there with the caption 'more work still to do'.

In his introduction to Ireland's book, Laurie Lee writes of Epstein: 'he haunts these photographs; a broad-boned working figure, homely as a riveter, untouched by the professional vanities of dress or posture, almost unnoticeable except for his tough absorption in his work and the profound enquiry of that unforgettable face'. This photograph shows the sculptor, who was already in failing health, in a setting of operatic grandeur confronting for the first time the massive block of Roman stone from which he was to carve his Trades Union Congress War Memorial. This was commissioned for Congress House, Great Russell Street, which was then under construction. The block was lowered into place in February 1956, and Epstein began work shortly after on his figure of a mother cradling in her arms her dead son. It was 'devilish hard work as this particular block is as hard as granite and tools just break on it', with 'terrific noise of building going on all about me'. It was finished by Christmas that year, but the building was not formally opened until 1958.

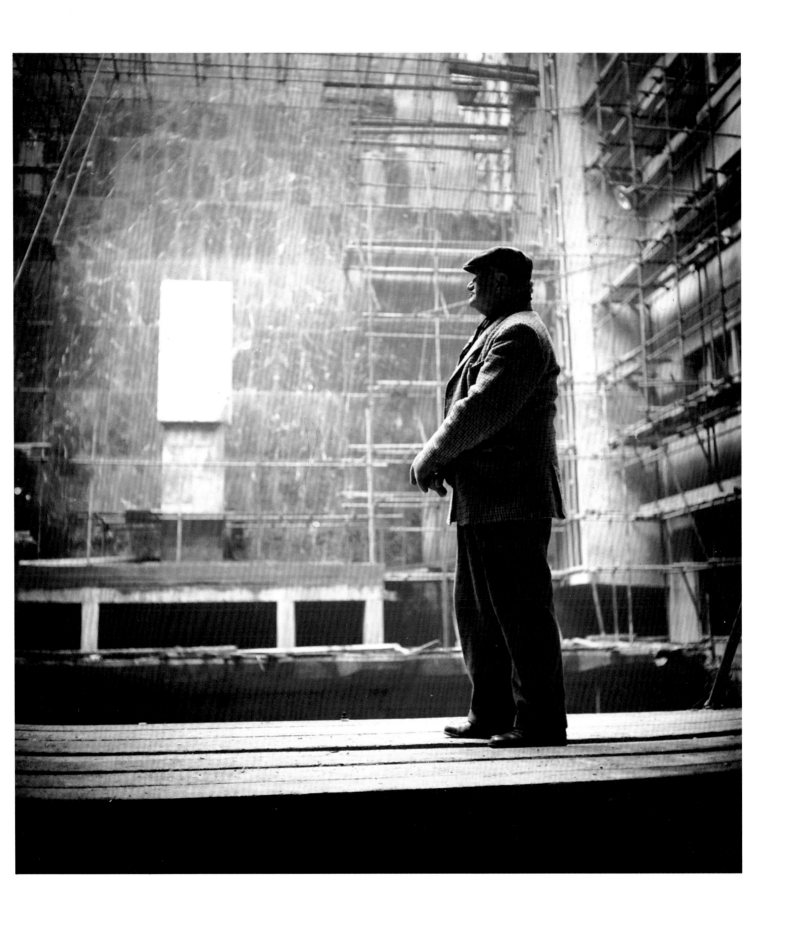

129

John Osborne born 1929

Mark Gerson born 1921

Bromide print, signed and inscribed on the mount, 1957
43.2 × 38 (17 × 15)
Purchased from the photographer, 1989 (X32734)

One of the original 'Angry Young Men', John Osborne made his name with his play *Look Back in Anger*, which opened at the Royal Court Theatre in May 1956. It was set in a one-room flat in a Midlands town, and centred on the marital conflict between Jimmy Porter, from a 'white tile' university, working on a market stall, and his wife Alison, a colonel's daughter. A landmark in British theatre, this 'kitchen sink' drama was a focus for reaction against the work of a previous generation – the middle-class comedies of Coward (no. 101) and Rattigan and the portentous verse-plays of T.S. Eliot (no. 127) and Christopher Fry. In the plays which followed Osborne presented a series of tormented or tragic heroes, Archie Rice in *The Entertainer* (1957), *Luther* (1961) and Colonel Redl in *A Patriot for Me* (1965). Later works such as *A Sense of Detachment* (1972) and indeed his autobiography *A Better Class of Person* (1981), have proved that his anger has not diminished over the years, even if the viewpoint has become more conservative.

Mark Gerson took up professional photography in 1947, working from a studio near Marble Arch for magazines such as *John O'London's Weekly* and *Books and Book-men*. He has made a speciality of portraits of writers, photographed informally in their gardens or homes, and he believes that the photographer's role should be as neutral as possible. His study of Osborne is therefore untypical. Gerson first photographed him at his house in Woodfall Street, Chelsea, on 22 February 1957 for *The Tatler*, and afterwards Osborne asked him to take a photograph of the front of the Royal Court Theatre with his name up in lights for his own use. It was Gerson's idea to make a montage of the two photographs in one image. He writes: 'I did it for fun and presented it to John, who was very impressed and ordered masses of postcard size prints for his fans'.

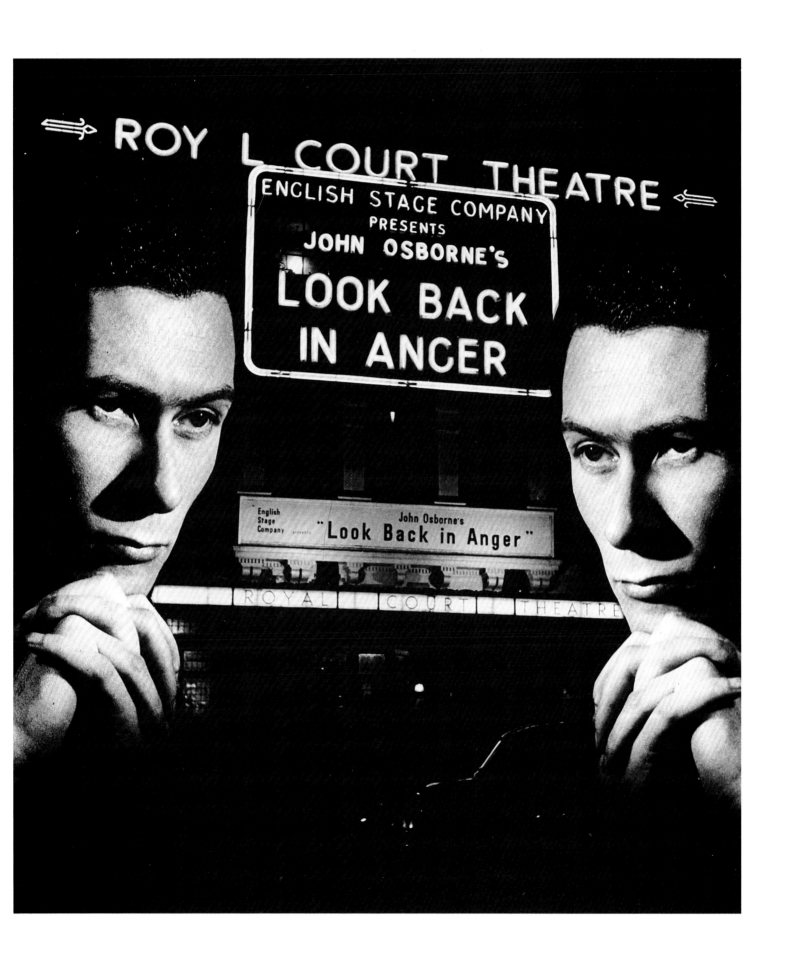

130

Her Majesty Queen Elizabeth II born 1926 and her Family

Lord Snowdon born 1930

Bromide print, with the photographer's stamp on the reverse, 10 October 1957
28.6 × 23 (11¼ × 9)
Purchased, 1985 (X32733)

The sitters are (left to right): The Princess Royal, Mrs Mark Phillips born 1950; Charles, Prince of Wales born 1948; The Queen; Prince Philip, Duke of Edinburgh born 1921.

As Tony Armstrong-Jones, Lord Snowdon began his professional career in 1951 as assistant to the society photographer Baron, and opened his own studio on the Pimlico Road, London, in 1953. He has worked as a freelance photographer for many magazines, among them *Vogue*, *The Tatler*, and *Harper's Bazaar*, and in 1962 was appointed artistic adviser to *The Sunday Times*. He acknowledges the influence of his uncle, the stage-designer Oliver Messel, on his life and work, and his early photographs especially show an ingenuity of presentation which can be theatrical. His later work, especially his studies of the old, disabled or handicapped, for whom he feels a special concern – he designed a chairmobile for the disabled (1972) – though it is more documentary in character, is filled with compassion.

He photographed The Queen, Prince Philip and their two eldest children in the gardens of Buckingham Palace in 1957, three years before his own marriage to Princess Margaret. Only twenty minutes were available for the sitting, so he planned it carefully in advance, submitting a sketch of the composition for approval. He intended to base the photograph on eighteenth-century paintings, and the royal children were to be shown fishing. For this purpose he hired a rod, and bought two trout from the fishmonger. He records that

> on the morning of the assignment, Mrs Peabody, who looked after me in Pimlico, came in with breakfast. 'I thought you needed a good start to the day today', she said; and I took off the lid to find she had grilled the trout quite beautifully.

The royal children were therefore shown reading a book.

277

131

The Reverend Martin Cyril D'Arcy 1888–1976

Richard Avedon born 1923

Bromide print, New York City, 1 October 1959, edition number 3/15
15.2 × 15.2 (6 × 6)
Purchased from the photographer, 1983 (P235)

As lecturer and tutor at Oxford in the 1920s and 1930s Father D'Arcy became the fore-most English apologist for Roman Catholicism, and brought into that church a stream of notable converts, of whom the most celebrated was Evelyn Waugh. So much so that Muriel Spark in one of her novels described the process of conversion as 'doing a D'Arcy'. Both in his writing and preaching he worked with all the force of his magnetic personality to stir the emotions; he was a brilliant conversationalist, and in appearance strikingly idiosyncratic. In 1945 he left his beloved Oxford to become head of the English Jesuit province, but in 1950 was relieved of this post. The rest of his life was clouded by this humiliation. He was out of step with post-war England, and spent much of his later years in America, where he felt he was better understood and appreciated.

Richard Avedon was born in New York City, and studied photography at the New School for Social Research. He set up his own studio in 1946, and worked freelance for numerous periodicals, including *Life* and *Harper's Bazaar*. He has been staff photo-grapher for *Theatre Arts* and *Vogue*, and is one of America's most distinguished portrait-ists, whose style can be dramatic but is always clinical. He has written of his work – and his remarks illuminate this portrait of D'Arcy – 'A photographic portrait is a picture of someone who knows he's being photographed, and what he does with this knowledge is as much a part of the photograph as what he's wearing or how he looks . . . We all perform . . . I trust performances'.

132

The Cast of *Beyond the Fringe*

Lewis Morley born 1925

Bromide print, 1961
38.3 × 29.4 (15 × 11½)
Given by the photographer, 1989 (X32732)

The sitters are (left to right): Peter Cook born 1937; Jonathan Miller born 1934; Dudley Moore born 1935 and Alan Bennett born 1934.

In 1961 a precociously clever satirical revue, which was created for the Edinburgh Festival in the previous year, opened at the Fortune Theatre in London. *Beyond the Fringe* was a triumphant success on both sides of the Atlantic, and seemed to signal a new era in satirical theatre. In reality it was the death-knell of revue on stage, but had a revolutionary impact on television comedy, and inspired satirical programmes including *That Was The Week That Was* and Rowan and Martin's *Laugh-in*. Of the four stars only Peter Cook has not ventured beyond comedy but is the main shareholder of *Private Eye*. Dudley Moore now has a career as a film actor and jazz musician; Jonathan Miller is one of the most distinguished of theatre and opera producers, and Alan Bennett a leading playwright.

Lewis Morley was born in Hong Kong, and became interested in photography while serving in the RAF. He studied painting at Twickenham College of Art, London, but moved into professional photography in the late 1950s. In 1961 he moved into a studio above Peter Cook's Establishment Club in Greek Street, Soho. His work in the 1960s – portraits and photo-journalism – is absolutely in tune with the times: informal, irreverent, with a gently anarchic sense of humour. This photograph was taken in Regent's Park, as one of the front-of-house photographs for the original production of *Beyond the Fringe*.

133

The Beatles

Norman Parkinson 1913–90

Bromide print, 12 September 1963
39.5 × 59.4 (15$\frac{1}{2}$ × 23$\frac{3}{8}$)
Given by the photographer, 1981 (X27128)

The sitters are (left to right): George Harrison born 1943; Paul McCartney born 1942; Ringo Starr born 1940 and John Lennon 1940–80.

In 1963 Beatlemania swept Britain (it was to sweep America in the following year). With the release of their hit single 'She Loves You' the 'Fab Four' from Liverpool and their 'Mersey Sound' created a popular music phenomenon. They were the first group to write, sing and play their own material, and, skilfully produced, they revolutionized the sales of long-playing records throughout the world. Their services to music (and to the balance of payments) were recognized by the award of MBEs in 1965. Two years later they released *Sergeant Pepper's Lonely Hearts Club Band*, often considered the finest rock music album ever made. The group split up in 1970.

Norman Parkinson, who trained with the society photographers Speaight & Sons of Bond Street, opened his first studio at 1 Dover Street, Piccadilly, London, and rapidly established a reputation as one of the top portrait photographers, with a modern and creative approach to portraiture based on imaginative film-lighting effects. After the war he began a long association with the Condé Nast organization, working for *Vogue*. At the time of his death he was recognized as the doyen of British fashion photographers. He photographed The Beatles in their hotel room in Russell Square, when they were in London to record tracks for their LP *With the Beatles* on the eve of their first tour of America, under the initial impact of fame: a frieze of smiling faces.

134

David Hockney born 1937

Jorge Lewinski born 1921

Bromide print, signed and dated 1969 on the reverse of the mount, 1968
37.7 × 29.1 (8 × 5⅜)
Purchased from the photographer, 1970 (x13726)

Already famous before he left the Royal College of Art, London, in 1961, Hockney has acquired an international celebrity which tends to obscure his achievement. He is nevertheless one of the most accomplished and continuously inventive of contemporary artists, whether working as a painter, printmaker, photographer (see no. 144) or theatre designer (for instance, his highly original designs for *The Rake's Progress* for Glyndebourne). His line-drawings, classically composed portraits, and mesmeric swimming-pool paintings, are readily approachable, and have spawned many imitators, but his language remains entirely personal.

Jorge Lewinski was born in Poland, and came to Britain in 1942. He turned professional photographer in 1967, making a speciality of portraits of artists in their habitats, and studies of landscape. He is married to the photographer Mayotte Magnus (see no. 138). He portrays Hockney seated in front of his *A Neat Lawn* (1967; private collection, West Germany), in a composition of Hockneyesque neatness, the artist playfully juxtaposed with a lawn sprinkler. It is a disarming image of a disarming personality, which, like Hockney's paintings, dares the spectator to search below the carefully ordered surface.

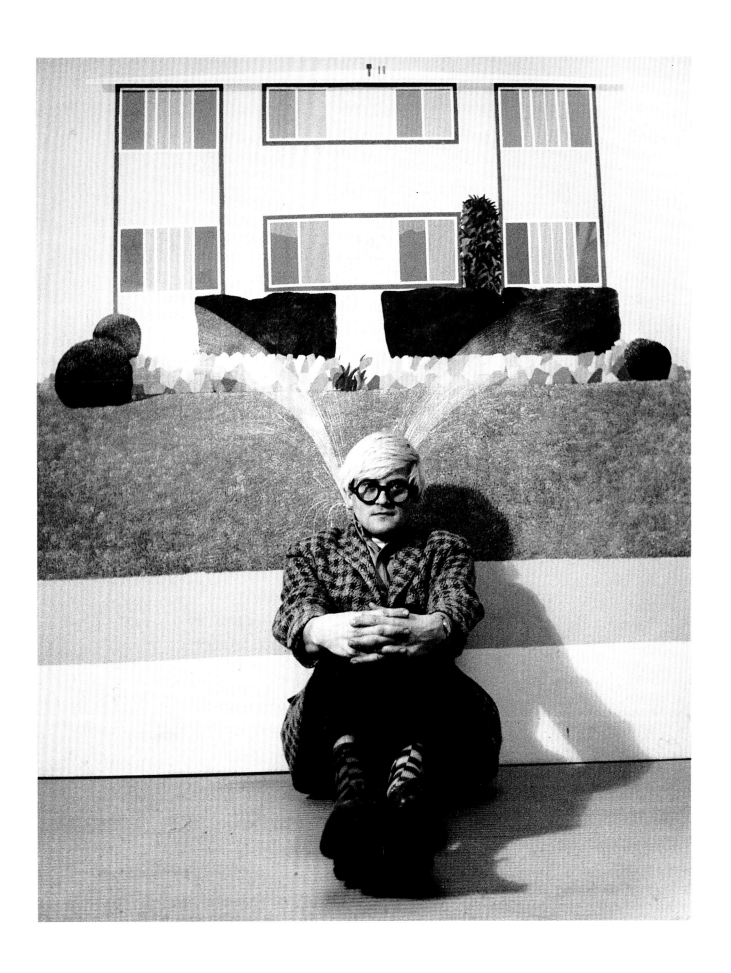

135

Vanessa Redgrave born 1937 and Tariq Ali born 1943 at the Grosvenor Square Demonstration

John Walmsley born 1947

Bromide print, 17 March 1968
45.1 × 35 (17¾ × 12)
Purchased from the photographer, 1978 (X6394)

The daughter of two distinguished actors, Sir Michael Redgrave and Rachel Kempson, Vanessa Redgrave is thought by many to be the leading British actress of her generation. She made her London début in *A Touch of the Sun* in 1958; soon after, she became a principal with the Royal Shakespeare Company, and, were it not for other commitments, she would never be out of the West End. At the same time she has had a prolific career in films, which include *Morgan – A Suitable Case for Treatment* (1966; Best Actress award at Cannes), *Camelot* (1967), *Isadora* (1968), *Julia* (1977; Academy award), *Yanks* (1979), *Wetherby* (1987) and *Prick Up Your Ears* (1987). She has said 'I choose all my roles very carefully so that when my career is finished I will have covered all our recent history of oppression', and she brings to politics, which since the early 1960s have become an increasingly important part of her life, the same passion and intensity which she shows in her acting. With her brother Corin she helped to found the Workers' Revolutionary Party, and has stood for Parliament. She has taken part in anti-nuclear demonstrations, and was once arrested. On 17 March 1968, shortly before the student riots in Paris, she led the anti-Vietnam War march on the United States Embassy in Grosvenor Square, and she is shown here on that march, with (left) the revolutionary student-leader Tariq Ali, about to present a letter to the United States ambassador. Born in Lahore, Ali studied politics and philosophy at Oxford, and became the first Pakistani to be elected President of the Oxford Union. He is the author of books on world history and politics, most recently *Street Fighting Years: An Autobiography of the Sixties* and *Revolution from Above: Where is the Soviet Union Going?* He has also written plays for television, and was a founder director of Bandung Productions.

Since leaving art school John Walmsley has been a freelance photojournalist, working for *The Listener*, *New Society* and *The Sunday Times*, among others. He has had one-man shows in London and Vienna, and has published books on the child psychologist and educationalist A.S. Neill. This photograph was taken while he was still at art school: 'I'd hitched up to London (with a borrowed college camera), took my pictures, and then hitched home again'. It is in essence a piece of reportage, but by careful cropping, he captures the full force of Redgrave's idealism, giving it a histrionic turn, setting her head high in the frame, in a way which recalls the revolutionary posters of Eastern Europe. According to Walmsley, 'The white headband is a Vietnamese sign of mourning'.

136

Charlotte Rampling born 1945

Helmut Newton born 1920

Bromide print, 19 October 1973
46.2 × 31.3 ($18\frac{3}{8}$ × $12\frac{1}{4}$)
Purchased, 1985 (X32395)

The daughter of an army officer and Olympic gold medallist, Charlotte Rampling first made a name in the early 1960s as a fashion model, but soon moved into films, playing in the quintessentially sixties pieces *The Knack and How To Get It* (1965) and *Georgy Girl* (1966). Over the years, in films such as *The Damned* (1969), *The Night Porter* (1974), *Farewell My Lovely* (1975) and *Paris by Night* (1989), her screen persona has become increasingly cool and sophisticated, a spellbinding *femme fatale* with almond eyes. She lives in France with her husband, the musician and composer Jean-Michel Jarre.

Helmut Newton was born in Berlin and trained there with the fashion and theatre photographer Yva. He left Germany in 1938, first for Singapore, and later Australia, where he worked as a freelance photographer, and met his wife June, the photographer Alice Springs. In 1955 the couple left Australia for Europe, and settled in Paris. They now live in Monaco. Newton is one of the world's best known fashion photographers, but since the late 1970s portraiture has been his main interest. His habitual subject is the international jet-set, on which he casts an ironic eye. His work has appeared in numerous magazines, in recent years particularly *Vanity Fair*, and he has published several books, including *47 Nudes* (1982), *World Without Men* (1984) and *Helmut Newton: Portraits* (1987). In 1988 the National Portrait Gallery held a retrospective exhibition of his portrait works. His photograph of Charlotte Rampling at the Hôtel Nord Pinus, Arles, is one of his earliest portraits, but entirely characteristic in its use of an elaborate *mise-en-scène* and tone of sexual audacity. The point of view is voyeuristic, suggesting an unspoken drama between photographer and subject.

289

137

Philip Arthur Larkin 1922–85

Fay Godwin born 1931

Bromide print, 1974
29.9 × 21 (11⅝ × 8¼)
Purchased from the photographer, 1980 (X12937)

'Deprivation is for me what daffodils were for Wordsworth': a typically ironic, melancholic remark of the man who at the time of his death was the most widely read and admired contemporary English poet. Born in Coventry, the son of the city treasurer, he went up to St John's College, Oxford, with Kingsley Amis. He assumed his mature persona when in 1955 he became librarian of the Brymor Jones Library at the University of Hull and published his second volume of verse, *The Less Deceived*. Ever self-conscious, he fancied he was seen as 'one of those old-type *natural* fouled-up guys', and in his gentle and retiring way did nothing to counteract the image. His poetry, which is direct and highly memorable, takes the rhythms of contemporary speech and coaxes them into unobtrusive metrical elegance. In *The Whitsun Weddings* (1964) and *High Windows* (1974) he ranges over sad urban and suburban landscapes, and the preoccupations of their inhabitants, but above all he writes of his own preoccupation with transience and death. He produced verse sparingly, but also wrote two novels, and quantities of jazz criticism in which he revealed an otherwise latent hedonism.

Fay Godwin first took up photography in 1966, when she began to photograph her young children. Despite the lack of any formal training, she has made a reputation for herself as a photographer of writers and, above all, of landscape, and has collaborated among others with John Fowles on *Islands* (1978), Ted Hughes on *Remains of Elmet* (1979), and with Alan Sillitoe on *The Saxon Shore Way* (1983). She photographed Larkin in wry mood at the library in Hull, looking, as he described himself in later life, 'like a bald salmon'.

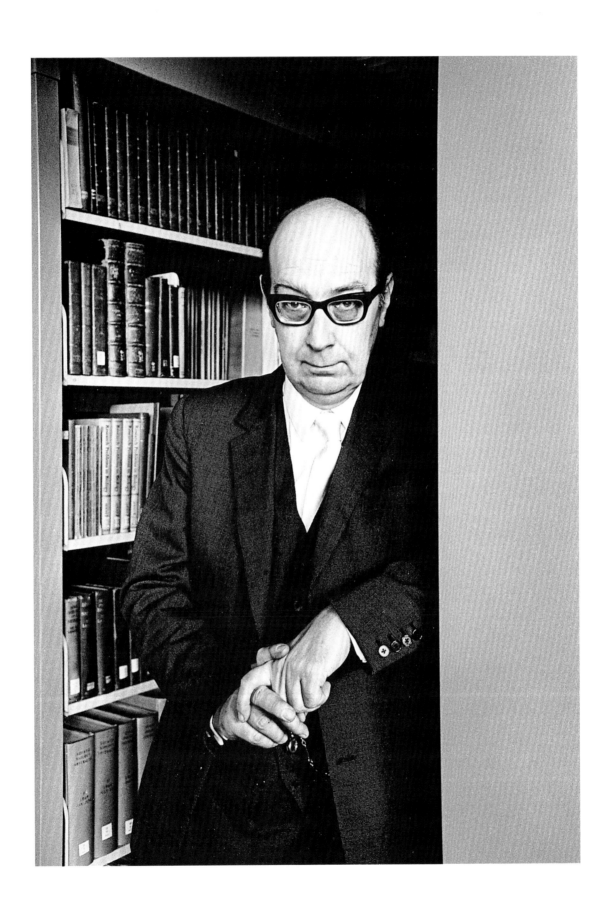

138

Elisabeth Agnes Lutyens, Mrs Edward Clarke 1906–83

Mayotte Magnus

Bromide print, with the photographer's stamp on the reverse, August 1976
40 × 29.7 ($15\frac{3}{4}$ × $11\frac{5}{8}$)
Purchased from the photographer, 1977 (X18622)

Elisabeth Lutyens, one of the first and most important English composers to adopt 12-note techniques, was the daughter of the architect Sir Edwin Lutyens. She studied composition at the Royal College of Music and the Paris Conservatoire. Though at first she worked in a late romantic style, she soon realized that her true idiom lay in serialism, and with typical decisiveness discarded fifty of her early works. An abrasive character, she dismissed the prevalent fashions in English composition as 'cow-pat music', and spent much of her time until the late 1950s in artistic isolation. Her works include six chamber concertos (1939–45), more than two hundred radio scores (including collaborations with Dylan Thomas and Louis MacNeice), and an opera *Time Off? Not the Ghost of a Chance* (1972), a virtuoso collage of music, pre-recorded tapes, dance and speech. But her greatest gifts were as a miniaturist in the manner of Webern and in the setting of words (usually for small choirs), tackling texts which range from Chaucer to Stevie Smith, and include African poems, letters by Flaubert, Japanese haiku and the writings of Wittgenstein.

Mayotte Magnus is the French-born wife of Jorge Lewinski (no. 134). She took up photography in 1970, winning a major Ilford photographic prize two years later. In recent years she has collaborated with her husband on a series of photographically illustrated books, and has worked for magazines including *Harpers & Queen* and *Fortune*. This portrait was taken for her exhibition 'Women' at the National Portrait Gallery in 1977, and shows Lutyens at her home in North London in the year of the first production of the ritualistic drama *Isis and Osiris*, in a composition of hieratic stylization.

139

Samuel Beckett born 1906

Paul Joyce born 1944

Platinum print, signed, inscribed and dated on the mount, 1979
24.4 × 24.1 ($9\frac{5}{8}$ × $9\frac{1}{2}$)
Purchased from the photographer, 1980 (P157)

The leading protagonist of the Theatre of the Absurd and dramatic minimalism, Beckett was born in Foxrock near Dublin, but has lived in France since the 1930s. He was the friend and, to an extent, spiritual heir of James Joyce. Much of his work – novels, short stories and plays – was first written in French, but he is one of the most controversial figures on the English literary scene. His trilogy of novels *Molloy* (1951), *Malone Dies* (1958) and *The Unnameable* (1960) are all desolate interior monologues, occasionally relieved by flashes of last-ditch humour. This mood of tentative despair had its first and fullest dramatic expression in *Waiting for Godot* (1955), in which the two tramps Estragon and Vladimir endlessly wait for the mysterious Godot. Each act ends with the interchange: 'Well, shall we go?' 'Yes, let's go', and the stage direction 'They do not move'. Late plays have shown an increasing minimalism: *Come and Go* (1966) is a 'dramaticule' of 121 words; *Breath* (1969) lasts only 30 seconds, and begins with the cry of a newborn baby and ends with the final gasp of a dying man; in *Not I* (1973) only a disembodied mouth is illuminated on stage, to deliver its fragmentary monologue.

Paul Joyce had his first exhibition in Nottingham in 1974, and this was followed by 'Elders' at the National Portrait Gallery in 1978. He has also written and directed stage plays and several film profiles, among them studies of the film-makers John Huston and Nicolas Roeg (no. 144). In his portraits his usual habit is to place his sitters in their natural environment, without any attempt at symbolism. However, in the case of Beckett, whom he photographed during a lunch break from rehearsals of his own production of his *Happy Days* at the Royal Court Theatre, London, he has chosen a location generally evocative of his work, and perhaps more specifically of the play *Endgame* (1958), in which the blind man Hamm sits in an empty room flanked by two old people, his 'accursed progenitors', who spend the action in dustbins.

140

Richard Rogers born 1933

Michael Birt born 1953

Bromide print, signed, inscribed and dated, 15 October 1982
25.4 × 25.8 (10 × 10⅛)
Purchased from the photographer, 1984 (X23476)

Born in Florence of British parents, the architect Richard Rogers studied in London and at Yale. In the 1960s he worked for a time with Norman Foster, and in 1970 formed a partnership with Renzo Piano, with offices in London, Paris and Genoa. His name is pre-eminently associated with the Hi-Tech style, and, though he has created some of the most visually exciting buildings in the world, he rightly sees advanced technology not as a stylistic end in itself, but, rather, as a way of 'solving long-term social and ecological problems'. This ideal is embodied in the calculated functionalism of his buildings. A charismatic figure, who can charm clients and motivate a team with little apparent effort, his Centre Georges Pompidou, Paris (completed 1977) and the headquarters building for Lloyds of London (1986) have proved that modernist architecture is capable of catching and holding the imagination of the general public.

Michael Birt, was born in Merseyside, studied in Bournemouth, and since 1976 has worked in London as a freelance portrait photographer. 'A serious photographer who is prepared to concentrate on clear and quiet portraits' (Norman Parkinson), Birt has been employed by a wide range of magazines, including *The Tatler, New Society, Ritz*, and *Woman's Journal. Famed*, an anthology of his work, appeared in 1988. He photographed Richard Rogers at his former offices in Princes Place, Holland Park. The sitter considers this portrait 'a refreshingly straightforward, unmannered study, full of shadows and wrinkles', but technically it is something of a *tour-de-force* in the way in which Birt overcomes the problems posed by double back-lighting.

141

Francis Bacon born 1909

Bruce Bernard born 1928

Bromide print, 1984
45.1 × 30.7 (17¾ × 12)
Given by the photographer, 1986 (x27588)

In speaking of himself Bacon uses the phrase 'exhilarated despair. . . . one's basic nature is totally without hope, and yet the nervous system is made out of optimistic stuff'. Undoubtedly the paintings which have brought him international recognition use a vocabulary of despair – mutilated bodies, agonized faces, stripped interiors – but the tone is vital: vibrant colour, intense physicality, and, at times, an illusion of silvery, glittering movement which comes from the cinema. In his reworking of a great portrait by Velázquez, Pope Innocent X takes on the wounded mask of the nurse in Eisenstein's *Battleship Potemkin*. Bacon was brought up in Ireland, and, after a brief period in Paris and Berlin, came to London and worked in the 1930s as an interior designer. Although he had no formal training, he turned increasingly to painting, and from 1944 and the completion of *Three Studies for a Crucifixion* (Tate Gallery, London), it became his exclusive *métier*.

Like his friend Bacon, Bruce Bernard, journalist, writer on art and photography, and occasional photographer, is no stranger to the bars and clubs of Soho. Both men were close friends of the legendary John Deakin (see no. 123). Bernard photographed Bacon in his studio, melancholy, the available surfaces daubed with paint, behind him a bare room and a familiar motif from his paintings, a naked light-bulb hanging on its despairing cord.

142

John Davan Sainsbury, Baron Sainsbury of Preston Candover
born 1927

Denis Waugh born 1942

C-type colour print, signed by the photographer, 1984
30.4 × 39.4 (12 × 15½)
Given by the photographer, 1986 (X32372)

Lord Sainsbury, eldest son of Lord Sainsbury of Drury Lane, has been chairman of the family firm of J. Sainsbury PLC (whose supermarkets occupy a commanding position in British retail trading) since 1969. He married the ballerina Anya Linden in 1963, and together they have been notable supporters of the arts in Britain. Lord Sainsbury is chairman of the Royal Opera House, London, with which he has long been associated, and has served as a Trustee of the Tate Gallery, the Westminster Abbey Trust, and the National Gallery, to which, with his brothers Simon and Timothy, he has donated a new wing, designed by the American architect Robert Venturi.

Denis Waugh came to London from New Zealand in 1967 to take up a job as art director and photographer, but in 1968 he was chosen as one of the first two students on the Royal College of Art's new course in still photography. Since leaving the College he has travelled, taught at several London colleges, and undertaken an increasing number of commissions. He photographed Lord Sainsbury for *Fortune* magazine at Stamford House, the headquarters of Sainsbury's, with (left) Bridget Riley's painting *Persephone* (1969) and (right) Brendan Neiland's *Building Projection* (1977). Both these works were later given by Lord and Lady Sainsbury's Linbury Trust to the Contemporary Art Society, and are now in the Grundy Art Gallery, Blackpool.

143

Sting born 1951

Terry O'Neill born 1938

Bromide print, 1984
35.5 × 35.7 (14 × 14)
Given by the photographer, 1985 (X322001)

The son of a Geordie milkman, Gordon Sumner took the nickname Sting, which was to become his stage name, from a wasp-striped tee-shirt which he once wore. After dropping out of the University of Warwick he became a primary school teacher, playing in bands in his spare time. In 1977 he became lead singer of the phenomenally successful group Police, writing all their hit songs. The album *Synchronicity* (1983), influenced by the works of Arthur Koestler and Jung, sold over seven million copies. He made his film début in *Quadrophenia* (1978), and has subsequently appeared in *Brimstone and Treacle* (1982), *Dune* (1984), and *Plenty* (1985). He is teetotal with a keep-fit mentality and social conscience. A proportion of the earnings of Police went to help youth clubs, and most recently he has been working with all the resources at the command of an international star to save the rain forests of Brazil.

Terry O'Neill was born in East London, and was a professional jazz musician by the age of fourteen. He took up photography at the age of twenty, and within nine months began working for *The Daily Sketch*. Three years later he became a freelance, and has since ranged the world photographing celebrities. He was for a time married to the American film actress Faye Dunaway. His work has appeared in many magazines, including *Life*, *Time*, *The Observer*, *The Sunday Times* and *Première*, and he published a collection of his work, 'Legends', in 1985. Many of his portraits are coloured by the instinctive spontaneity of the reportage photographer, but he portrays Sting posed in self-consciously pugnacious guise.

144

Nicolas Roeg born 1928

Dudley Reed born 1946

Bromide print, signed and dated, 1985
31.6 × 26.5 ($12\frac{3}{8}$ × $10\frac{3}{8}$)
Purchased from the photographer, 1989 (X32172)

Nic Roeg began his film career as a cinematographer, working on *The System* (1963), *The Caretaker* (1966), *Far from the Madding Crowd* (1968), and many other films. He is now recognized as one of Britain's leading modernist directors, whose enigmatic, shocking and highly original films are always controversial and rarely commercial. His first was *Performance* (1970), starring Mick Jagger, which he co-directed with Donald Cammell. This was followed by *Walkabout*, set in Australia (1971), the psychological thriller *Don't Look Now* (1973) and *The Man Who Fell to Earth* (1976). Recent works include *Castaway*, *Track 29* and a section of *Aria*. He is a meticulous craftsman, with a cameraman's eye for a sumptuous shot, who has done much to establish the acting careers of Jenny Agutter, Donald Sutherland and David Bowie. He has also made some of the most inventive of commercials – 'when I do a commercial, it's not just a technical exercise done for the money. Interesting things happen' – including *Tombstone*, the first to publicize the threat of AIDS.

Dudley Reed studied at Guildford School of Art (1968–71), before working as assistant to Adrian Flowers and Lester Bookbinder. He began freelancing in 1974, and has worked for *The Tatler*, American *Vogue*, *GQ*, and *The Sunday Times*. He had his first one-man show in 1985, and his work was included in 'Twenty for Today' (1986) at the National Portrait Gallery. He photographed Roeg in company with David Hockney's photographic collage ('joiner') *Nude 17th June 1984*. This is a portrait of Roeg's second wife the actress Theresa Russell, and consciously imitates Tom Kelly's pin-up portrait photographs of Marilyn Monroe. It was commissioned by Roeg for his film *Insignificance* (1985), in which his wife plays the leading role of Monroe.

145

Bruce Oldfield born 1950

John Swannell born 1946

Bromide print, 1985
38.4 × 30.4 (15 × 11⅞)
Given by the photographer, 1986 (X27936)

One of Britain's leading fashion designers, and a favourite of the Princess of Wales (no. 149), Oldfield's reputation is based on his ability to create glamorous, sophisticated clothes which are also practical. He was brought up in a Dr Barnardo's children's home, and after a spell at teacher-training college, went to St Martin's College of Art, London. After an unsuccessful début in New York, he worked freelance, with assignments in Paris designing shoes for Yves St Laurent and furs for Dior. He opened his own salon in Knightsbridge in 1975 with a bank loan of £1,000. There he produced designer collections of high fashion clothes for the United Kingdom and overseas market. Six years later he began making couture clothes for individual clients, who now include members of the Royal Family, Joan Collins (no. 122), Charlotte Rampling (no. 136) and Bianca Jagger. He opened the first Bruce Oldfield retail shop selling ready-to-wear and couture in 1984.

John Swannell left school at sixteen, and worked as a messenger with Keystone Press, as an assistant at Vogue Studios, and subsequently with David Bailey (see no. 149). He went freelance in 1973, and has travelled widely, mainly for fashion magazines, including *Vogue*. His work has appeared in *Harper's & Queen*, *The Tatler*, *The Sunday Telegraph*, *The Sunday Times*, *Interview* and *Ritz*. He has published *Fine Lines* (1982) and *The Naked Landscape* (1986). In this cool and elegant portrait of Oldfield the strong diagonal of the sitter's back and the cropping at the hairline concentrate attention on Oldfield's frankly assessing stare.

146

Sir Clive Marles Sinclair born 1940

Simon Lewis born 1957

Bromide print, signed, inscribed and dated on the mount, 1985
41 × 28 (16⅛ × 11)
Purchased, 1988 (P365)

Latest in the line of great British inventors, Sir Clive Sinclair is a retiring mathematical genius, whose creations – the pocket calculator, the low-cost digital watch, the miniature television set, and the cheap home computer – have revolutionized popular attitudes to technology, and changed the lives of millions. The son of a mechanical engineer, he worked first as a technical journalist, and in 1962 founded his own company selling build-your-own-radio kits by mail order. He is now chairman of Sinclair Research Ltd, with a multi-million-pound turnover, and also Chairman of MENSA. Only his electric car, the Sinclair C5, has so far proved a failure, and Sir Clive has quickly moved on, to the problems of improving the silicon chip.

The London-based Simon Lewis first studied graphic design, before becoming a freelance photographer in 1983. He photographed Sir Clive for his series *The Essential Britain*, on which he is working with the writer Tadgh O'Seaghdha. In a portrait of steely brilliance Sir Clive holds his favourite circular slide rule – hardly high technology – but used here emblematically as the index of a numerate mind.

147

The Rt. Hon. Margaret Hilda Roberts, Mrs Denis Thatcher
born 1925

Brian Griffin born 1948

Bromide print, 1986
22.8 × 22.8 (9 × 9)
Purchased from the photographer, 1989 (P415)

Member of Parliament for Finchley since 1959, Margaret Thatcher was elected Leader
of the Conservative Party in 1975, in succession to Edward Heath, and has been Prime
Minister since 1979. She has now spent a third of her parliamentary career as premier.
Born in Grantham, Lincolnshire, the daughter of a grocer, she read chemistry at Oxford,
and, after four years as a research chemist, was called to the Bar in 1954. She first achieved
government office in 1961, and between 1970 and 1974 was Secretary of State for Educa-
tion and Science. A conviction politician of the greatest energy and determination, she
is the most controversial figure in modern British politics. With her faith in the free-
market economy and the enterprise of the individual, she has brought about wide-ranging
social and economic changes, the full significance of which remains to be assessed.

Brian Griffin, photographer, poet, performance-artist and self-publicist, was born
in Birmingham, and, after working for some years in the engineering industry, studied
photography at Manchester Polytechnic (1969–72). Highly prolific, his work has been
seen in many exhibitions in Britain and abroad, including 'Twenty for Today' (1986)
and a one-man show 'Work' (1989) at the National Portrait Gallery, and in numerous
magazines. Above all, however, he is associated with *Management Today*, and his series
of portraits of businessmen. The best of these have a surreal, almost subversive quality,
which is, however, shrewdly managed, and never allowed to undermine his subjects.
This portrait of the Prime Minister in hard hat is characteristic. It was commissioned
by Rosehaugh Stanhope Developments PLC as part of a series of photographs of manage-
ment and workers commemorating their massive Broadgate development scheme in
London.

148

Harold Evans born 1928 and Tina Brown born 1953, 'The Editors'

David Buckland born 1949

Cibachrome print, signed, inscribed and dated on the reverse by the photographer:
The Editors Buckland. Aug 87/$\frac{1}{10}$ Printed August 88; 1987
99.1 × 76.2 (39 × 30)
Purchased from the photographer, 1988 (P380)

Harold Evans and his wife Tina Brown are two of the most successful and original editors today. Evans made his reputation on northern newspapers, before moving south to *The Sunday Times* in 1966. He was editor there from 1967–81, in arguably its greatest days, moving to *The Times* in 1981. Tina Brown won the Catherine Pakenham Prize for most promising female journalist in 1973, and was Young Journalist of the Year for 1978. As editor of *The Tatler* (1979–83) she was a triumphant success, bringing wit and bite to a tired favourite, and tripling its circulation in the process. In 1981 she married Harold Evans, and the pair now work in New York, he as editor-in-chief of *Traveler Magazine* and vice-president of Weidenfeld and Nicolson, she as editor-in-chief of *Vanity Fair*, where she has again worked the *Tatler* miracle.

David Buckland studied at the London College of Printing (1967–70) and held a Northern Arts fellowship in photography (1971–3). He has taught at the Royal College of Art in London, and in addition to his photographic work, has designed sets and costumes for Ballet Rambert and the London Contemporary Dance Theatre. He has had numerous one-man shows in England and abroad, and his work was included in 'Twenty for Today' (1986) at the National Portrait Gallery. His large portraits have a mythic quality, and he undoubtedly sees his sitters as types in a pageant of contemporary society. For Evans and Brown he creates a glowing image of international celebrity, and he has spoken of the photograph's 'Hollywood colour'. It was taken in a New York studio, the back-drop of the Manhattan skyline supplied by front-projection, a film technique which he uses to dramatic effect in his still photography.

149

Her Royal Highness The Princess of Wales born 1961

David Bailey born 1938

Bromide print, 1988
50.4 × 37.3 (19$\frac{7}{8}$ × 14$\frac{3}{4}$)
Commissioned by the Trustees and given by the photographer, 1988 (P397)

Lady Diana Spencer, daughter of the 8th Earl Spencer, married The Prince of Wales in July 1981. The couple have two children, Prince William (born 1982) and Prince Henry (born 1984). Fun-loving, elegant and goodlooking, she makes the perfect foil to her husband. The Princess has been increasingly involved in work for charity, and shows particular interest in children, and in drugs- and AIDS-related causes. In Britain and on her many tours abroad, in private and in public life, she has become a leader of fashion with an assured style of her own.

David Bailey was born in East London, left school aged fifteen, and, after national service in Singapore and Malaya, began work as assistant to the fashion photographer John French and produced his first work for *Vogue* in 1960. He starred in a series of television advertisements for Olympus, and as a result he is is now the most famous living British photographer. To both fashion and portrait photography he has brought qualities of fantasy and invention, which can make him seem eclectic. In his non-commissioned work he has revealed an endless creative fascination with the female body. He has published numerous books of his work, including *David Bailey's Box of Pin-ups* (1965), *Goodbye Baby & Amen* (1969), *Beady Minces* (1973) and *Trouble and Strife* (1980), which appeared in America as *Mrs David Bailey*. For his portrait of the Princess he takes an uncharacteristically straightforward approach, and produces a classically elegant study in black and white.

150

Anita Roddick born 1942

Trevor Leighton born 1957

C-type colour print, signed, 1989
$(39.4 \times 39.4 \ (15\frac{1}{2} \times 15\frac{1}{2}))$
Given by the photographer, 1989 (X33001)

Anita Roddick presides over a cottage-industry which has grown into a multi-million pound business. The daughter of Italian immigrant parents who ran a café in Littlehampton, Anita Parella campaigned as a teenager for the Campaign for Nuclear Disarmament and Freedom from Hunger, and later worked on a kibbutz, a period which she describes as 'the benchmark of my life'. While working for an international charity she noticed that the peoples of the Third World countries used natural products on their skin. From this sprang the idea of the first Body Shop, which opened in Brighton in 1975, selling cosmetics made only from natural ingredients, involving no suffering to animals, packed in refillable containers and wrapped in recycled paper. With the help of her husband Gordon Roddick, the Body Shops have now grown into a franchised chain, and are the retail flagship of the environmentalist movement, in which she takes a leading role.

Trevor Leighton studied at Carlisle College of Art and Design, and for two years played guitar in a punk rock band. He worked first as a photographer in Newcastle, and opened a studio in London in 1981. He specializes in fashion and portraits, and his work has appeared in *The Tatler, Woman's Journal, The Observer* and *The Independent* magazine. He exhibited in 'Twenty for Today' (1986) at the National Portrait Gallery. For portraits he generally favours tight-cropped head shots, but he occasionally, as here, works at three-quarter-length; a format which allows greater scope for his evident fantasy. He portrays Anita Roddick in the clothes she wears for her expeditions to find new products, cradling in her hands a pat of mud, in witty allusion to her concern for all things natural, a 'friend of the earth'.

GLOSSARY

● **Albumen print** A print made using albumen paper, an improvement on salted paper (see *Salt print*), introduced by L.D. Blanquart-Evrard in 1850, which became the main medium for photographic printing throughout the nineteenth century. It was a very thin paper coated with a layer of egg white containing salt, and sensitized with silver nitrate solution. Prints made with it have a slight surface sheen, and were often toned with a gold solution, giving a rich purplish-brown colour to the image. The whites tend to yellow with age.

● **Ambrotype** A collodion positive. In 1851 Frederick Scott Archer published the first account of the wet collodion process, which revolutionized photography. In this a glass plate was coated with prepared collodion (pyroxyline dissolved in a mixture of alcohol and ether), and then immersed in silver nitrate solution. This was then exposed in the camera, and the negative developed while the plate was still wet. Between the mid-1850s and the 1880s wet collodion negatives were virtually the only type in use. Around 1852 it was found that such negatives, developed and bleached, appeared as positives when set against a dark ground and seen in reflected light. They were very rapidly taken up by commercial studios as cheap imitations of daguerreotypes (*q.v.*), and known as ambrotypes.

● **Autochrome** The product of the first commercially available colour process, invented by Auguste and Louis Lumière, patented in 1904, and first marketed in 1907. A glass plate was covered with microscopic grains of potato starch, dyed red, green and blue, producing a random pattern of coloured dots, and then coated with a pan-chromatic gelatin-silver emulsion. This plate was exposed in the camera, with the glass side towards the lens, so that the grains of starch acted as a colour filter on the light before it reached the emulsion. There followed a complex reversal development process to produce a positive image on the plate, which was then covered with another piece of glass to protect it. The resulting transparency had a grainy texture which made the technique popular with photographers seeking an Impressionistic effect. Autochromes were viewed either by projection or in a special viewer. Lumière Autochrome plates went out of production in the 1930s.

● **Bromide print** A print made with paper sensitized with silver bromide. Bromide paper was invented by Peter Mawdesley in 1873, and first produced commercially *c*.1880. It became the most popular and widely used photographic paper in the twentieth century, produced in a variety of finishes – matt, semi-matt and glossy. In bromide prints the blacks have a cold, green-grey quality.

● **Cabinet print** A format, introduced in 1865 and surviving until *c*.1910, similar to the carte-de-visite (*q.v.*), but larger in size, measuring 16.5 × 10.8cm. ($6\frac{1}{2} × 4\frac{1}{4}$in.). It was originally devised for landscape subjects, but soon taken up by portrait photographers for a market which was satiated with cartes-de-visite.

● **Calotype** A process discovered by W.H. Fox Talbot in 1840, and patented by him in the following year. Strictly speaking it is a paper negative process, but the name was soon applied to the positives produced by its means. High-quality writing paper was sensitized with potassium iodide and silver nitrate solutions and exposed in the camera. Exposure took between 10 and 60 seconds in sunlight. After exposure the negative was developed, fixed, washed, and dried, and waxed to give translucency. It was then used to print on to salted paper (see *Salt print*), and many prints could be made from the one negative. The calotype formed the basis of later photographic developments, but in its time it never attained the commercial success of the daguerreotype. It was, however, popular with amateur photographers, who favoured the process for architectural and landscape subjects.

● **Carbon print** The product of a photomechanical process invented by A.L. Poitevin in 1855, and popularized in the 1860s. In this a sheet of paper, coated with gelatin containing pigment (usually carbon black) and potassium bichromate, was exposed by daylight under a negative. To the extent that light was admitted to the surface by the negative the gelatin hardened. After exposure the paper was washed, removing the more soluble gelatin, and the hardened residue thus produced the image. Carbon prints are permanent, showing no signs of fading, and were very popular for commercial editions of photographs and for book illustrations. They may be either matt or glossy, and, when viewed in raking light, the surface has a relief effect.

● **Carte-de-visite** A format of photograph which became hugely popular around 1860, and which remained in use until *c*.1900. It consisted of a print mounted on a sturdy card measuring about 10.1 × 6.3cm ($4 × 2\frac{1}{2}$in.), and usually printed on the reverse with the photographer's or publisher's name and address. Cartes were cheap, since up to six exposures could be obtained from a single large-format negative measuring 25.4 × 20.3cm. (10 × 8in.).

● **Daguerreotype** The first photographic process to be publicly announced, invented in 1839 by the Frenchman L.J.M. Daguerre. It comprised a copper plate with a highly polished silver surface sensitized by iodine fumes, exposed in a camera, and the image developed by fuming over warmed mercury. The resulting image is, of course, reversed, and unique. Easily damaged by touching, daguerreotypes were mounted behind glass in decorative cases. The highlights of the image are formed of particles of a size and distribution that scatter light in the visible spectrum, and since they are dispersed upon a shiny silver surface, the daguerreotype, if it is to be seen properly, must be held so as to reflect a dark ground.

● **Gum platinum print** A print produced by a combination of two processes. A light platinum print (*q.v.*), was made first, and this was then sensitized with a gum bichromate mixture, and re-exposed under the same negative. This method enriched the blacks of the platinum print, and gave great tonal density.

● **Panel print** A format similar to the carte-de-visite (*q.v.*) and the cabinet print (*q.v.*), but measuring *c*.30 × 18.5cm. ($11\frac{3}{4} × 7\frac{1}{4}$in.).

● **Photogravure** The product of a photomechanical printing process invented by W.H. Fox Talbot in 1858, and which came into commercial use *c*.1880. It was in essence an etching process with affinities with the carbon process (see *Carbon print*), and was used for high quality reproduction of art photographs in the 1890s and 1900s.

● **Platinum print** A print made with paper sensitized with iron-salts (but no silver) and a platinum compound (a process invented by William Willis in 1873). The exposed print was developed in a solution of potassium oxalate, and the resulting image formed from platinum deposited on the paper. Prints produced in this way (sometimes known as platinotypes) are permanent and have a matt surface. They are especially rich and velvety in tone, with intense blacks and silvery-grey middle tones. The colour of the prints can be altered by toning.

● **Salt print** A print made using salted paper: high quality writing paper sensitized by immersion in a solution of common salt, and then floated on a bath of silver nitrate. Paper thus treated was used by W.H. Fox Talbot for his 'photogenic drawings' as early as 1834, and later to print from calotype and other negatives. Salt prints were superseded in the 1850s by albumen prints (*q.v.*) but had something of a revival in the 1890s and early 1900s. They have a matt surface, and may be toned with a gold solution to give a rich purple-brown image. They are susceptible to attack by airborne pollutants, and are often faded to yellow at the margins.

● **Silver print or gelatin silver print** Although strictly the term silver print may be applied to any photographic print made with paper in which the emulsion is sensitized with one of the silver compounds, the term now denotes prints made with gelatin silver halide papers, in use from the 1880s to the present day.

318

INDEX OF SITTERS